WORKBOOK

Photography ~ Spring 2012

Publisher/Owner ~	**BILL DANIELS**
Advertising Sales Director ~	**SUZANNE SEMNACHER**
Advertising Sales ~	**LINDA LEVY**
	MARY PREUSSEL
	LORI WATSON
Design Director ~	**ANITA ATENCIO**
Director of Production ~	**PAUL SEMNACHER**
Online Portfolio Manager ~	**KIRSTEN LARSON**
Social Media Manager ~	**WILL DANIELS**
Directory Manager ~	**ANGELICA VINTHER**
Directory Marketing Manager ~	**JOHN NIXON**
Directory Verifiers ~	**AURELIO FARRELL II**
	JORDAN LACEY
	DAVID PAVAO
	ANGELA PERKINS
Technology ~	**JIM HUDAK**
	STEPHEN CHIANG
	RYAN ADLAF
Finance ~	**ALLAN GALLANT**
	EDUARDO CHEVEZ
Security ~	**MR. "T"**

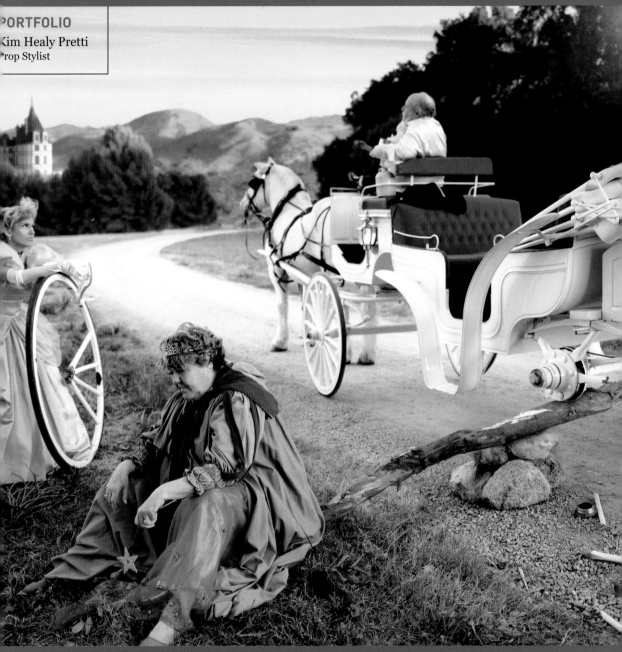

WORKBOOK

in print. online. workbook works.

Production Specialist Portfolios

PORTFOLIO
Kim Healy Pretti
Prop Stylist

Production Specialists: Prop Stylists • Set Designers • Studio & Stage Rentals • Wardrobe Stylists • Location Finders
CGI Services & Retouchers • Production Services • Food Stylists & Home Economists • Hair & Make-up Artists

workbook.com/production

34

~ Contents

see the workbook on the go
MOBILE.WORKBOOK.COM

download the iPhone app at
WORKBOOK.COM/IPHONE

participate in our
BLOG

follow us on
TWITTER

like us on
FACEBOOK

connect with us on
LINKEDIN

workbook.com/social
in print. online. workbook works.

~ **Index**

*Artist's Representative

~ Index

*Artist's Representative

*Artist's Representative

*Artist's Representative

THE GREATEST SHOW ON EARTH

THE GREATEST SHOW ON EARTH

WORKBOOK AND ART DIRECTORS CLUB

PROUDLY PRESENT

WITNESS ASTOUNDING CREATIVE PROCESS!

SEE REAL PHOTOGRAPHERS TAKE NEW PHOTOGRAPHS

SEE REAL ILLUSTRATORS DRAW

MYSTICAL FIRE WORSHIP

STRANGE AND CURIOUS

LIVE ON STAGE

CUNNING CRAFTERS OF DREAMS

MAYER

CREATIVE CARNIVAL

WITNESS LIVE ARTISTS AND PURCHASE THE WORK RIGHT OFF THE WALLS

check your inbox or workbook.com/blog for the next big show near you

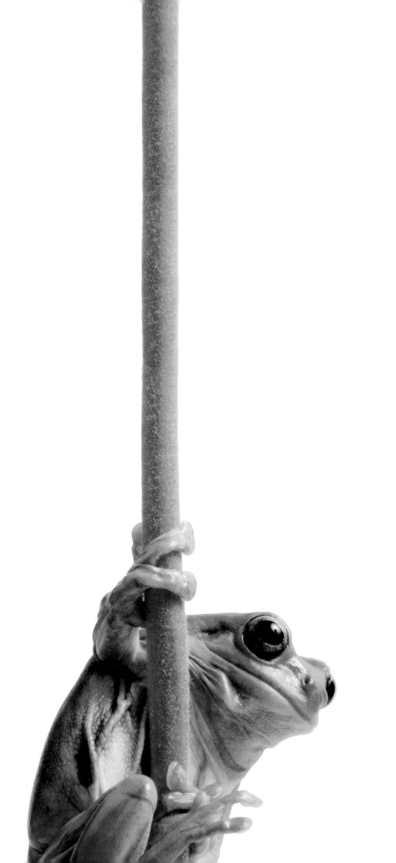

~ Photography

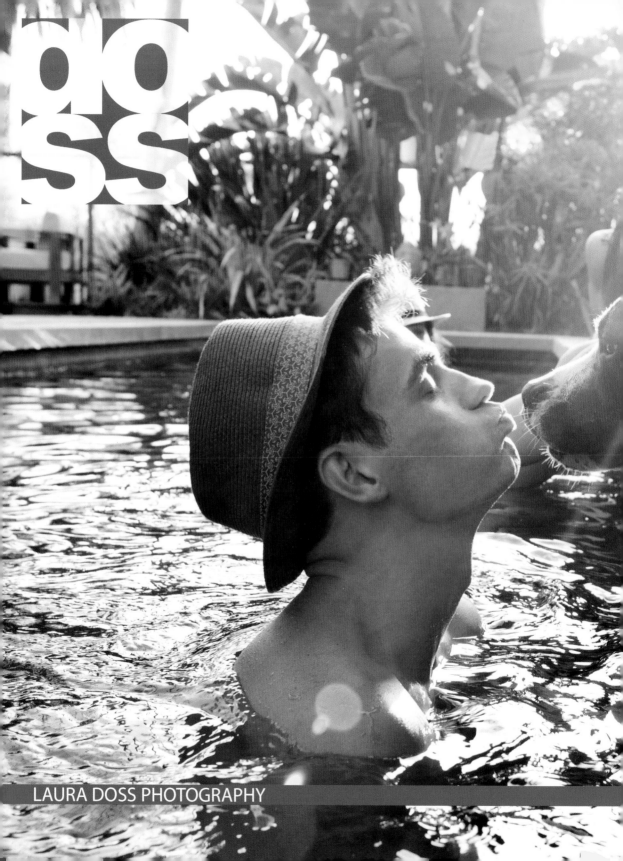

doss

LAURA DOSS PHOTOGRAPHY

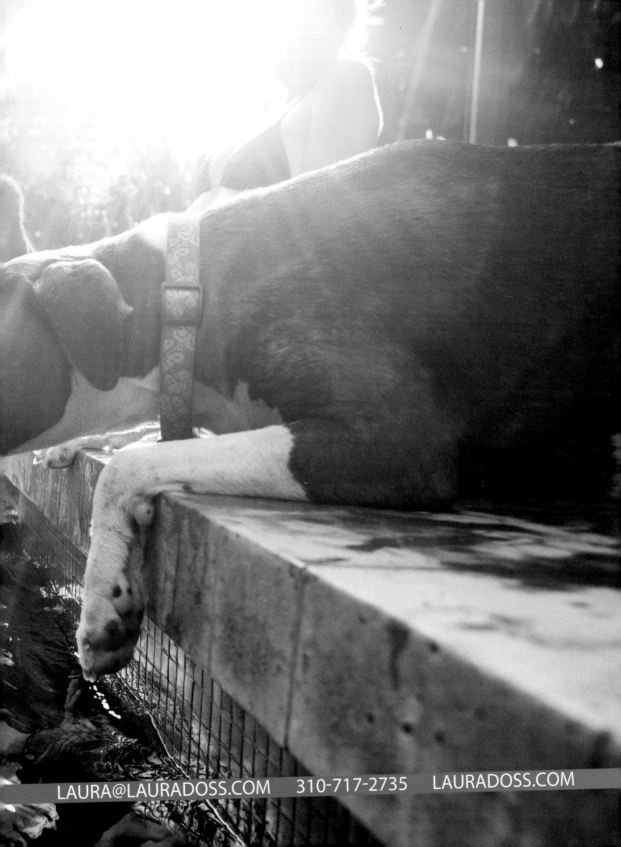

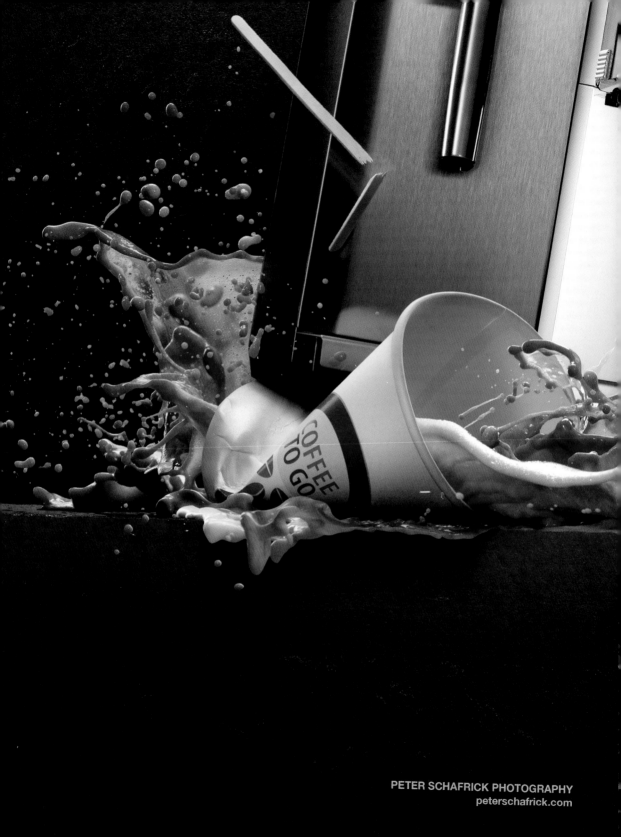

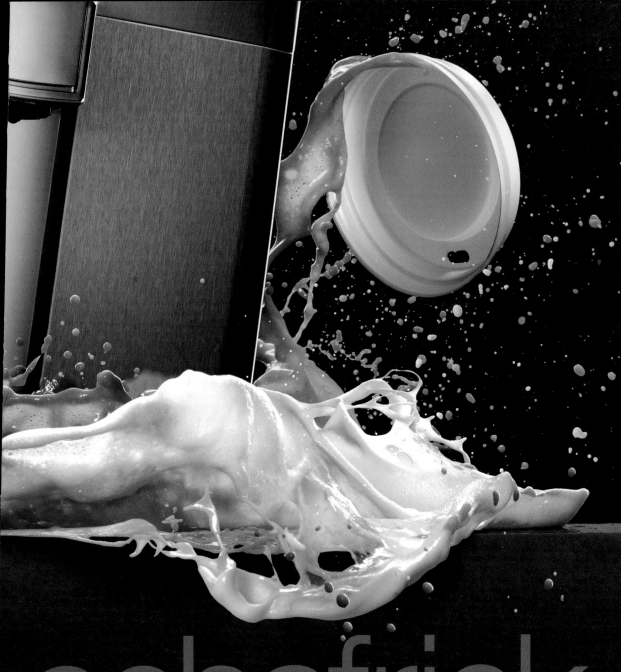

schafrick

U.S.A	CANADA	EUROPE
ray brown \| REP	arlene evidente \| REP	bogna brock \| REP
+1 212 243 5057	+1 416 823 1713	+49 (0) 211 325 175

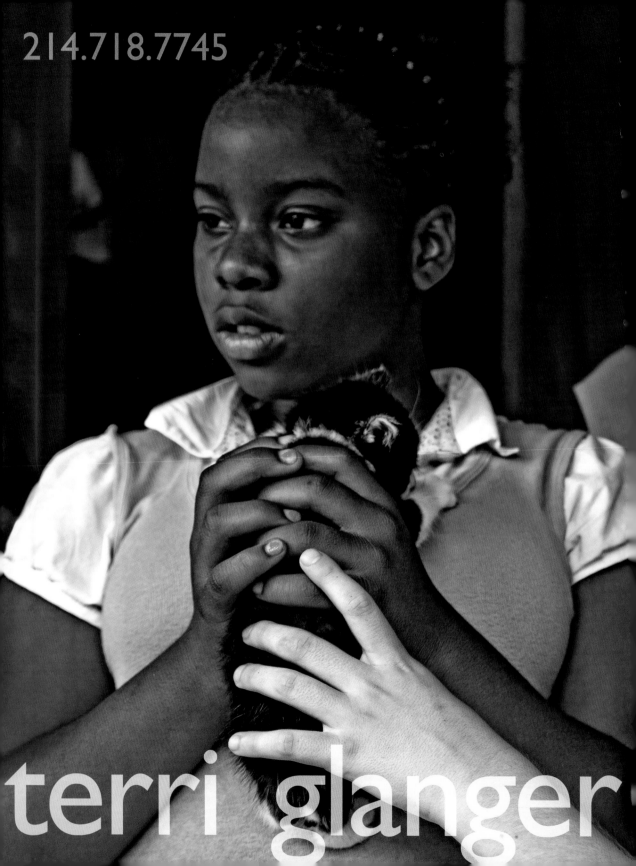

214.718.7745

terri glanger

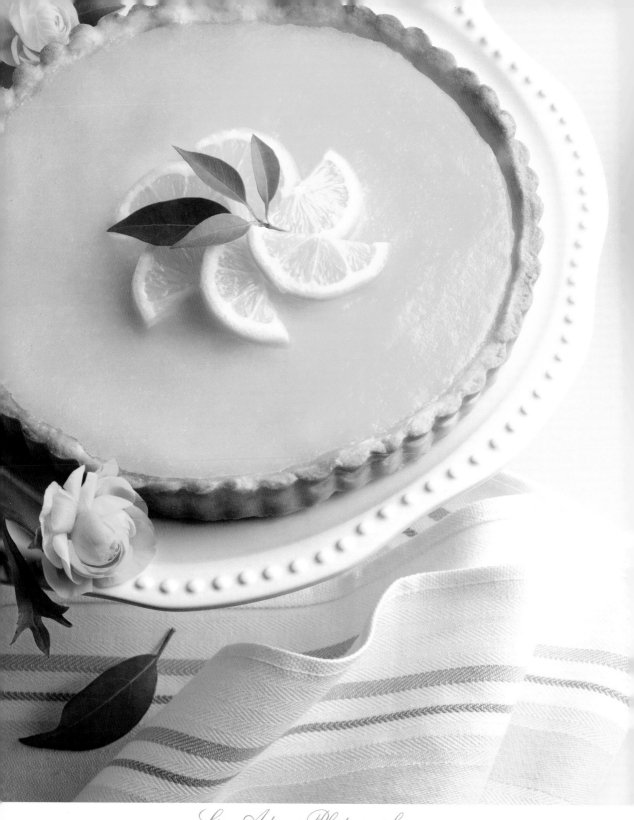

LisaAdamsPhotography.com

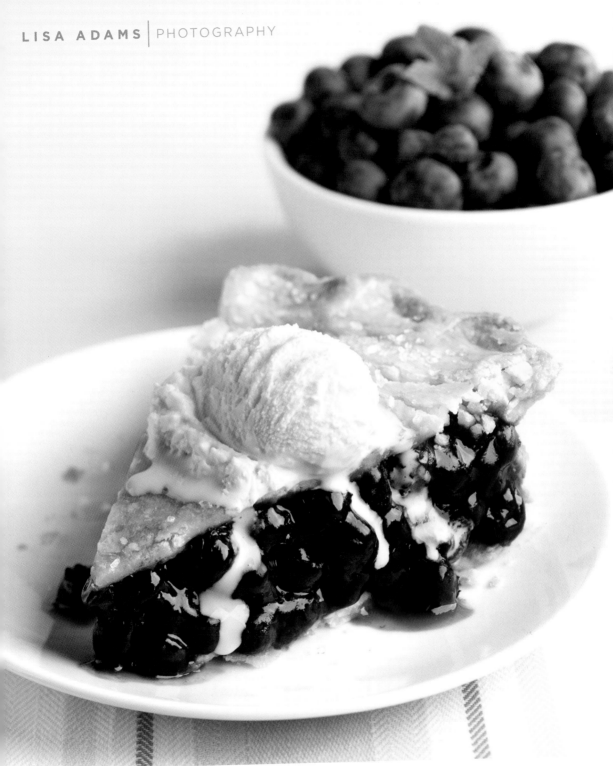

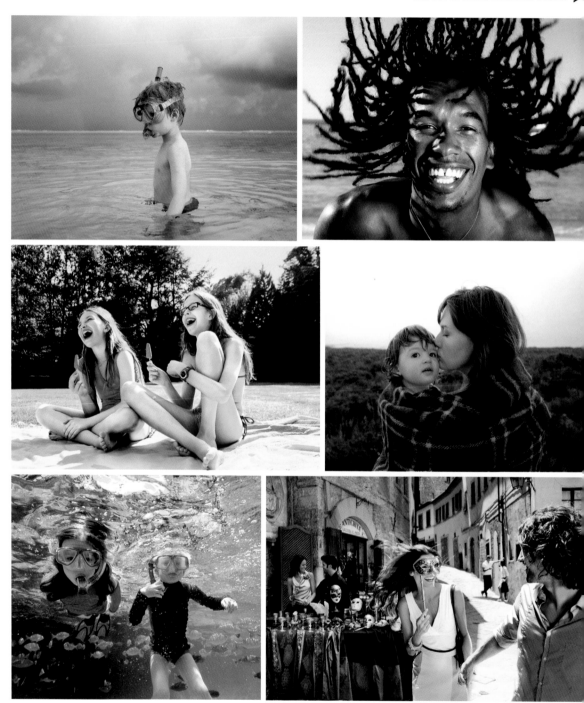

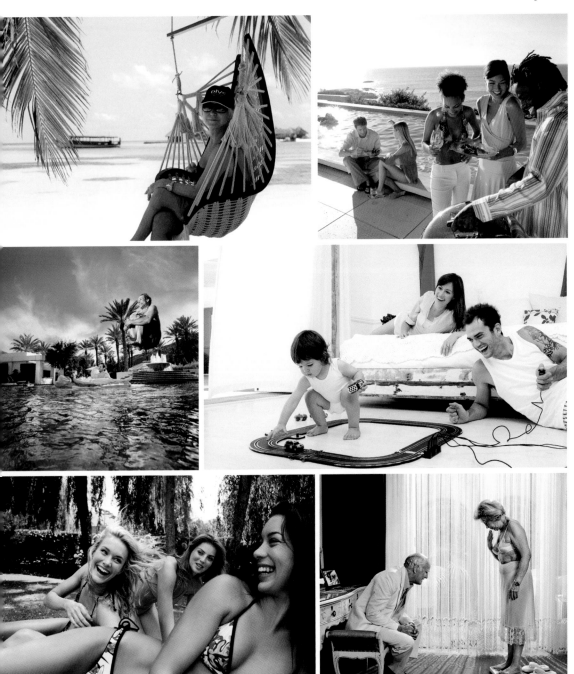

also see directors section on website ▶

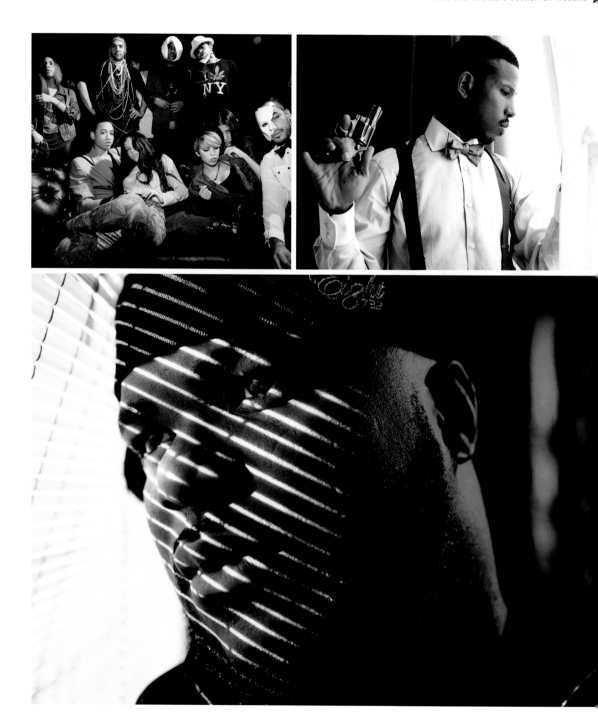

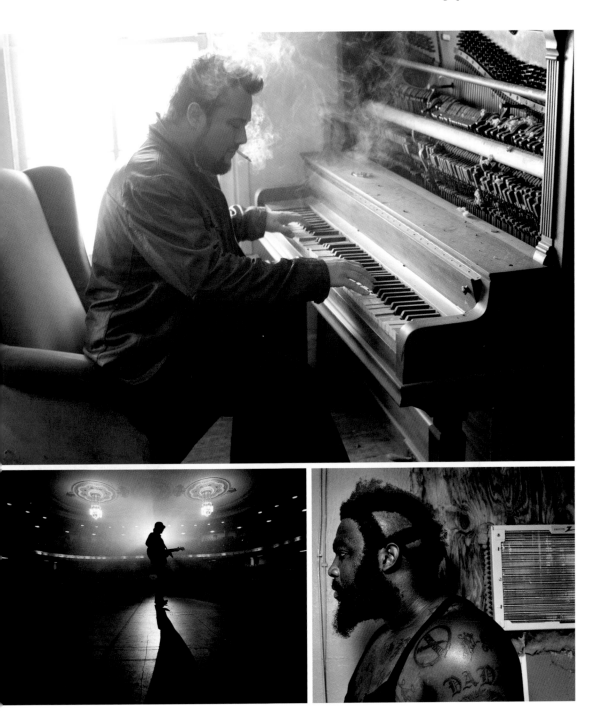

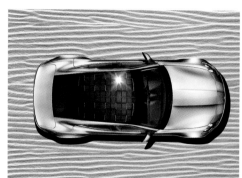

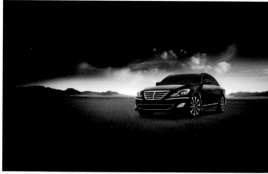

AH 212.431.5117 **www.andersonhopkins.com** blog.andersonhopkins.com

artists represented by **ANDERSON HOPKINS**

AH 212.431.5117 www.andersonhopkins.com blog.andersonhopkins.com

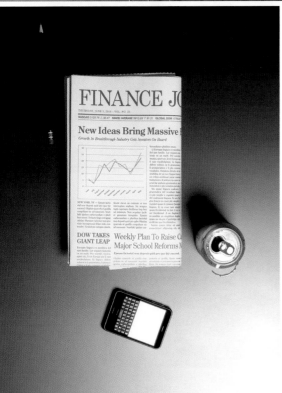

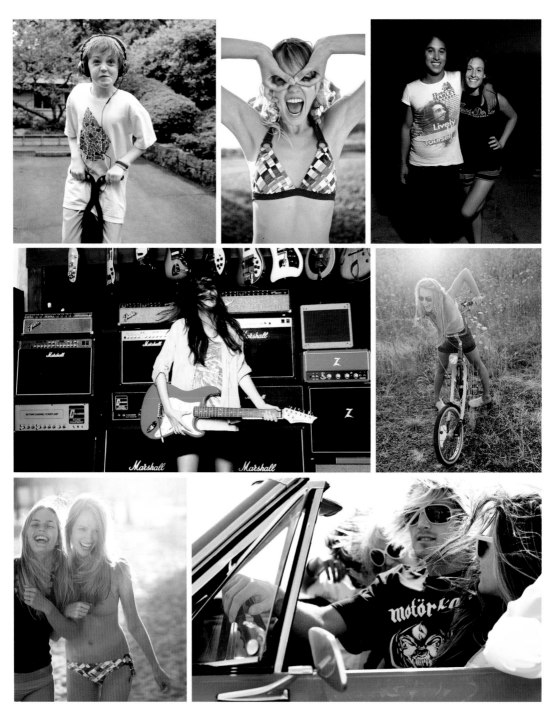

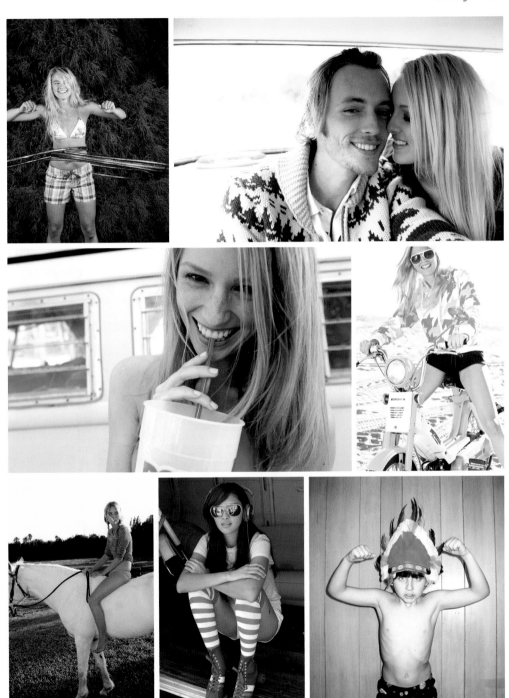

also see directors section on website ▶

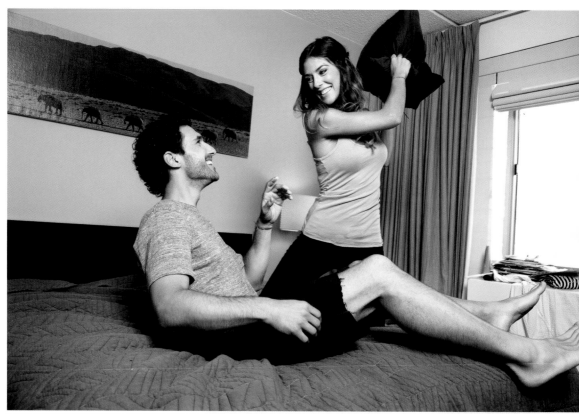

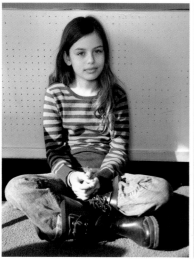

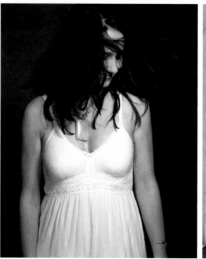

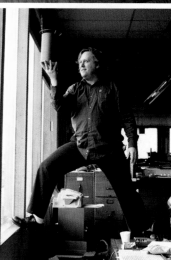

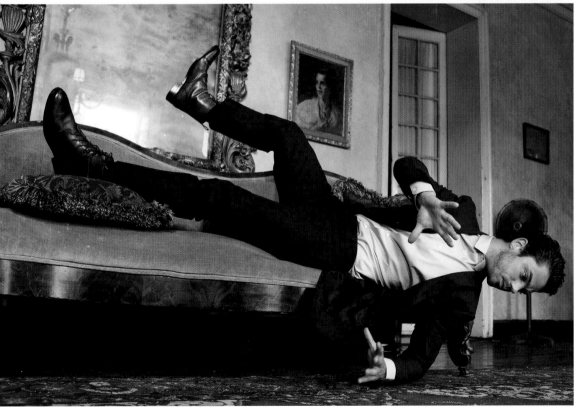

also see directors section on website ▶

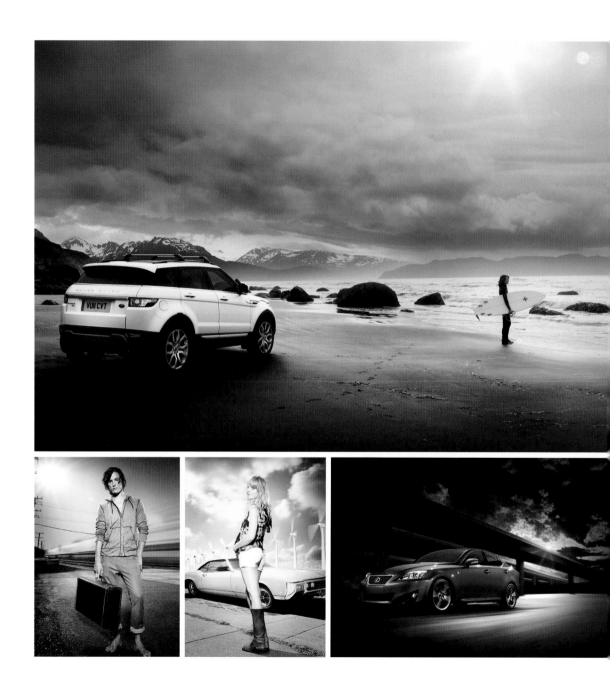

AH 212.431.5117 **www.andersonhopkins.com** blog.andersonhopkins.com

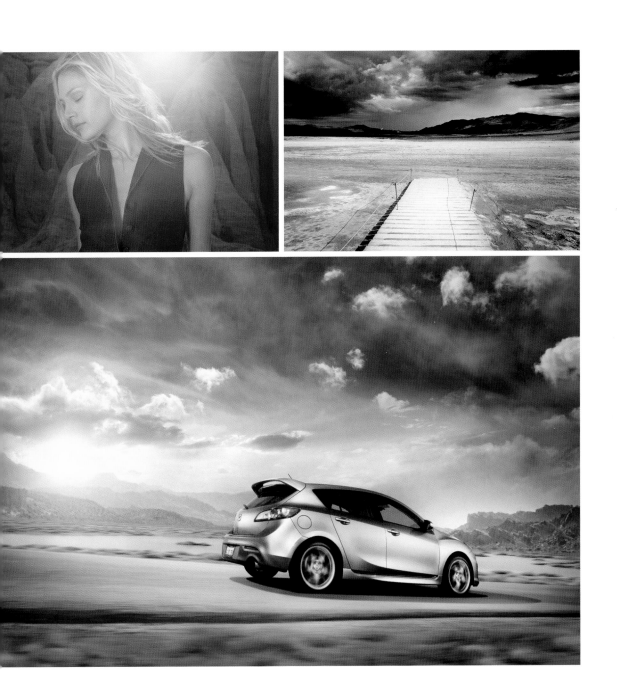

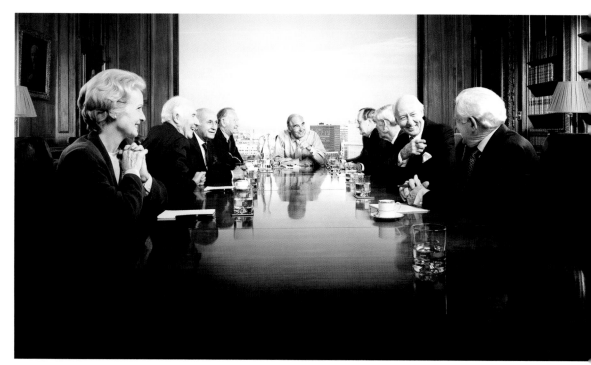

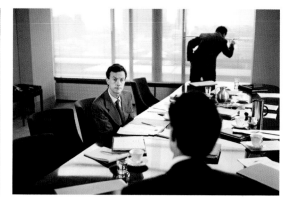

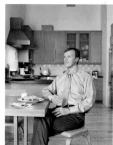

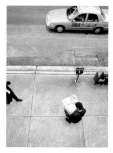

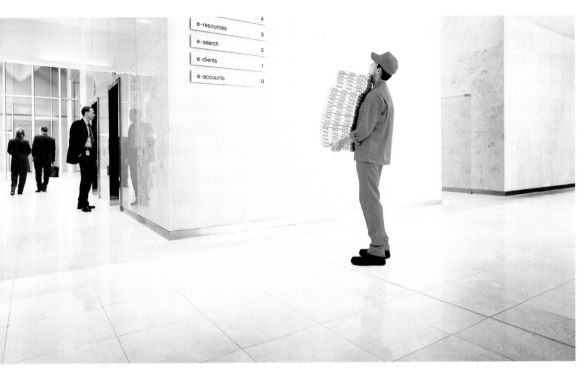

e-resources 4
e-search 3
e-clients 2
e-accounts 1
 0

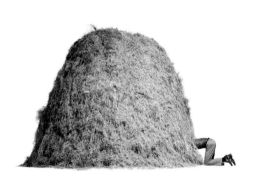

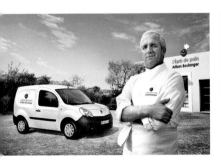

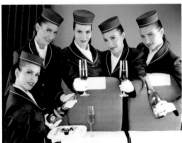

artists represented by **ANDERSON HOPKINS**

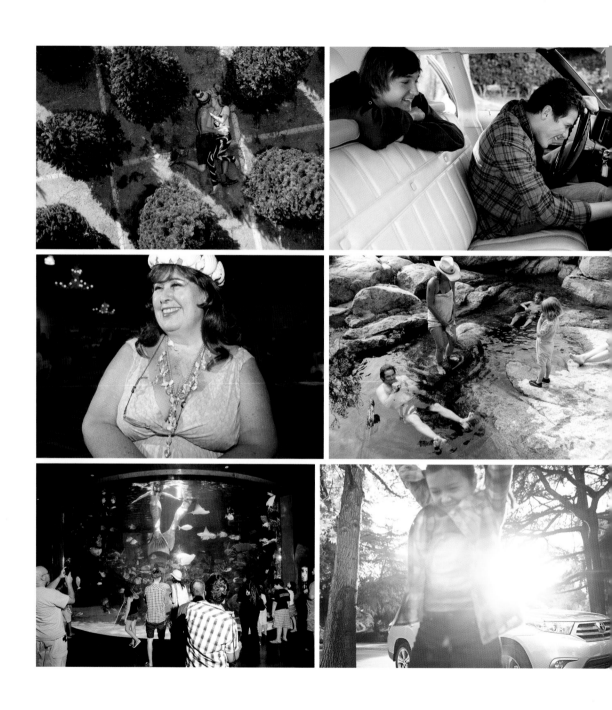

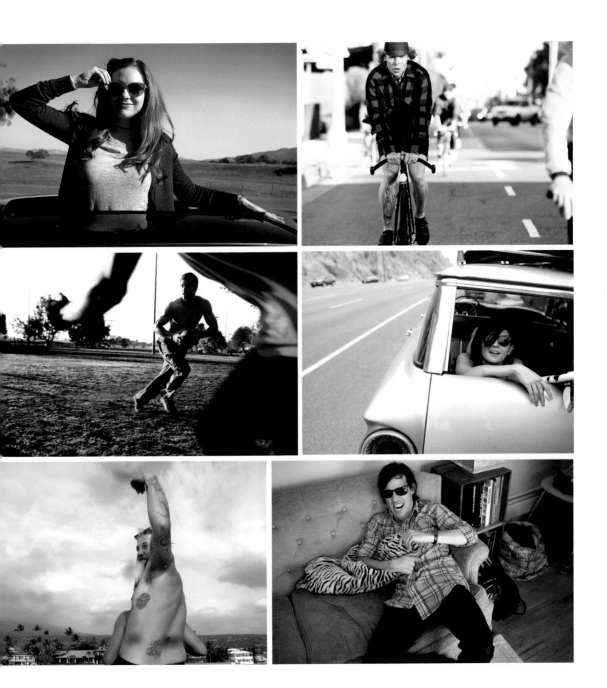

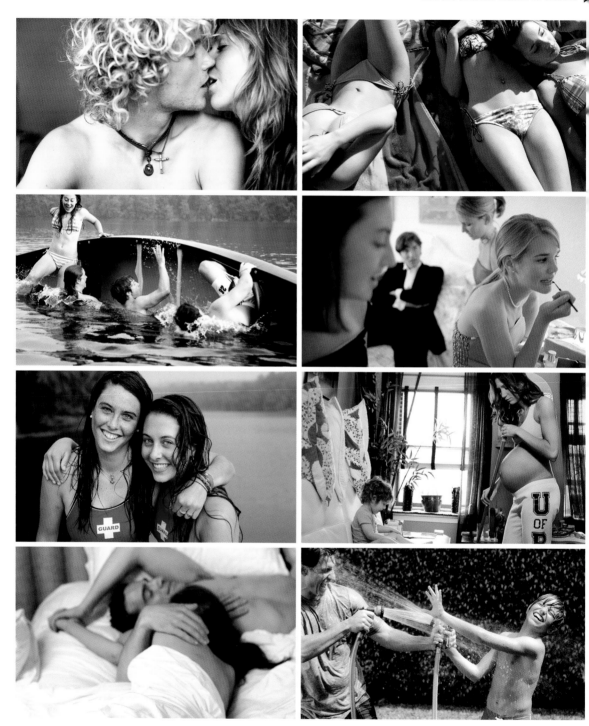

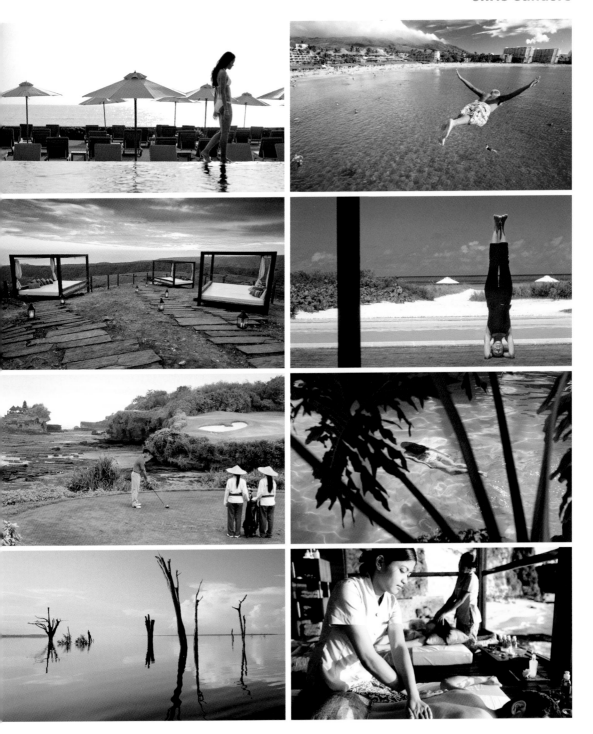

Form AND *Function* MEET.
AND BEGIN A TORRID AFFAIR.

Simply More.

CIVIC Si

civic.honda.com

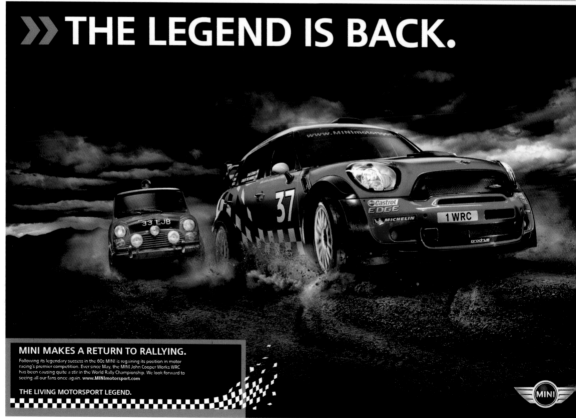

» THE LEGEND IS BACK.

MINI MAKES A RETURN TO RALLYING.

Following its legendary success in the 60s MINI is regaining its position in motor racing's premier competition. Ever since May, the MINI John Cooper Works WRC has been causing quite a stir in the World Rally Championship. We look forward to seeing all our fans once again. **www.MINImotorsport.com**

THE LIVING MOTORSPORT LEGEND.

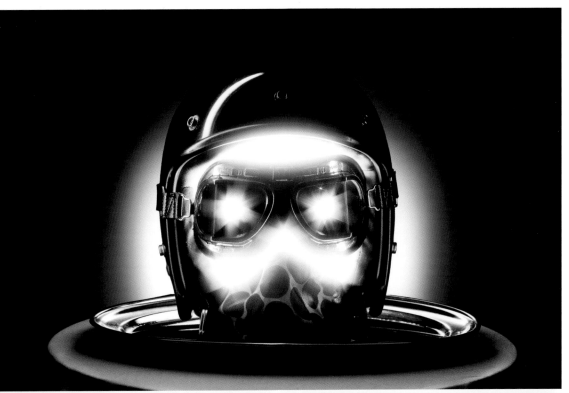

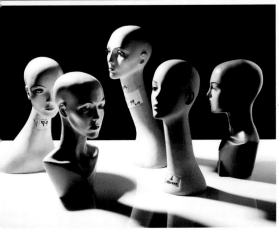

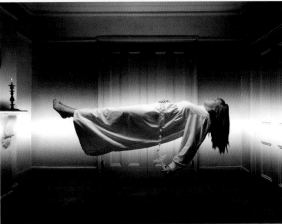

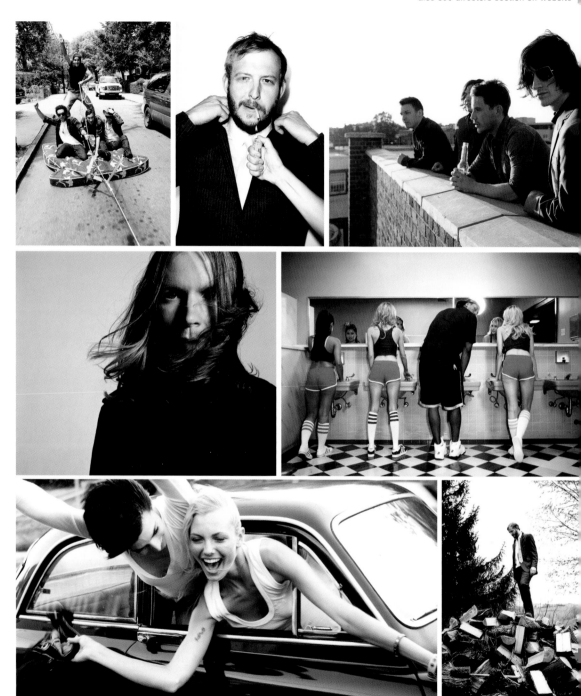

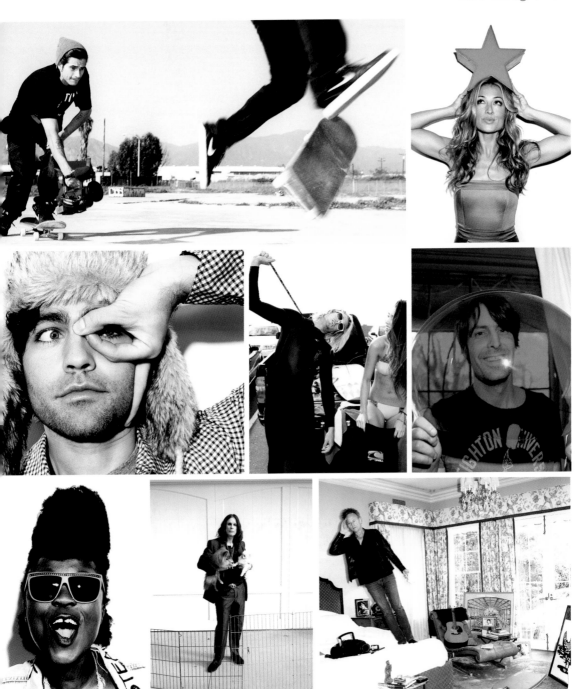

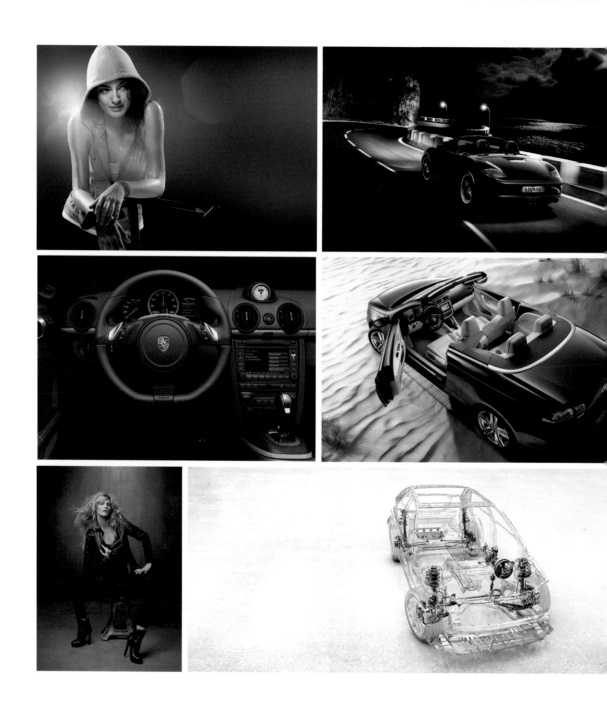

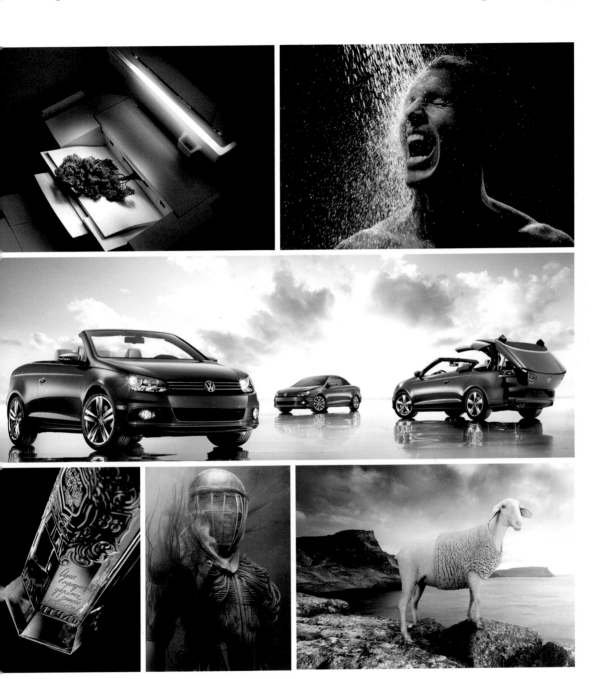

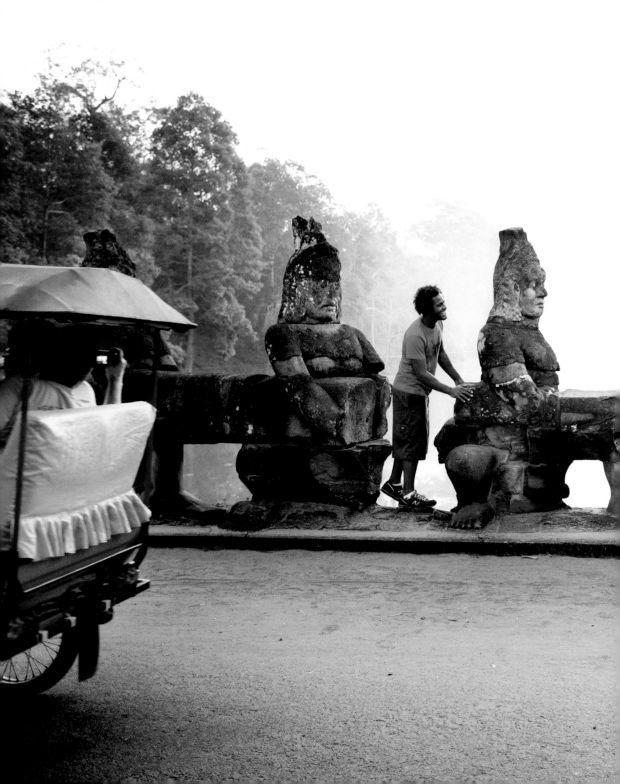

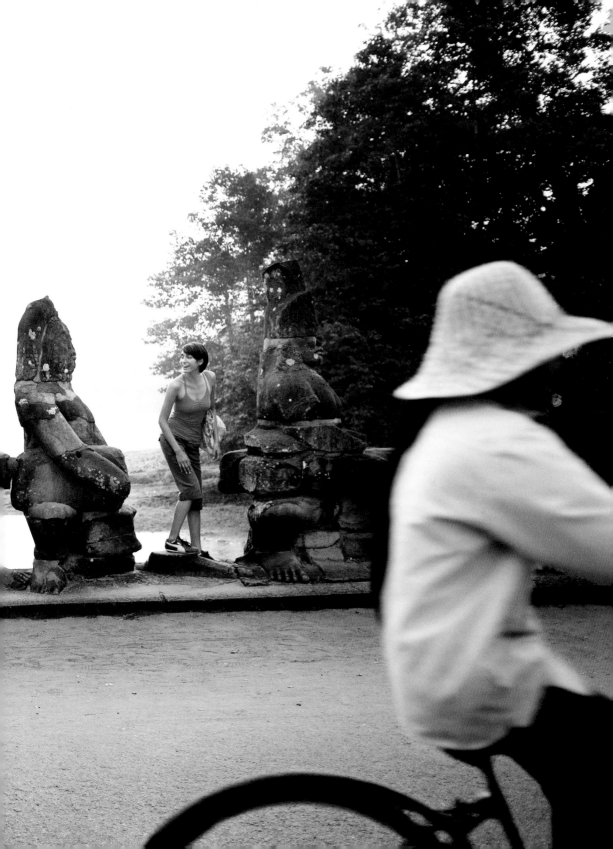

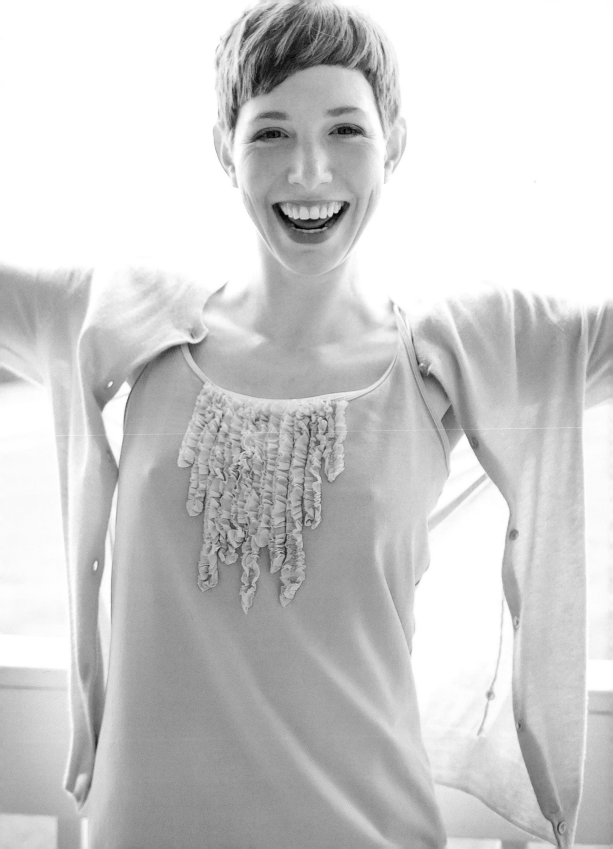

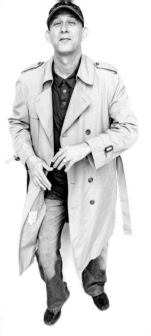
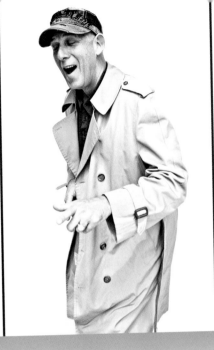
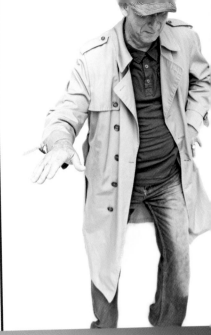

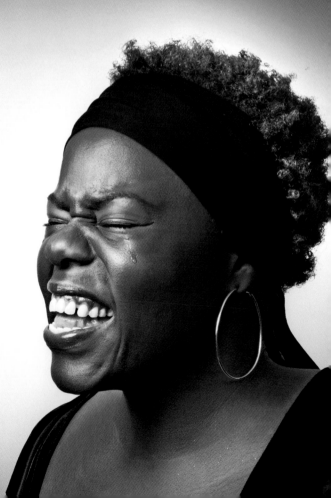

BRETT NADAL
—

via jim hanson artist agent ltd.
jimhanson.com

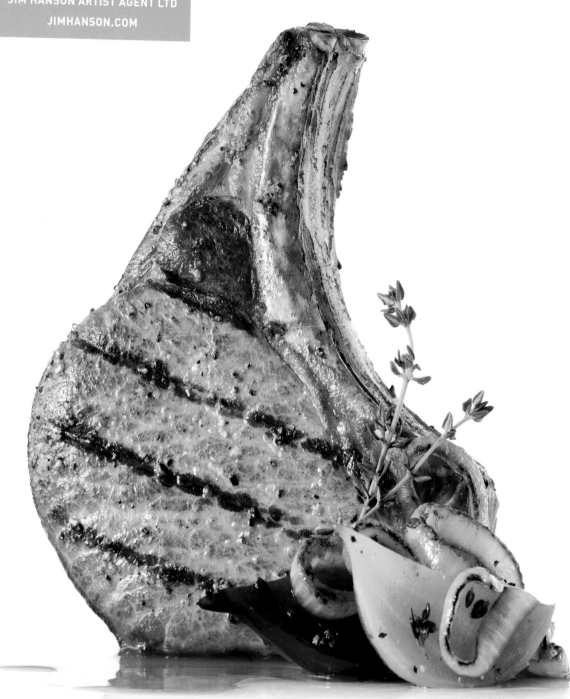

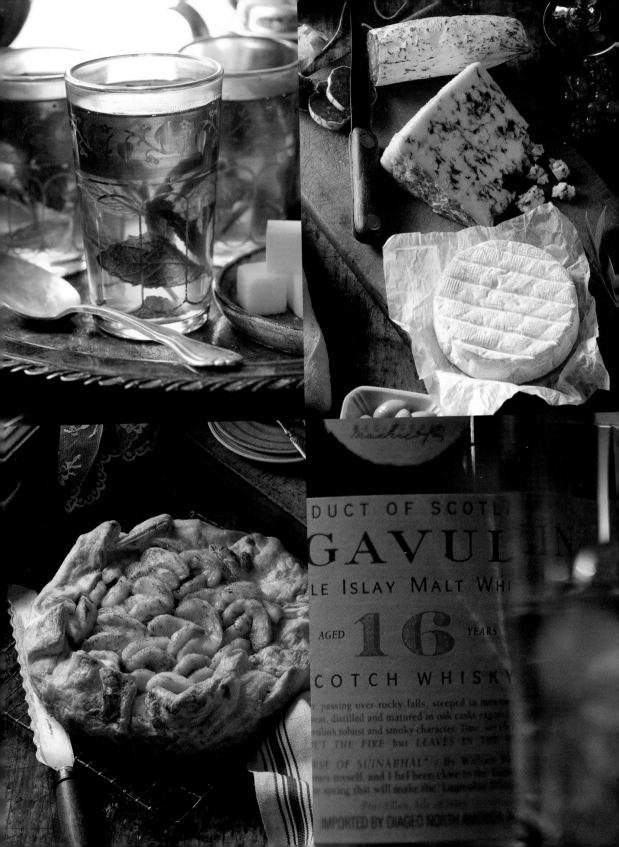

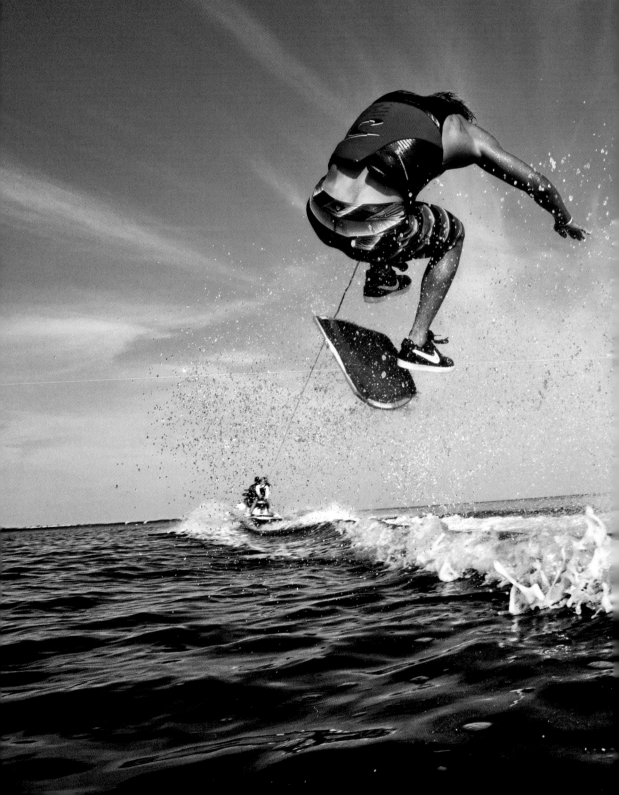

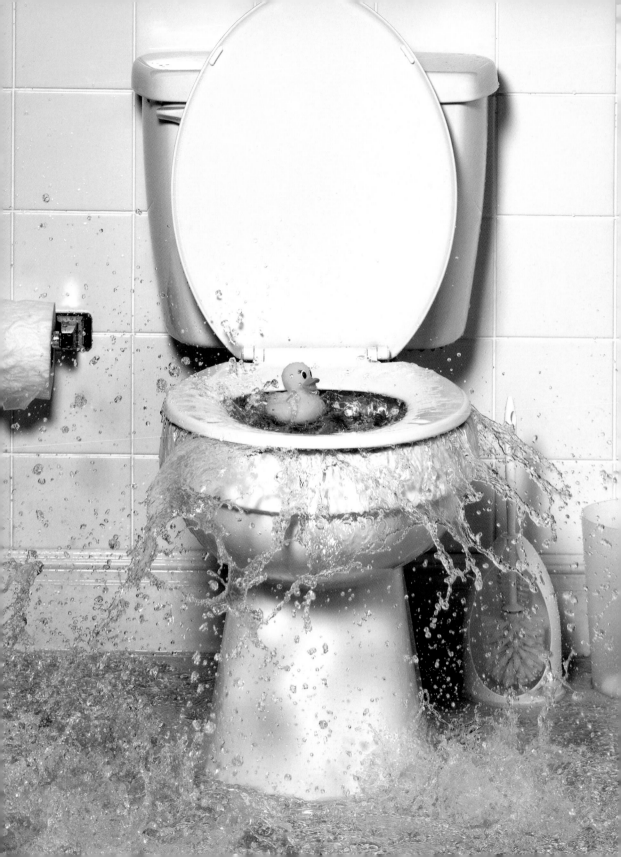

NOZICKA

STEVE NOZICKA PHOTOGRAPHY 314 WEST INSTITUTE PLACE CHICAGO, IL 60610

P)312-787-8925 nozicka.com nozickas@aol.com

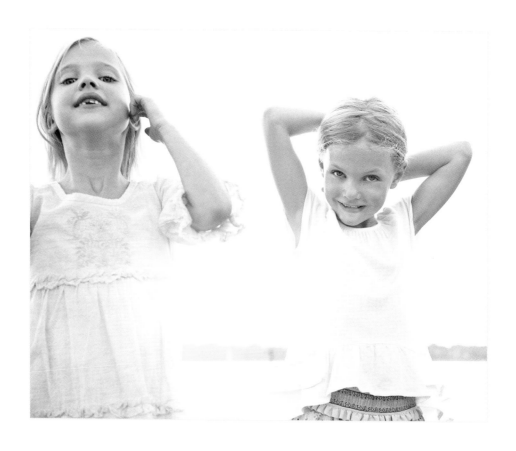

JILL BROUSSARD
PHOTOGRAPHY

The Photo Division 214.763.5887 m@thephotodivision.com

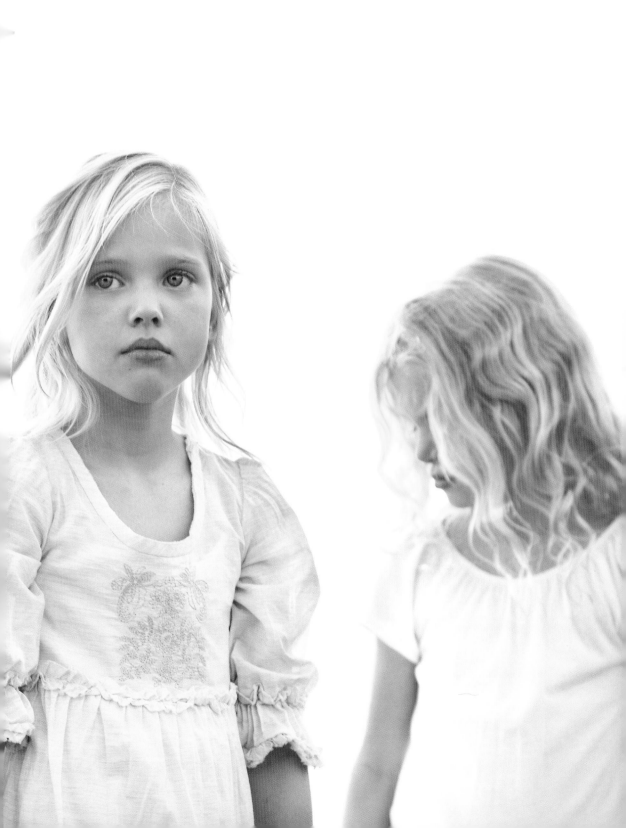

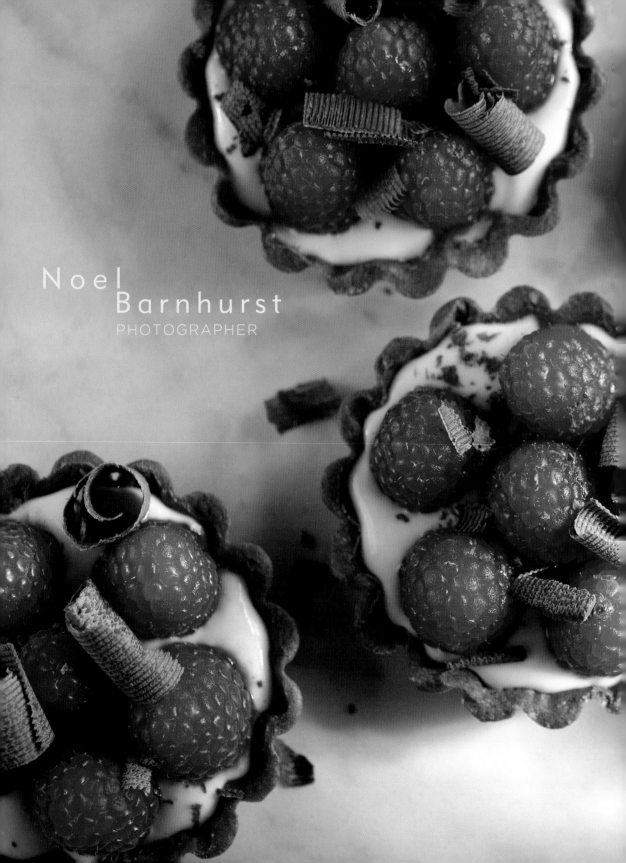

Noel
Barnhurst
PHOTOGRAPHER

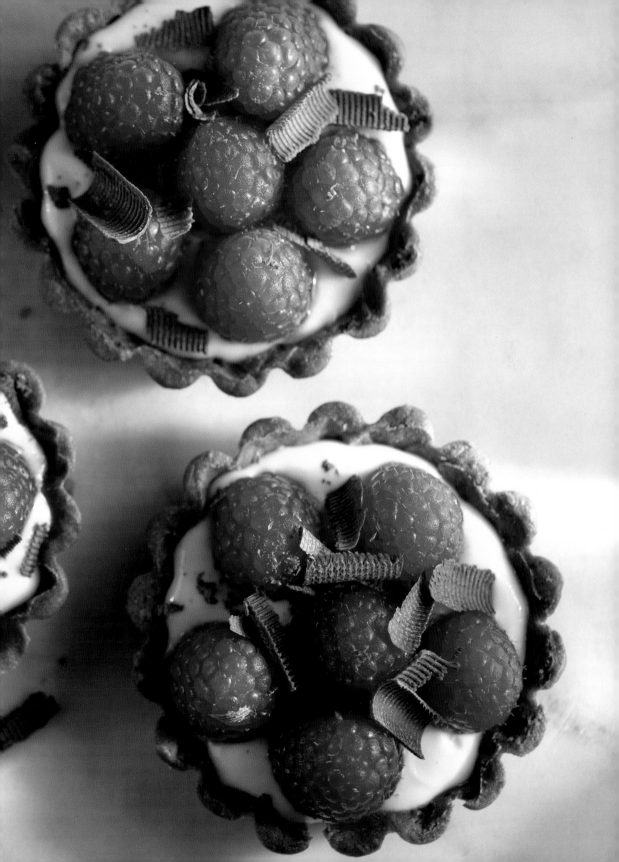

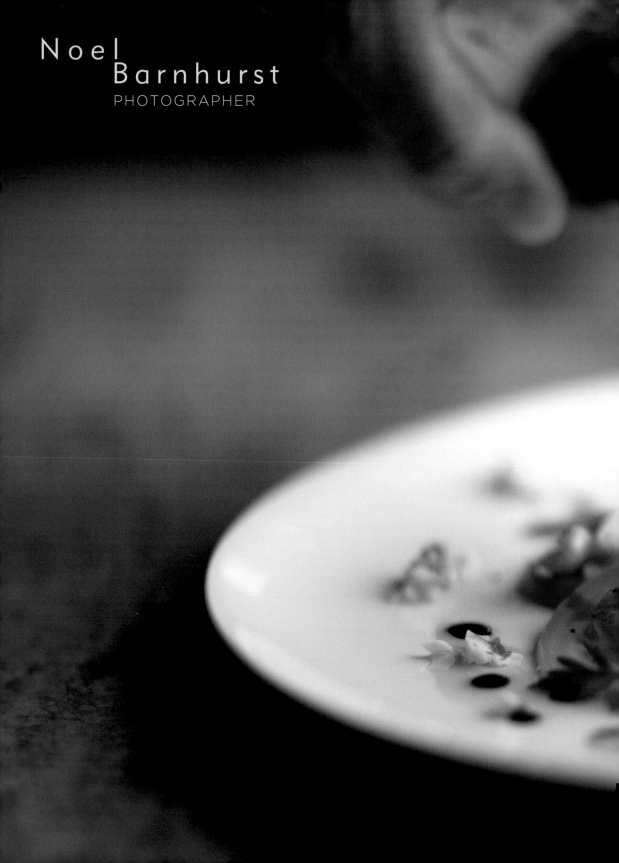

Noel **Barnhurst**
PHOTOGRAPHER

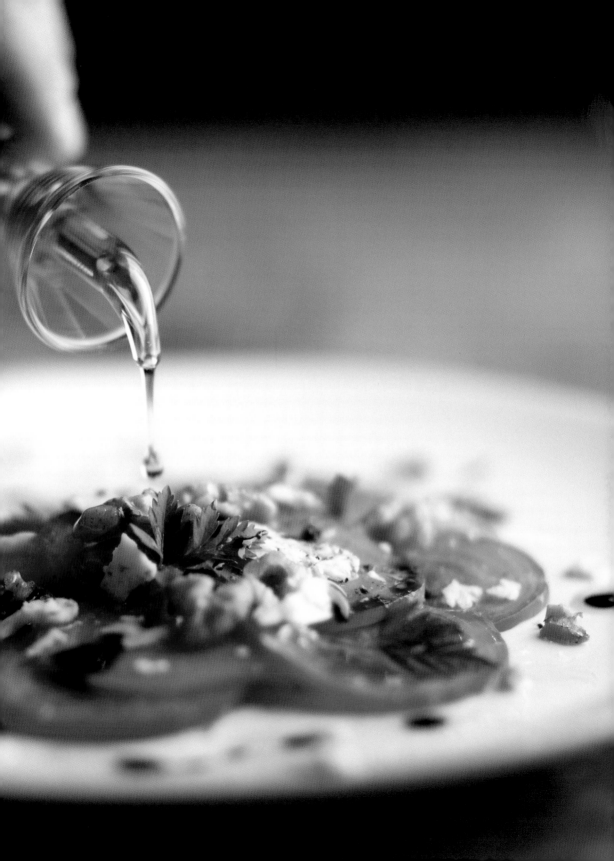

CANDACE GELMAN
& ASSOCIATES

SF 415-897-0808 **CANDACEGELMAN.COM**
CH 312-266-0808
NY 212-666-0808

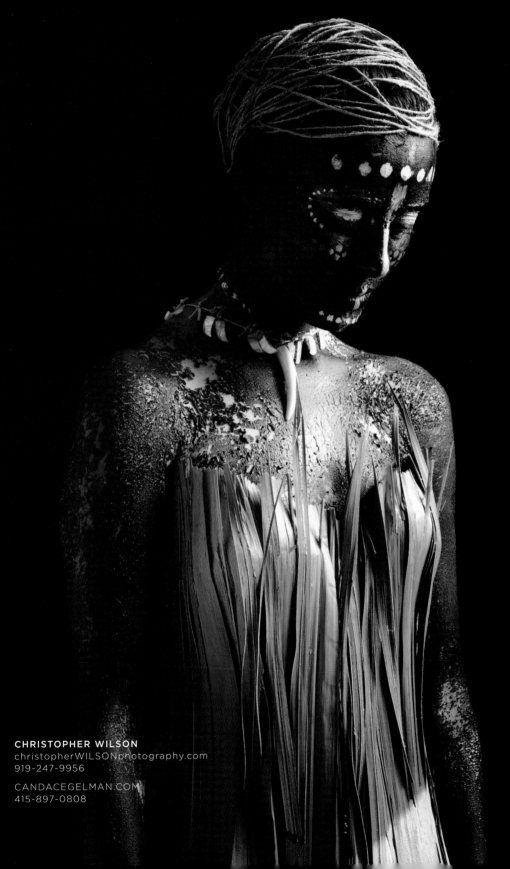

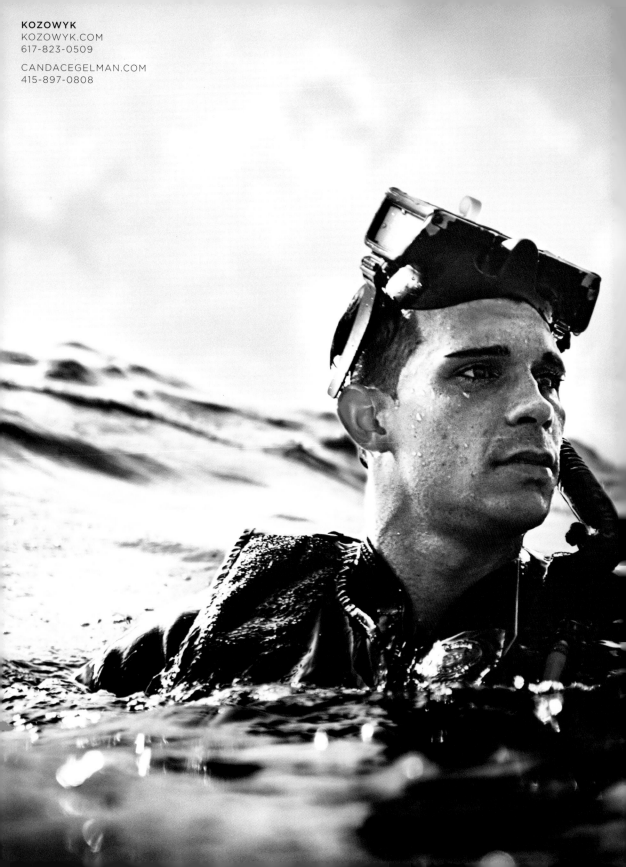

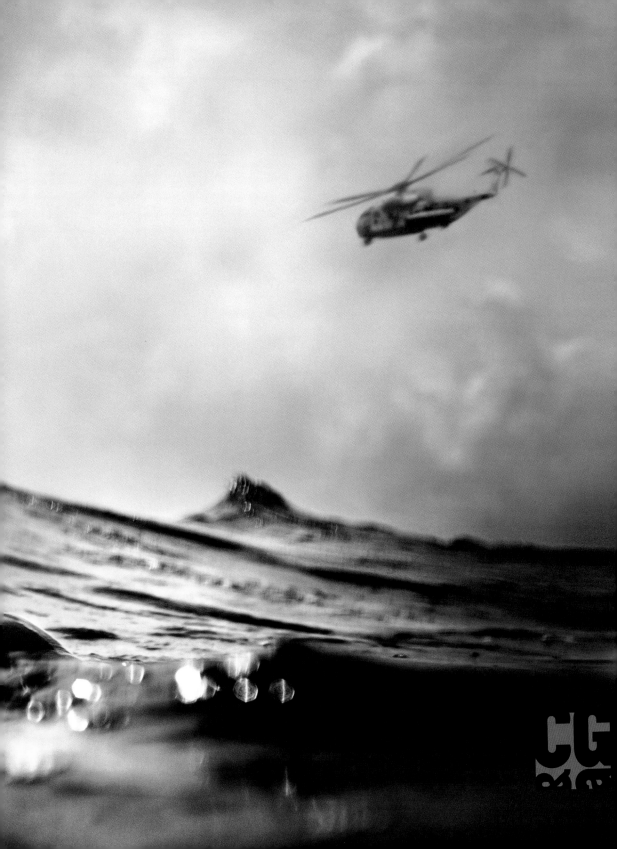

RENDERUNIT
RENDERUNIT.COM
805-658-2224

CANDACEGELMAN.COM
415-897-0808

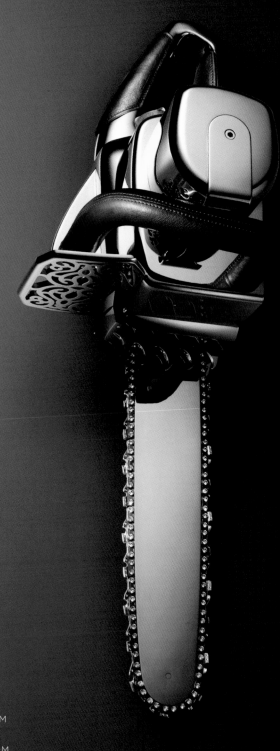

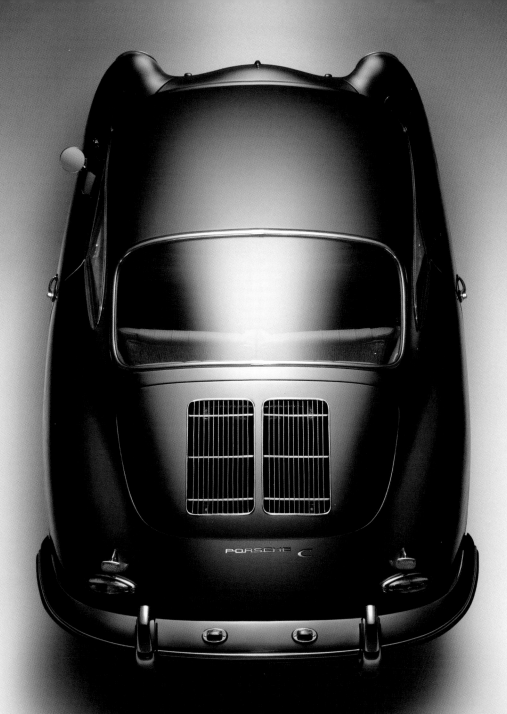

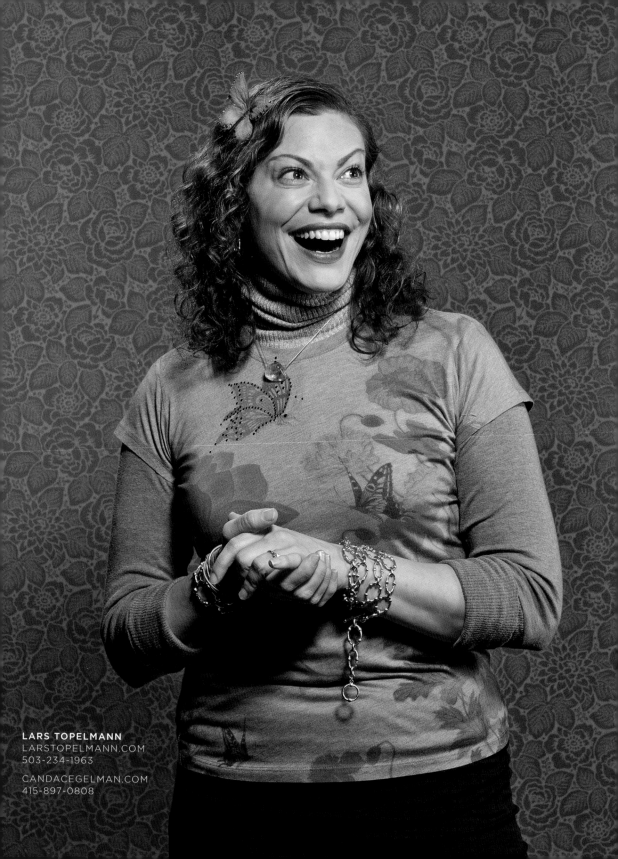

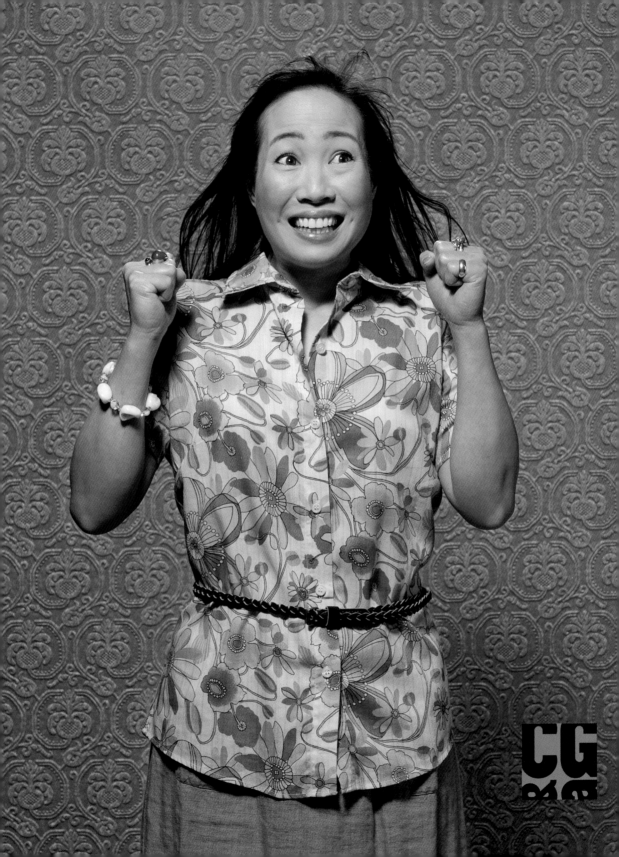

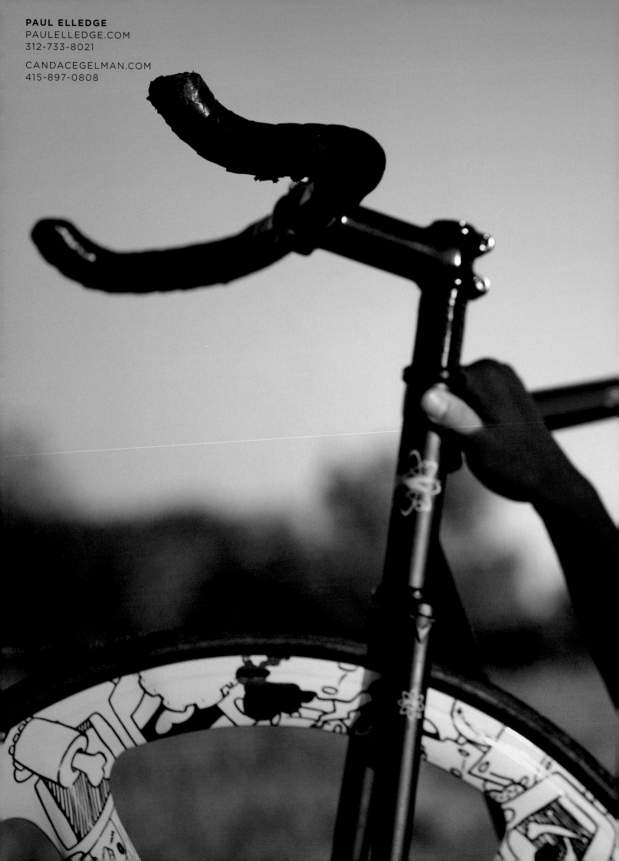

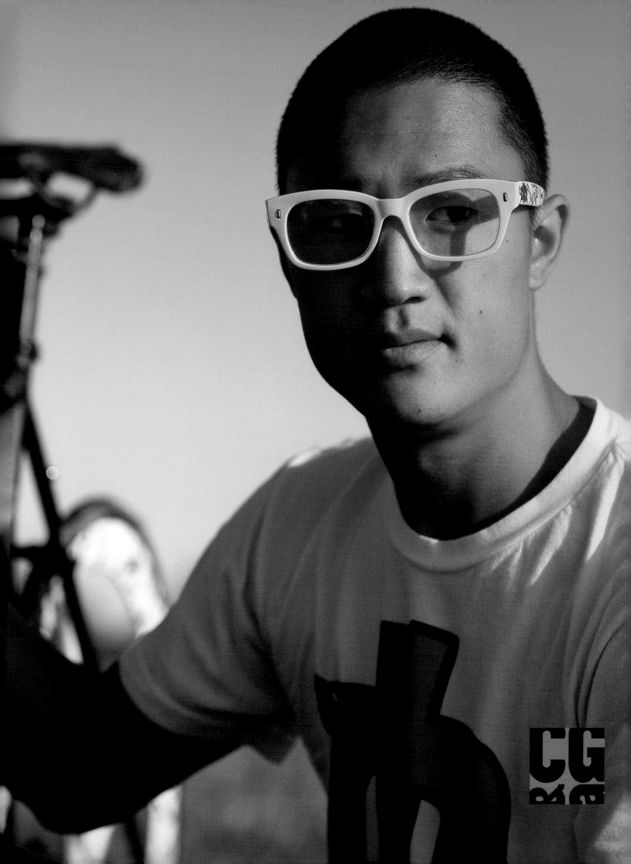

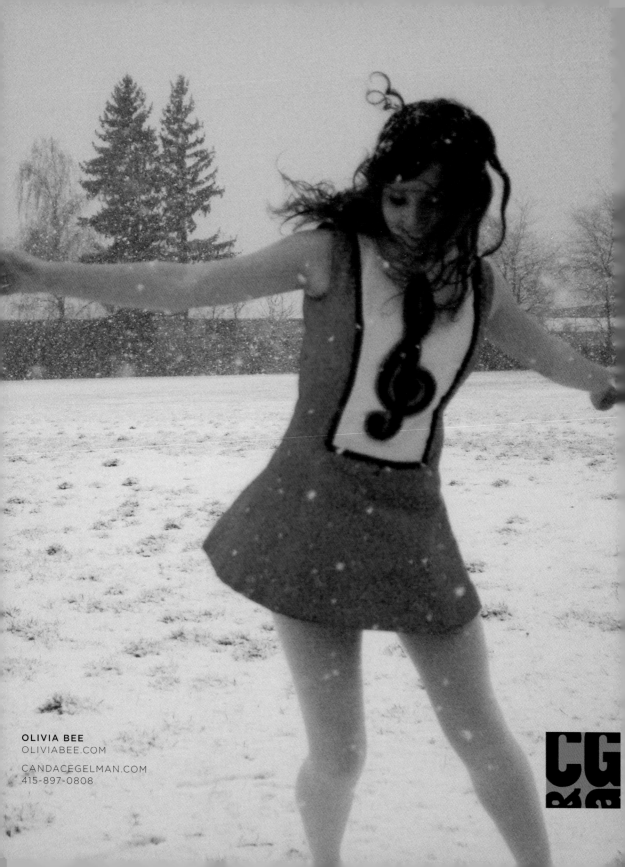

CANDACEGELMAN.COM

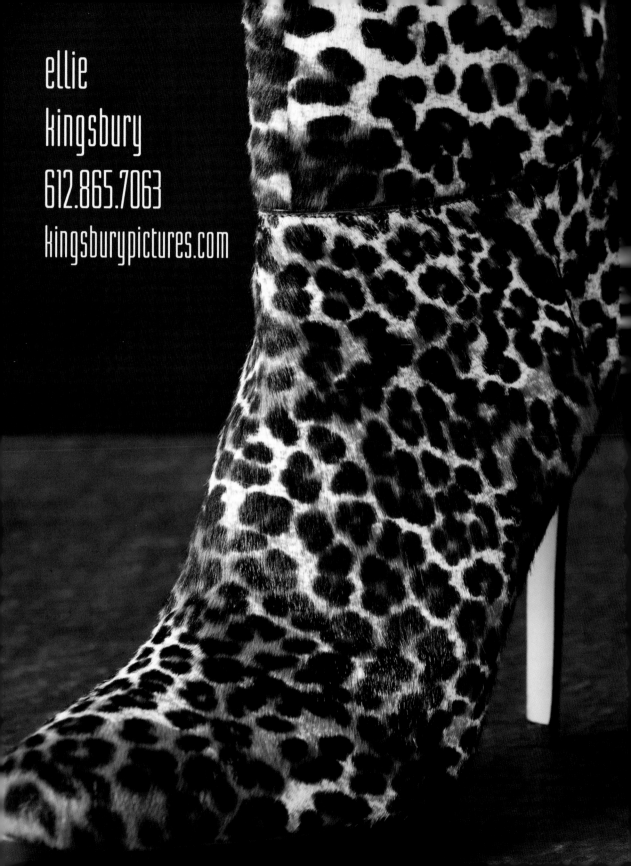

ellie
kingsbury
612.865.7063
kingsburypictures.com

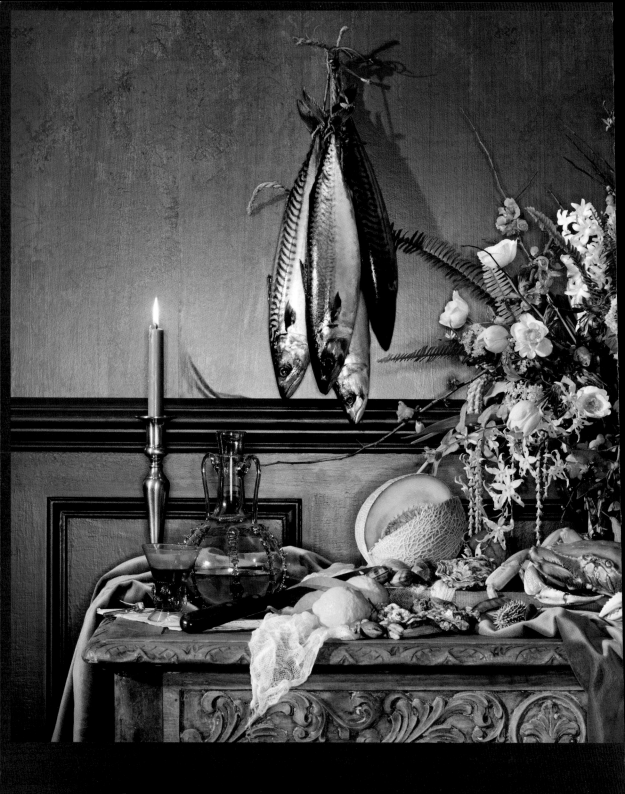

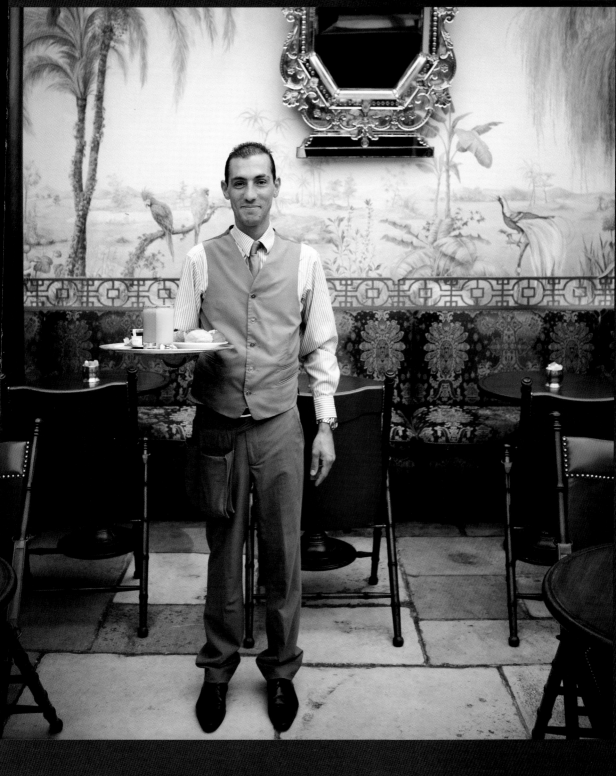

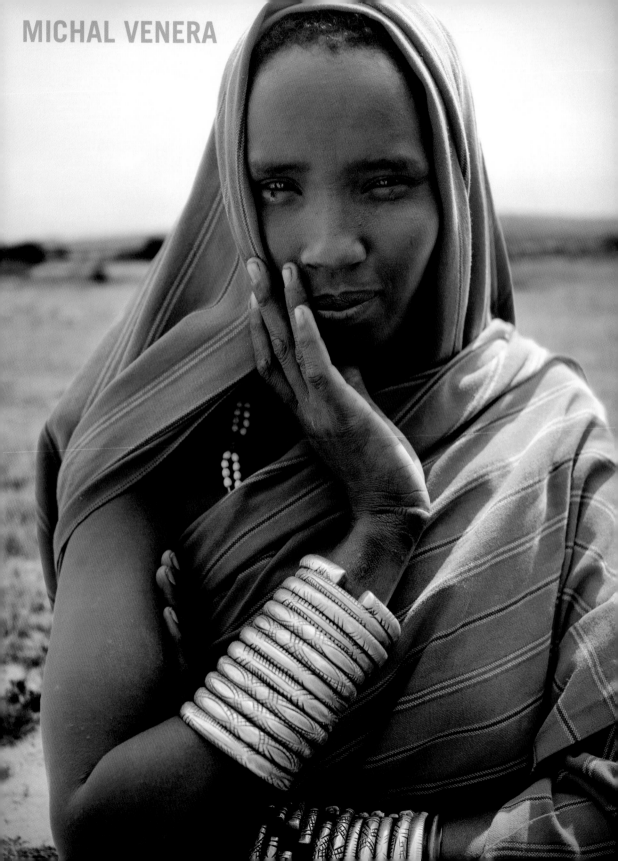

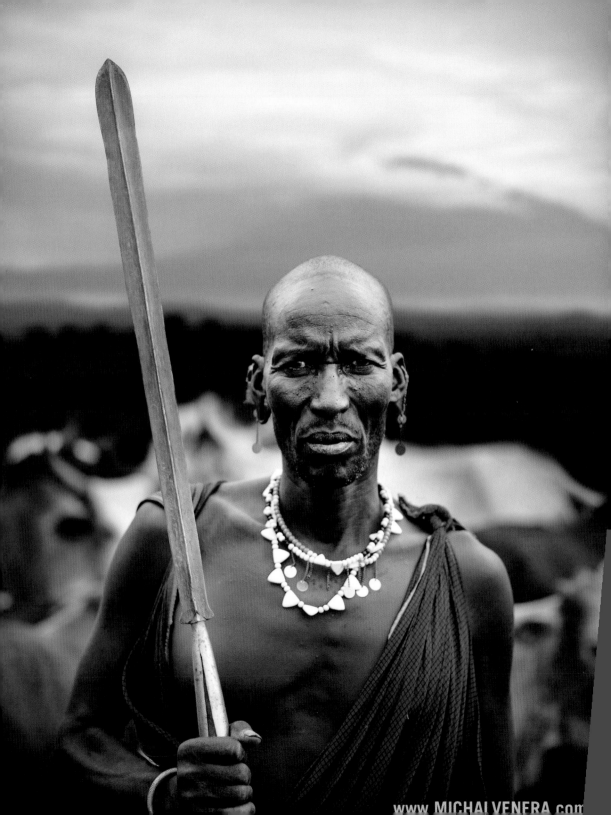

JAY SCOTT BAKER

represented by

FosterReps.com
314.909.7377

WILD
TURKEY
AMERICAN
HONEY

EXCEPTI

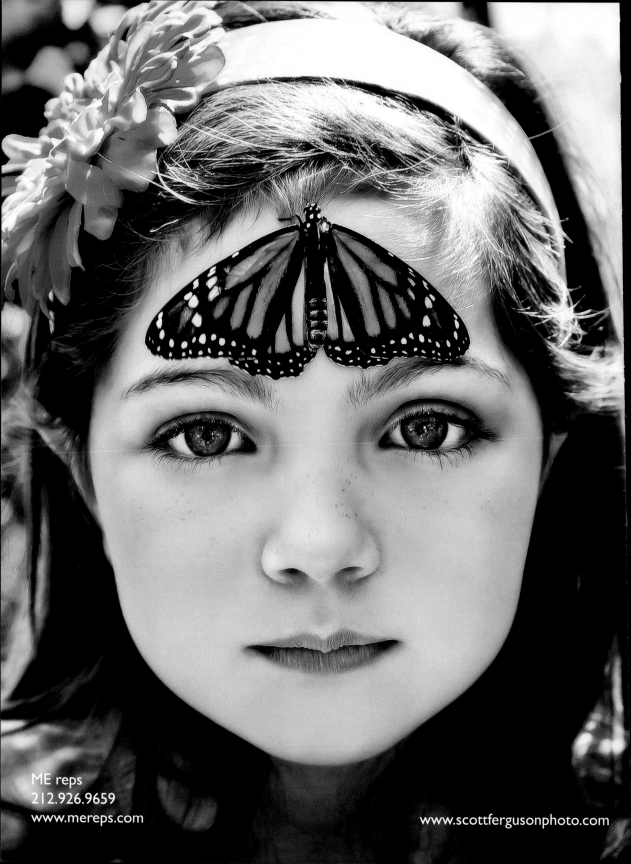

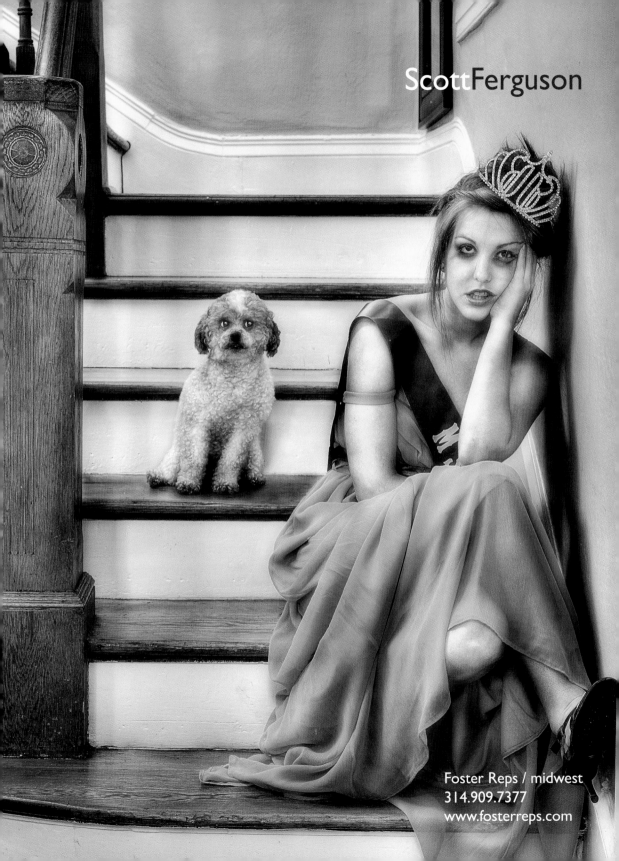

ScottFerguson

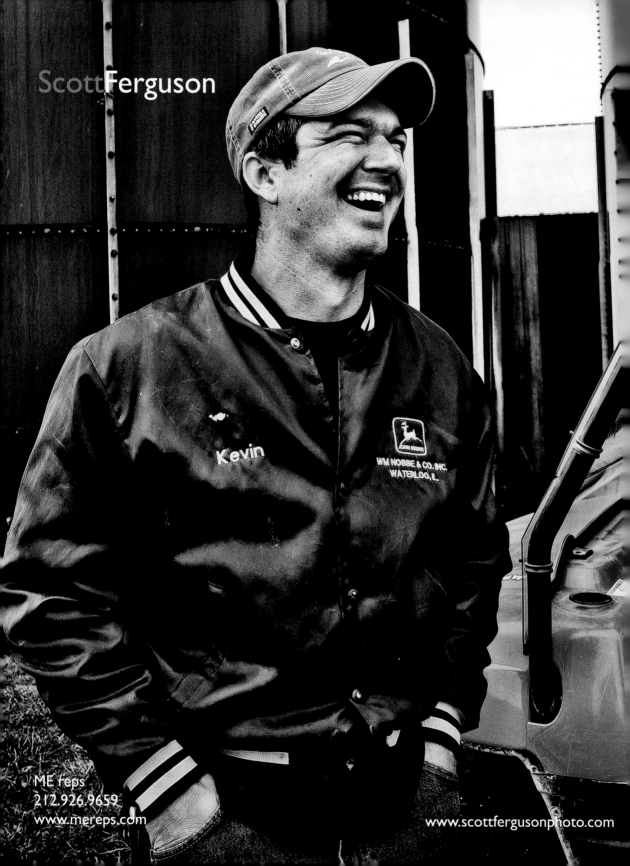

ScottFerguson

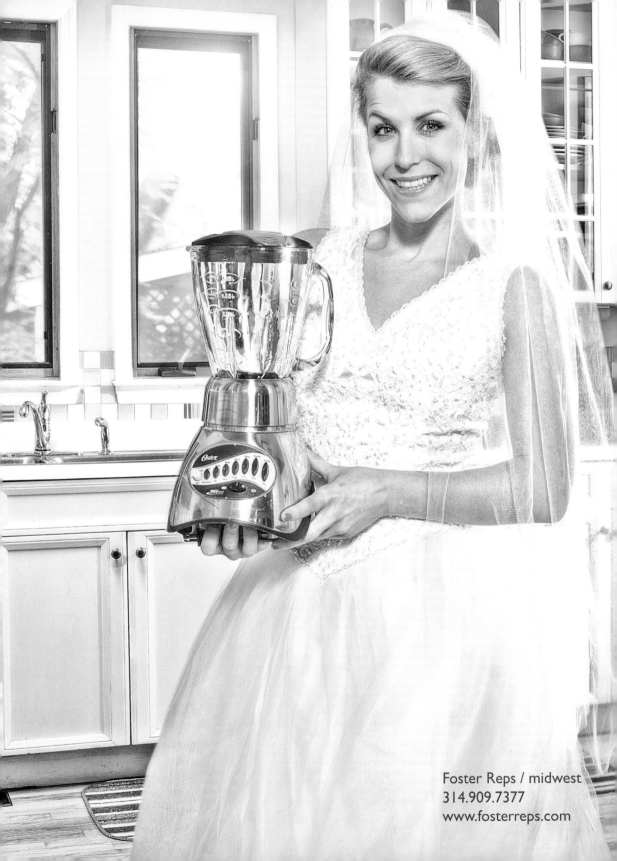

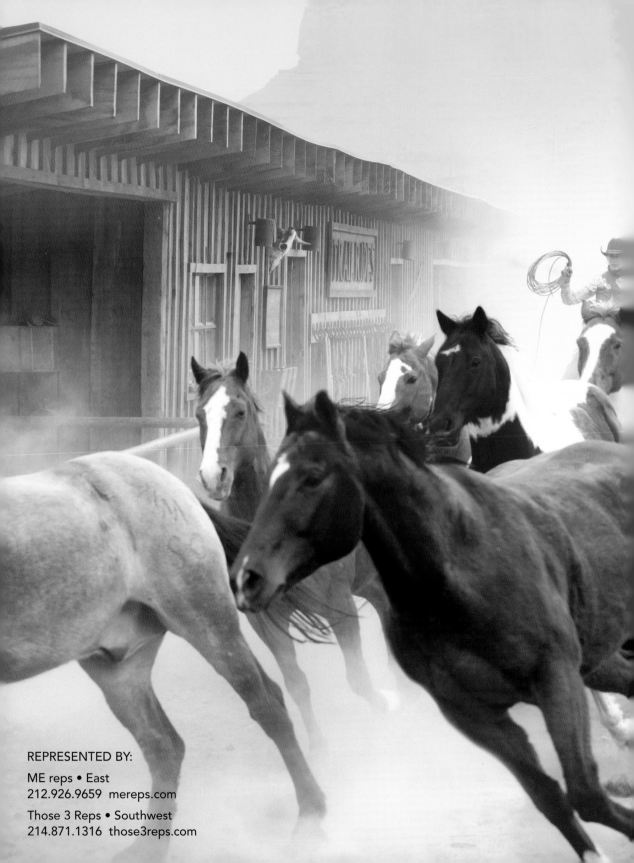

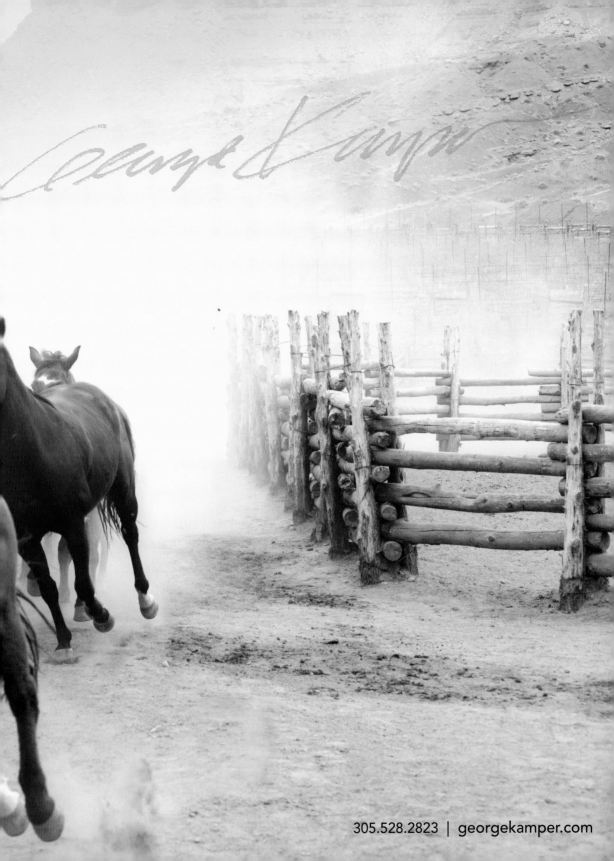

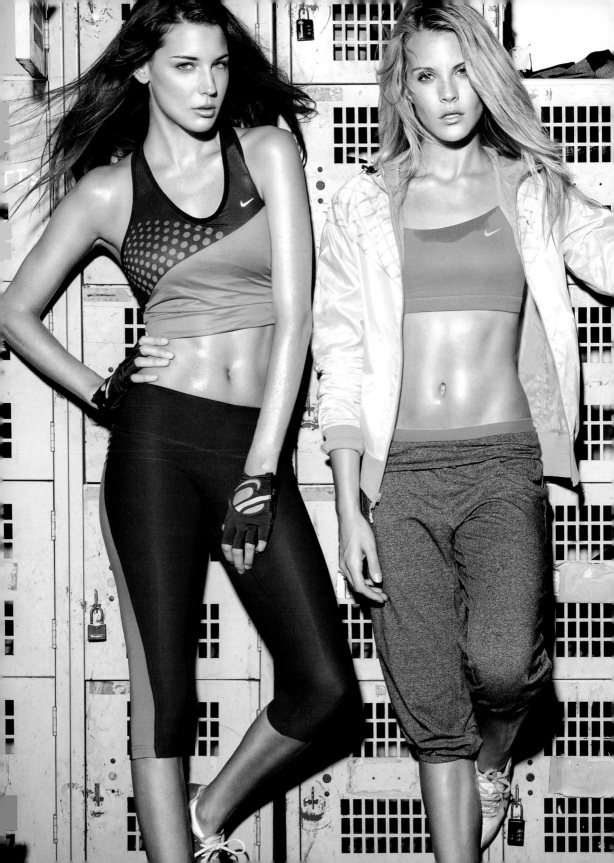

MATT
HAWTHORNE
PHOTOGRAPHY

JEN BUTTERS
AGENCY
972.385.0078 DALLAS
323.308.9223 LOS ANGELES
MATTHAWTHORNE.COM

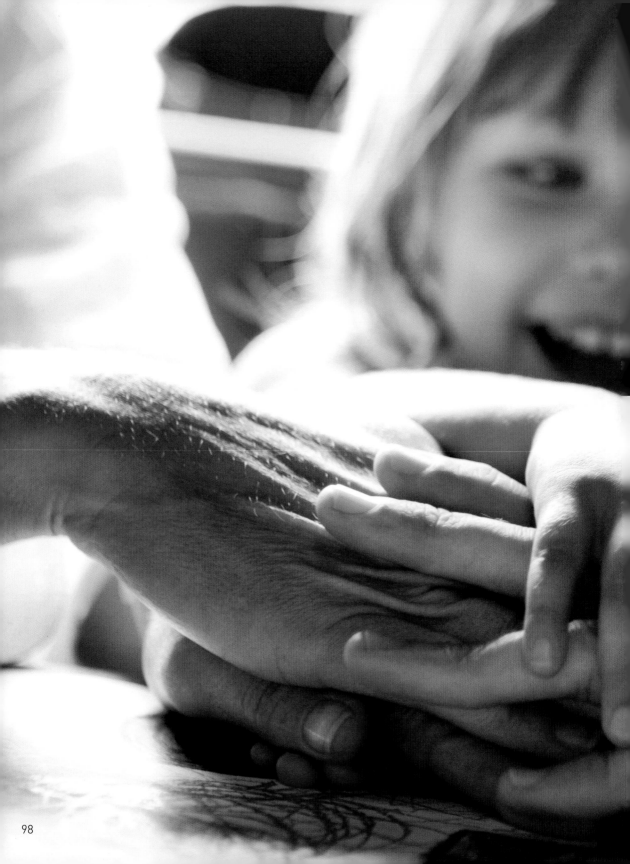

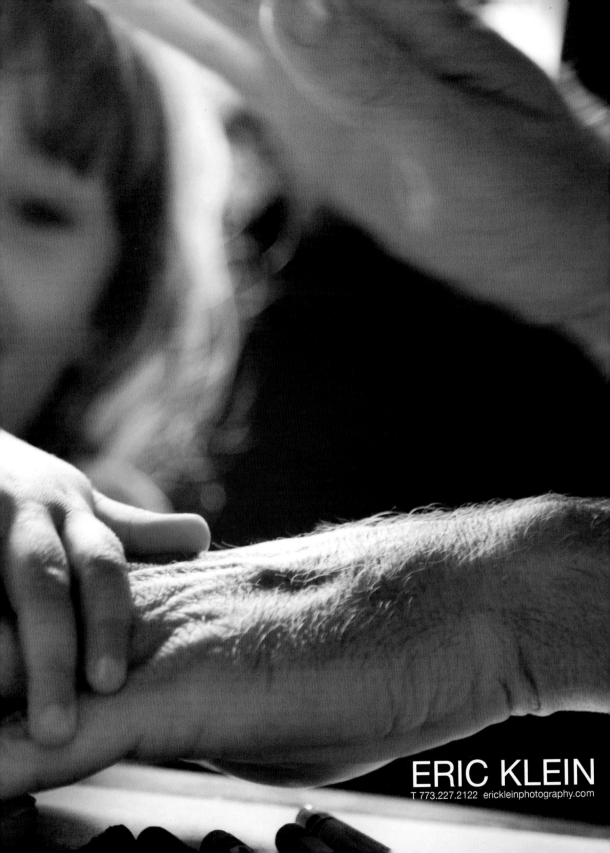

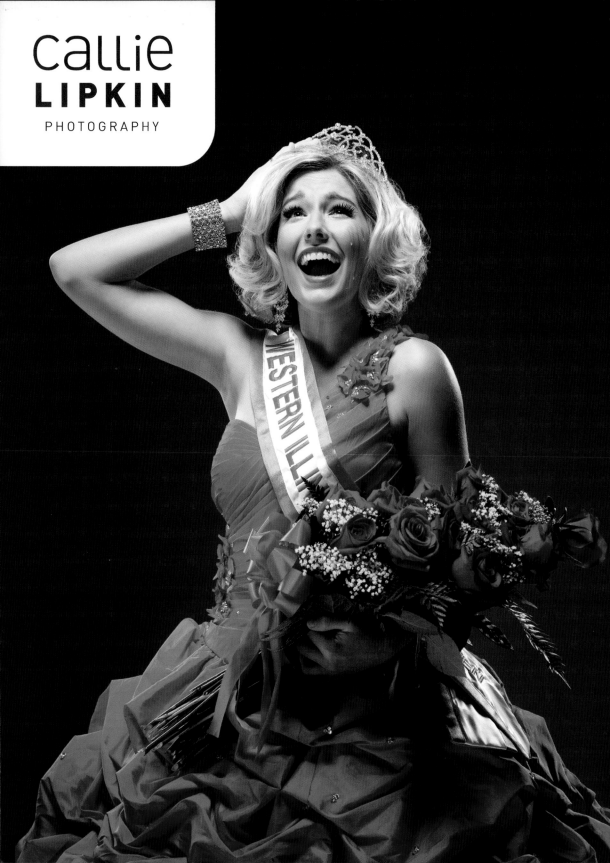

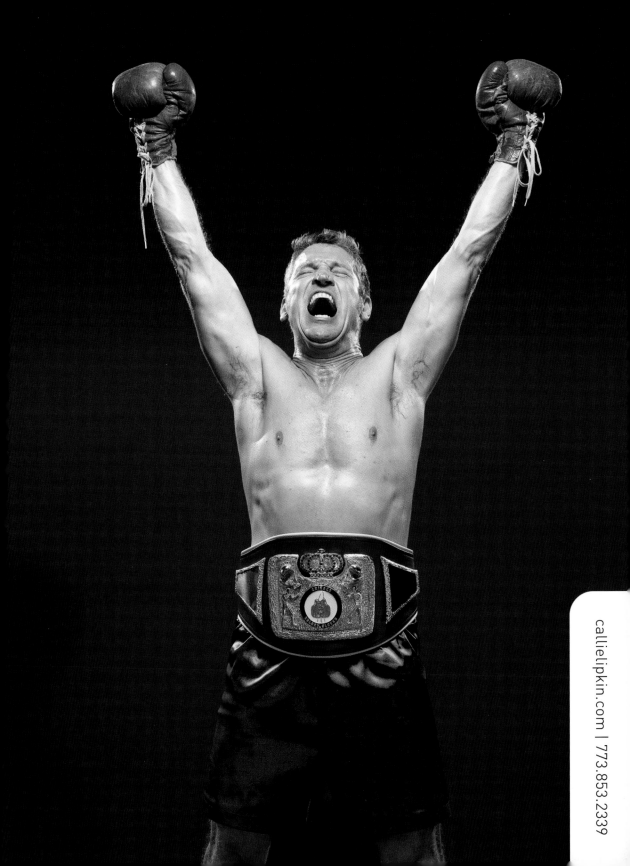

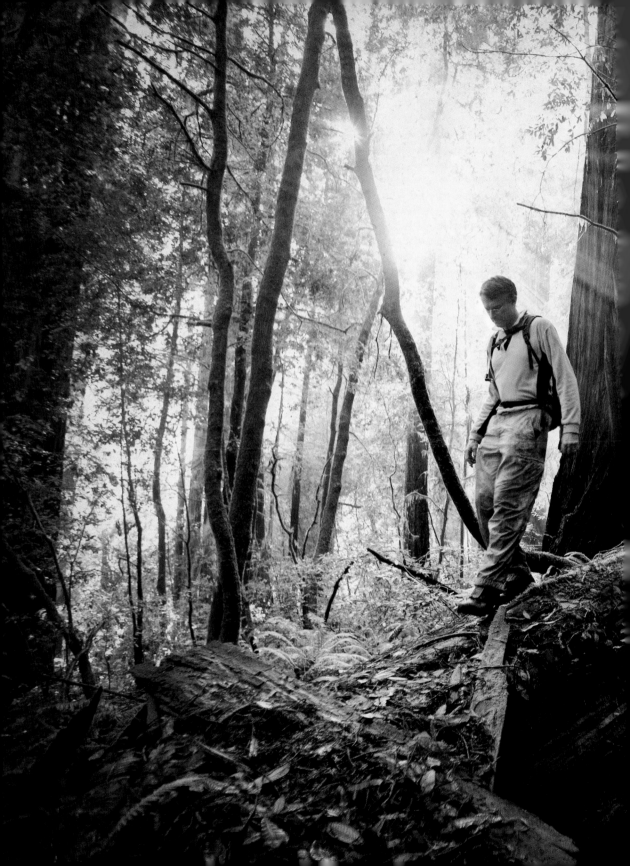

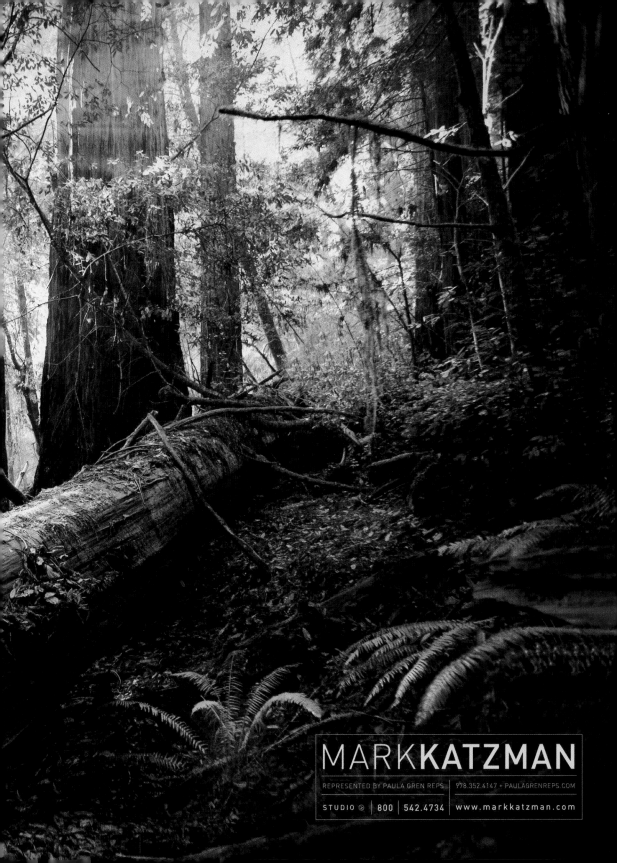

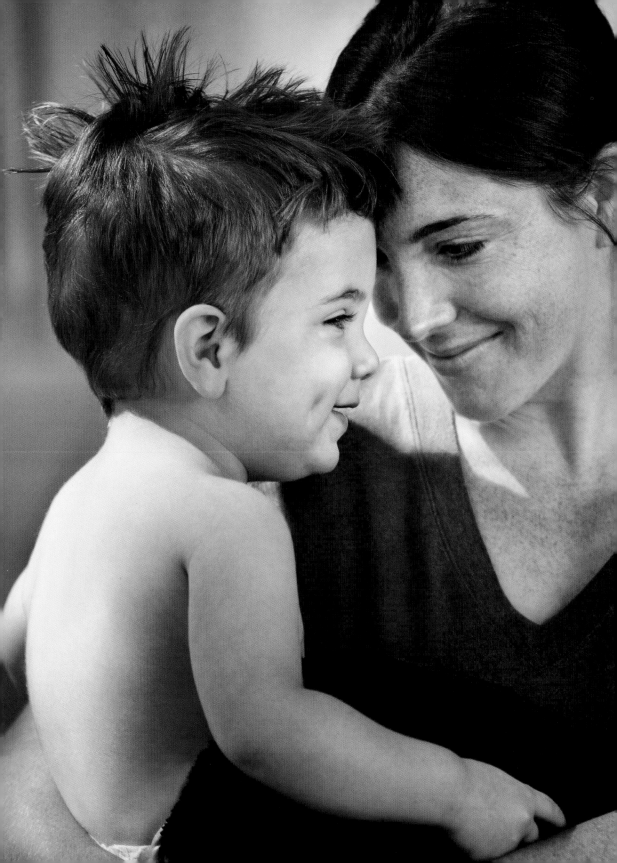

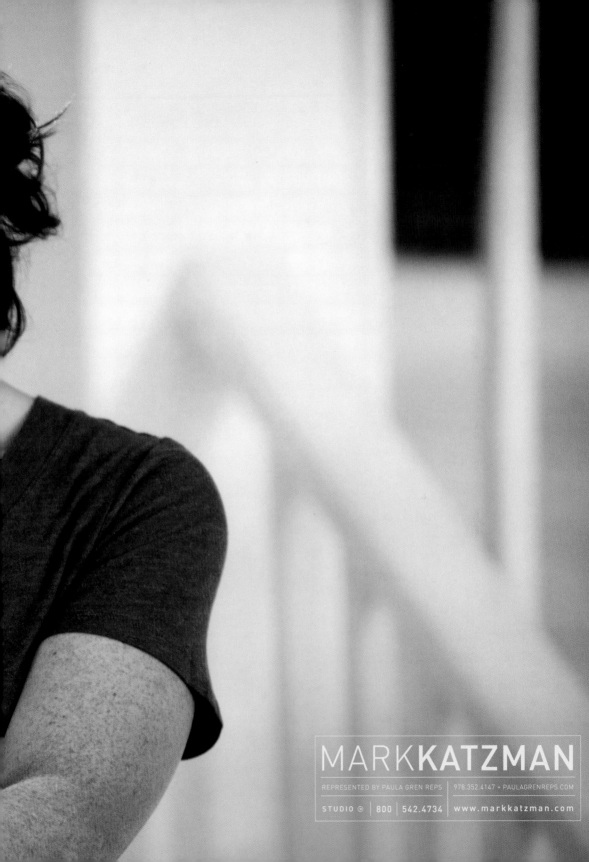

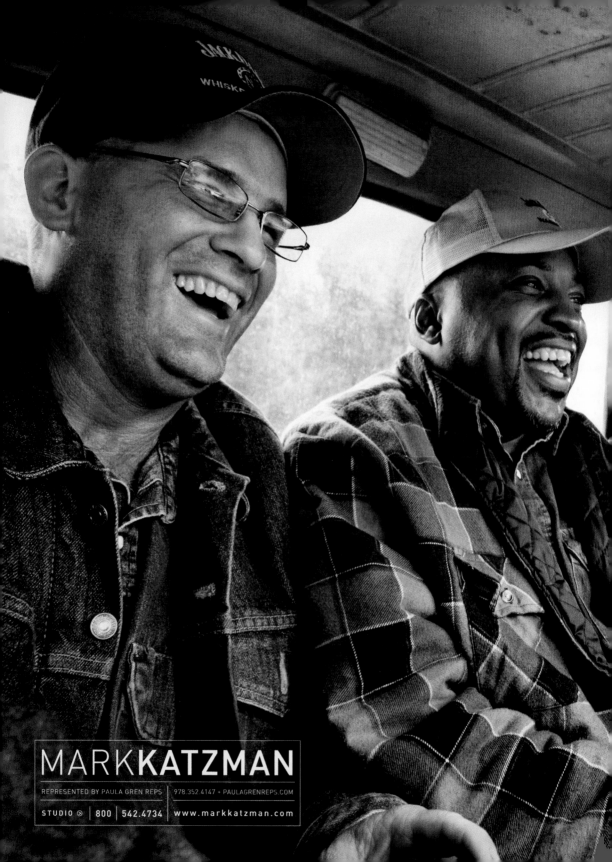

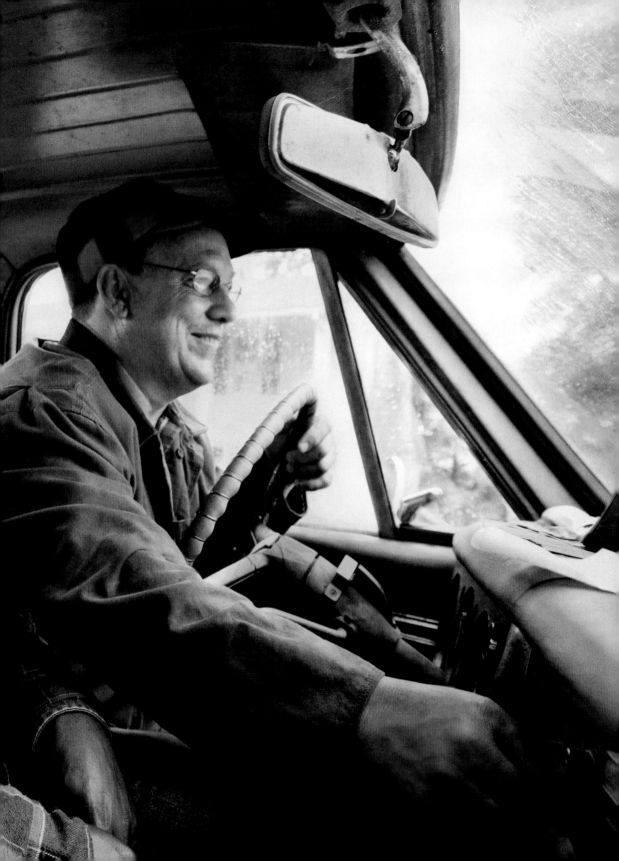

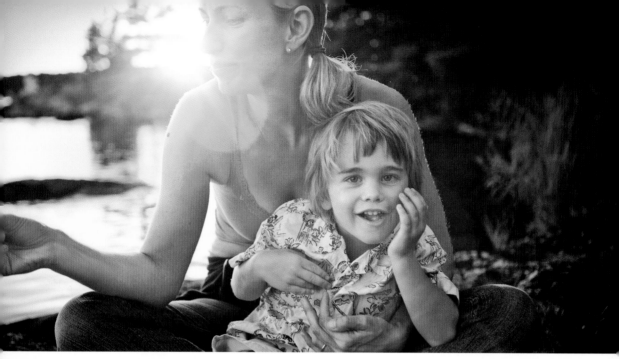

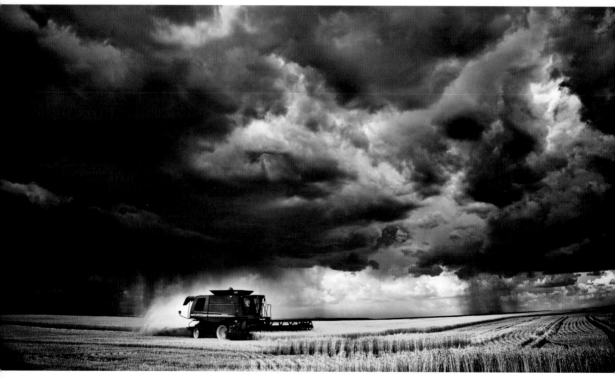

TALLGRASSPICTURES
PRINT // BROADCAST // MOBILE

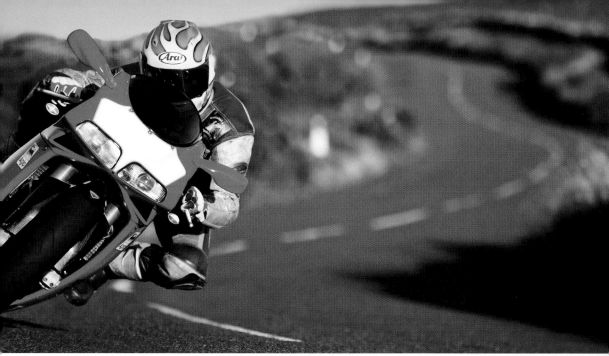

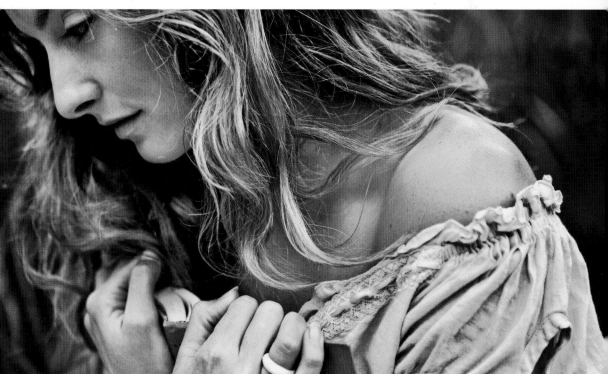

JEFFREYLAMONT**BROWN**
photographer // director

619.227.2701 | jb@jeffreybrown.com | tallgrasspictures.com
PAULA GREN REPS 415.550.2441

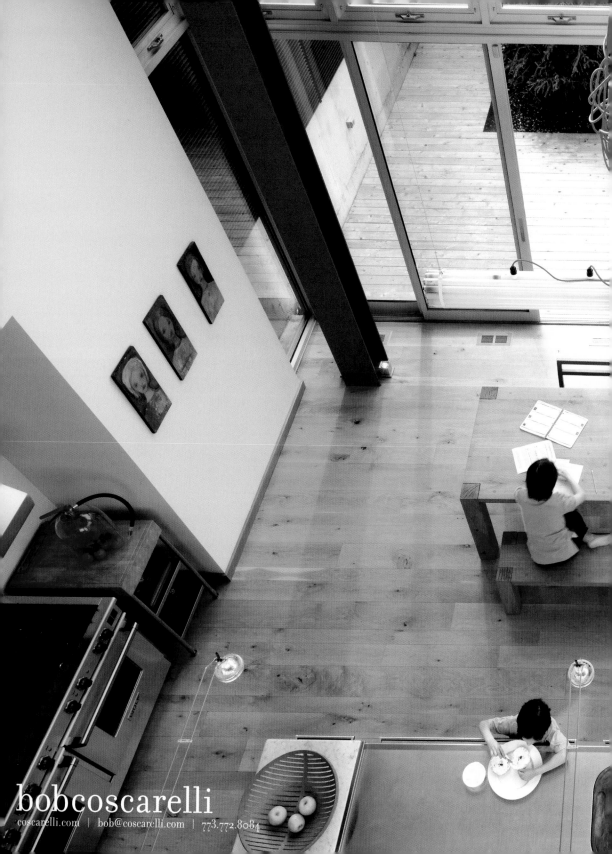

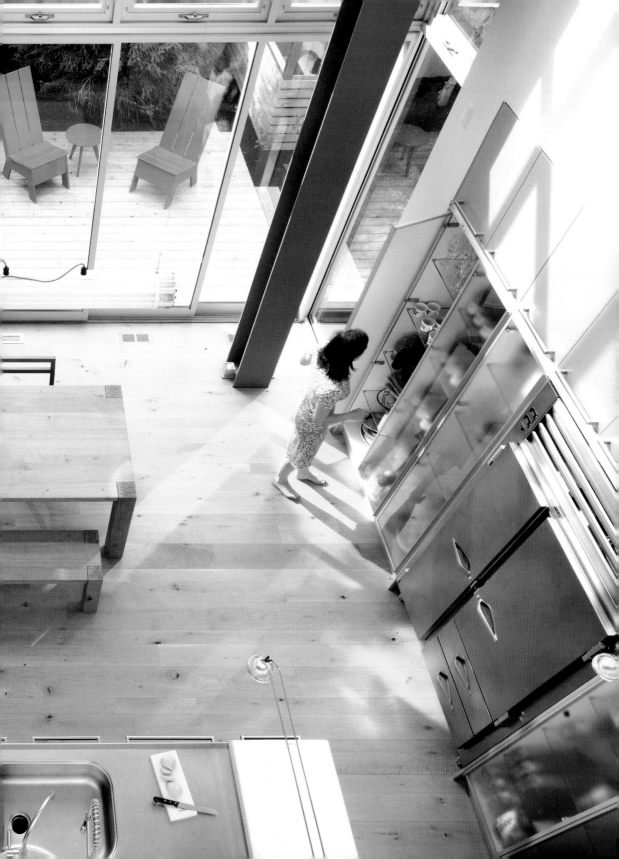

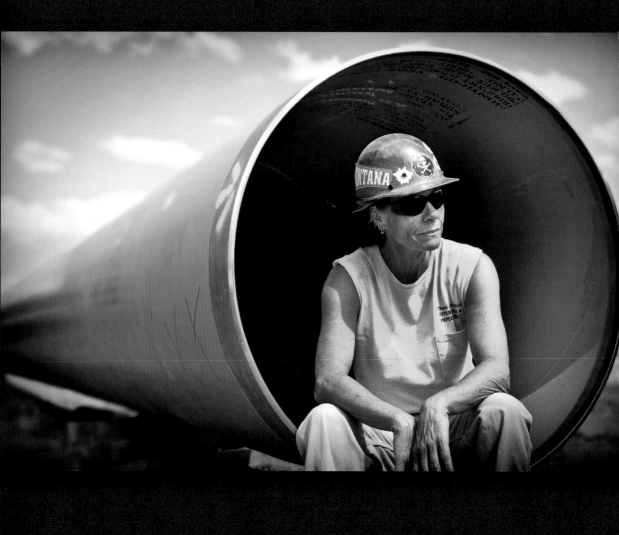

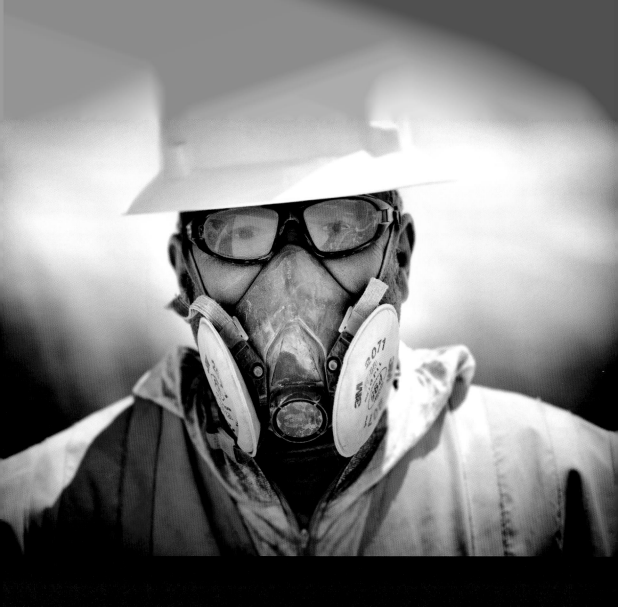

GREG**W**HITAKER

represented by Holly Hahn 312 371 0500 gregwhitaker.com

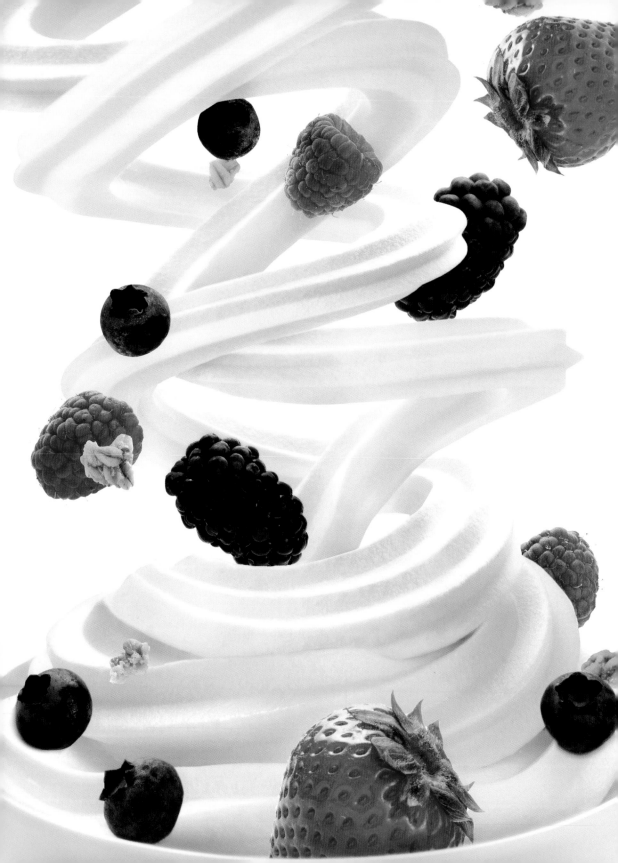

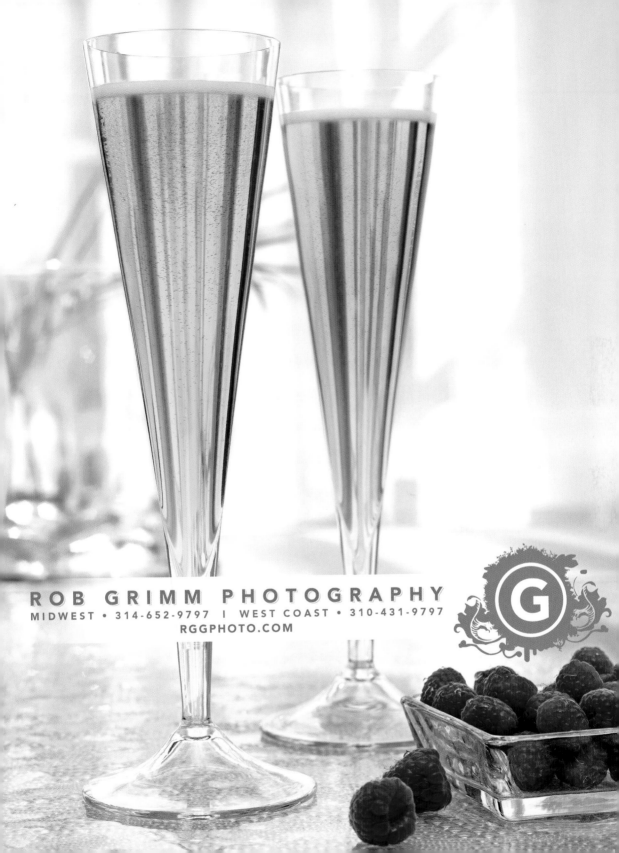

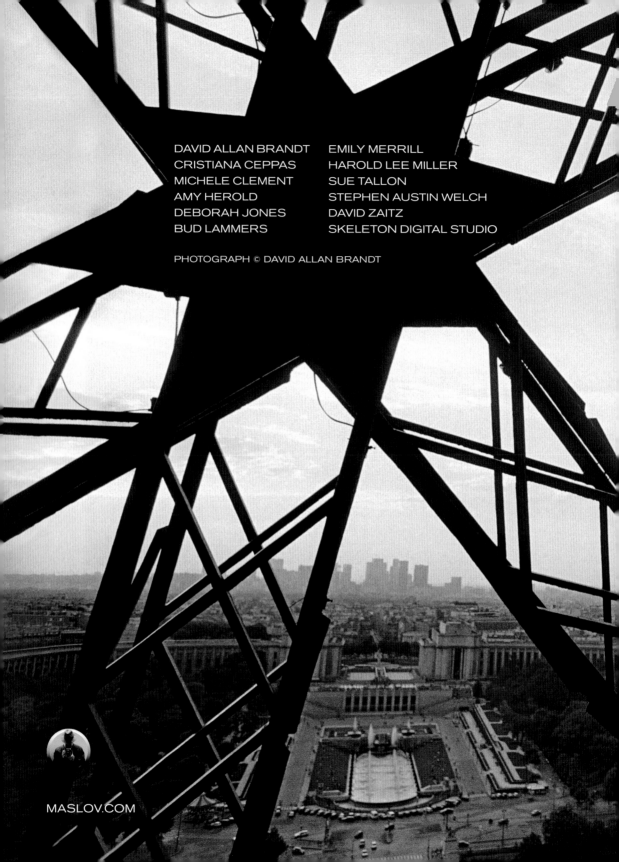

DAVID ALLAN BRANDT
CRISTIANA CEPPAS
MICHELE CLEMENT
AMY HEROLD
DEBORAH JONES
BUD LAMMERS

EMILY MERRILL
HAROLD LEE MILLER
SUE TALLON
STEPHEN AUSTIN WELCH
DAVID ZAITZ
SKELETON DIGITAL STUDIO

PHOTOGRAPH © DAVID ALLAN BRANDT

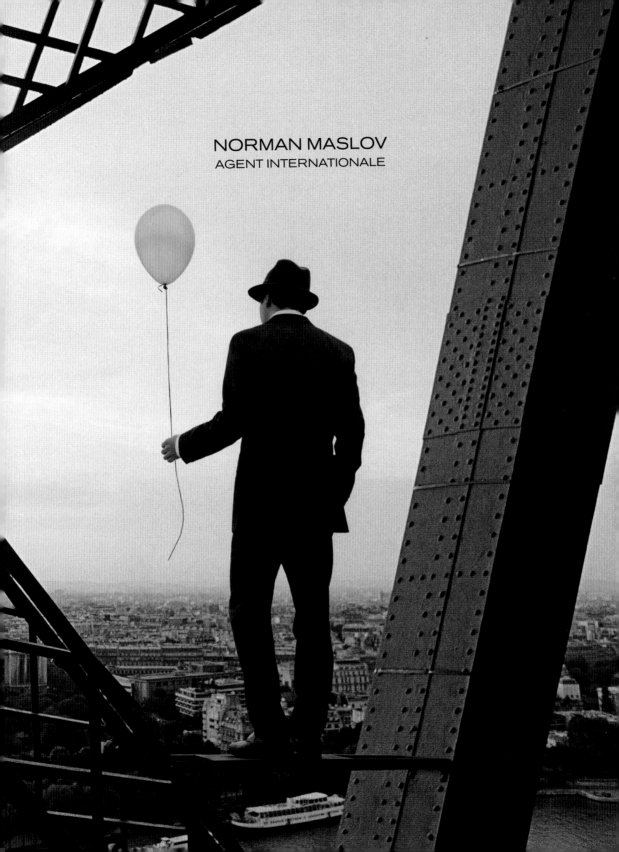

NORMAN MASLOV
AGENT INTERNATIONALE

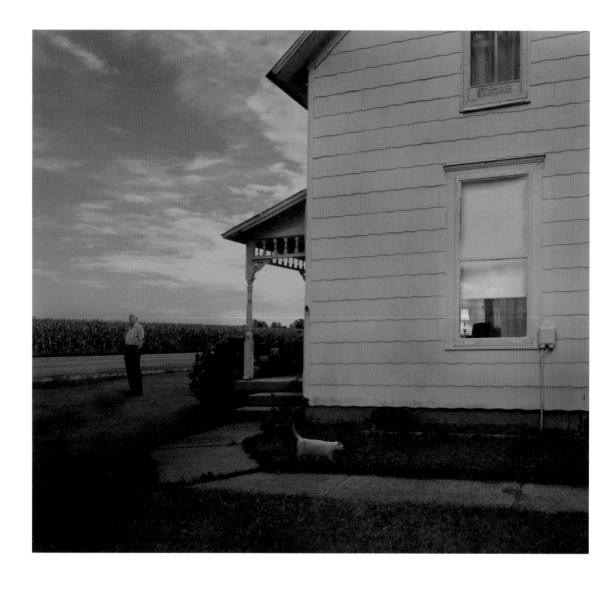

Lisa Button 312 399-2522 Mid & Southwest buttonrepresents.com

Norman Maslov Agent Internationale 415 641-4376 maslov.com haroldleemiller.com

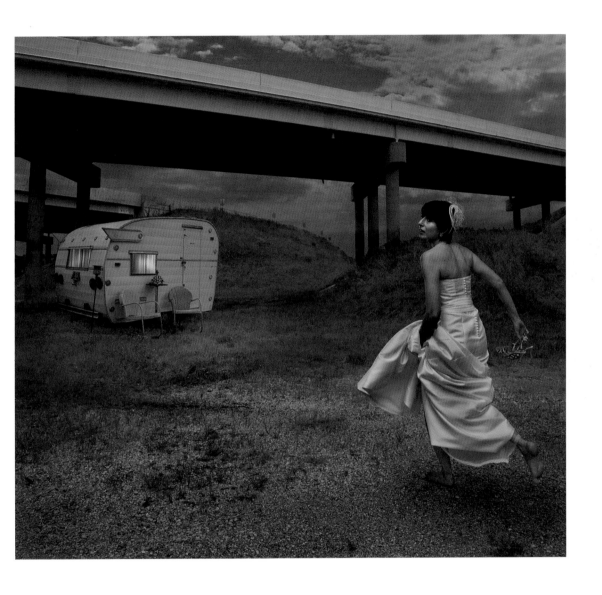

Lisa Button 312 399-2522 Mid & Southwest buttonrepresents.com

haroldleemiller.com Norman Maslov Agent Internationale 415 641-4376 maslov.com

CRISTIANA CEPPAS

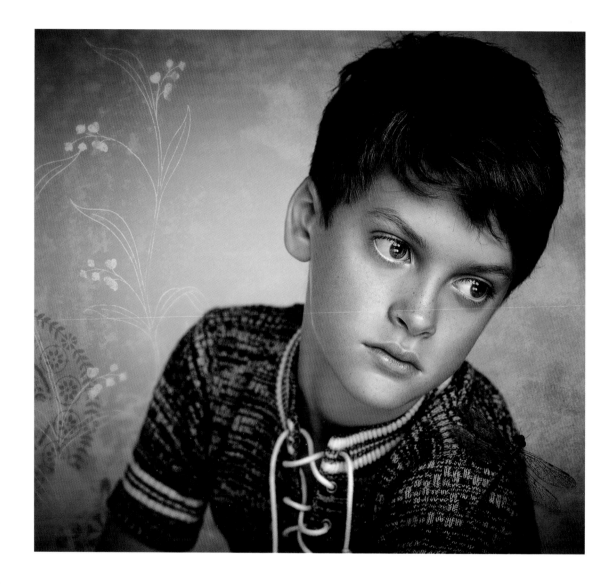

 Norman Maslov Agent Internationale 415 641-4376 maslov.com cristianaceppas.com

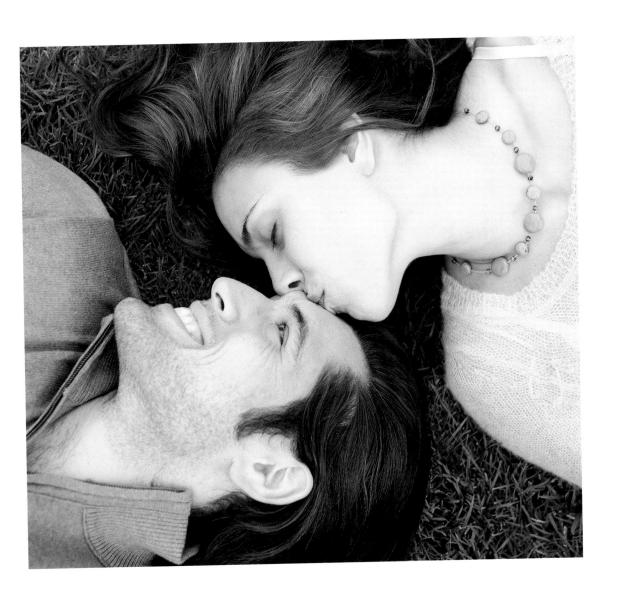

emilymerrill.com Norman Maslov Agent Internationale 415 641-4376 maslov.com

DAVID ZAITZ

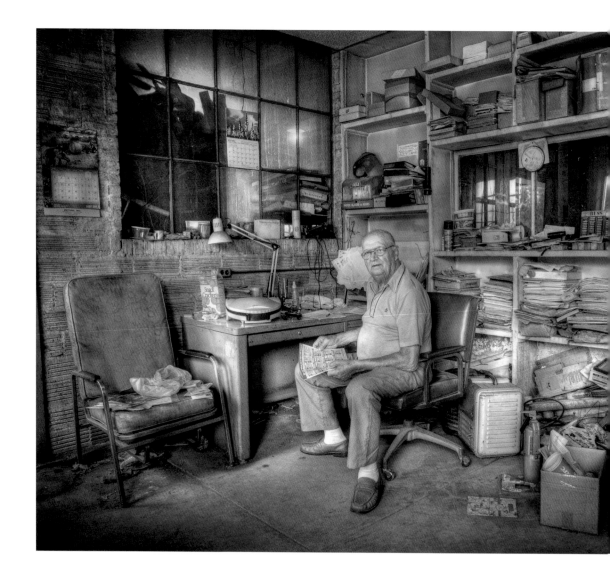

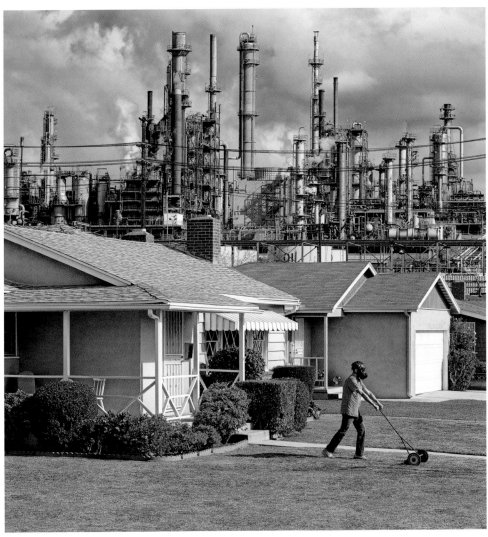

Norman Maslov Agent Internationale 415 641-4376 maslov.com suetallon.com

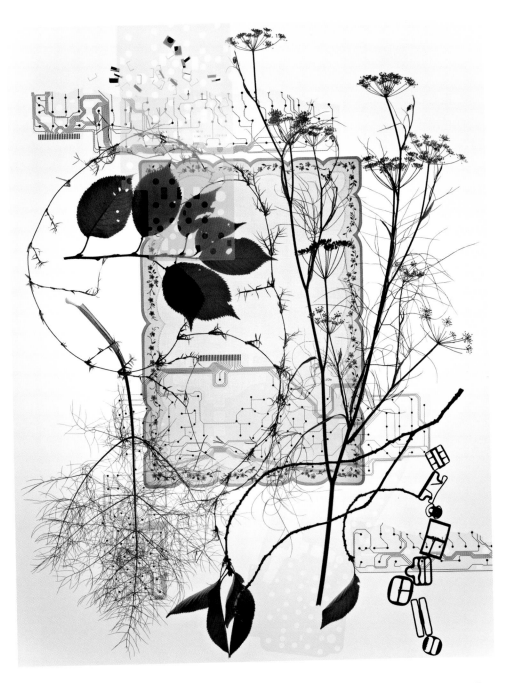

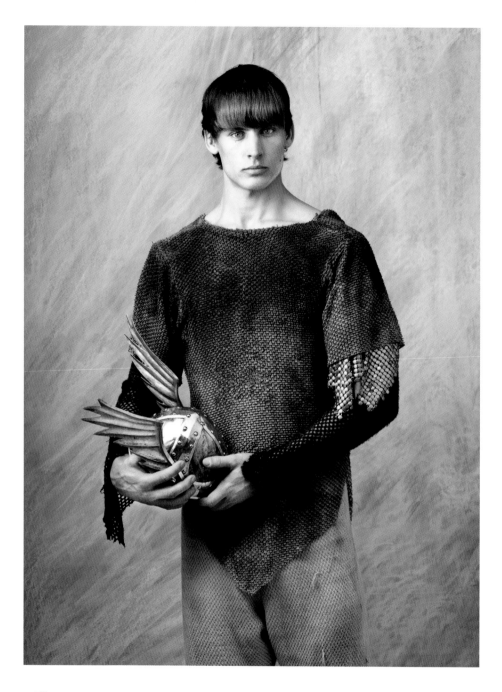

 Norman Maslov Agent Internationale 415 641-4376 maslov.com micheleclement.com

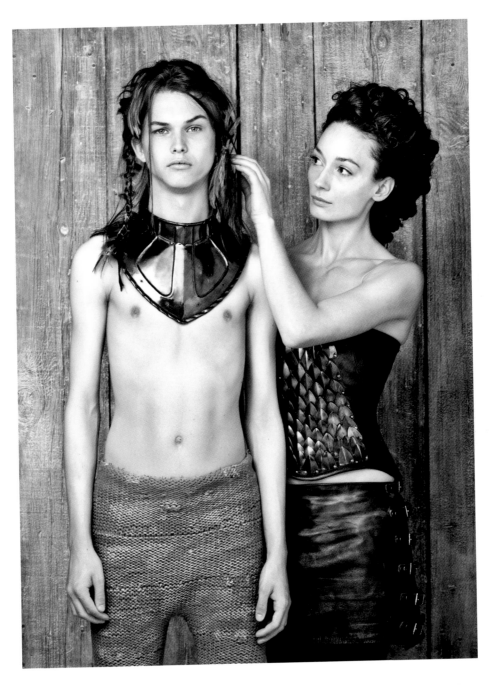

micheleclement.com Norman Maslov Agent Internationale 415 641-4376 maslov.com

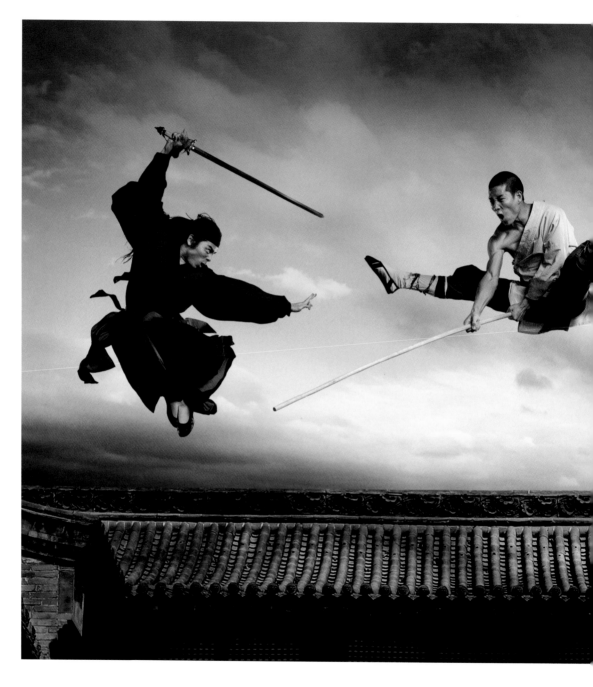

Norman Maslov Agent Internationale 415 641-4376 maslov.com davidallanbrandt.com

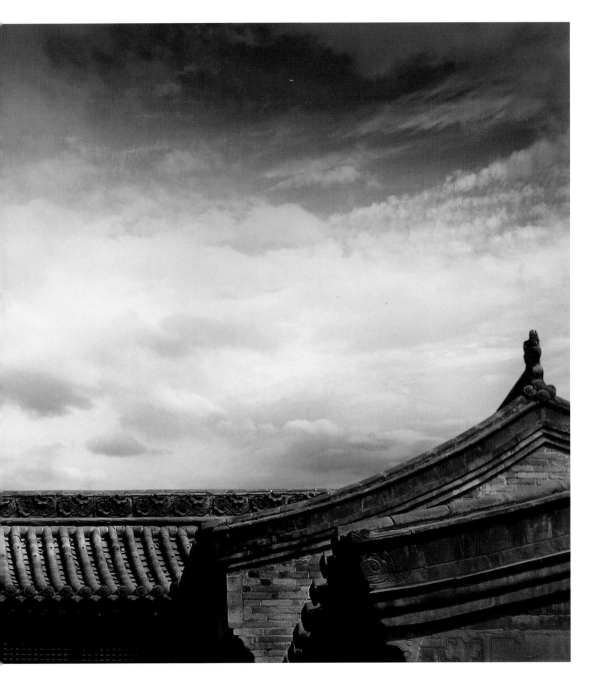

davidallanbrandt.com Norman Maslov Agent Internationale 415 641-4376 maslov.com

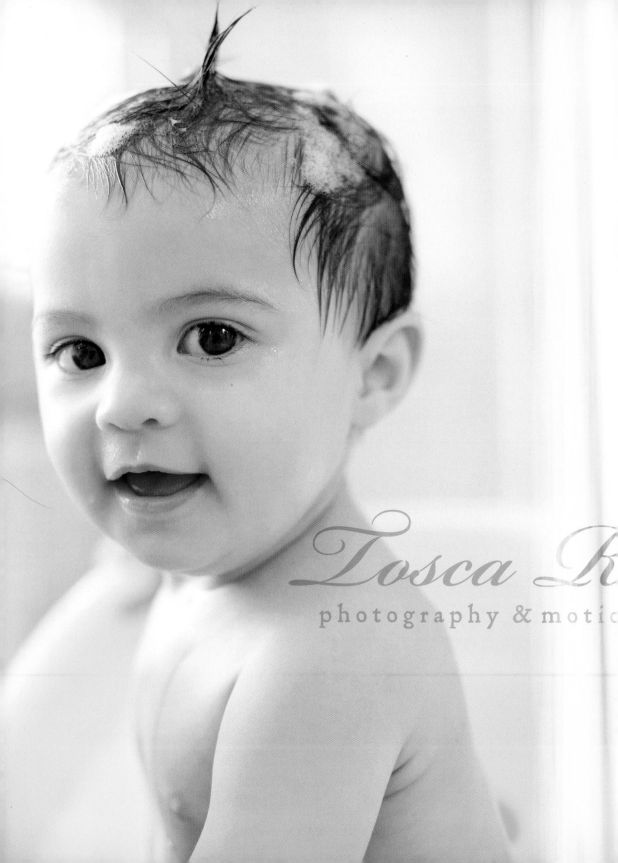

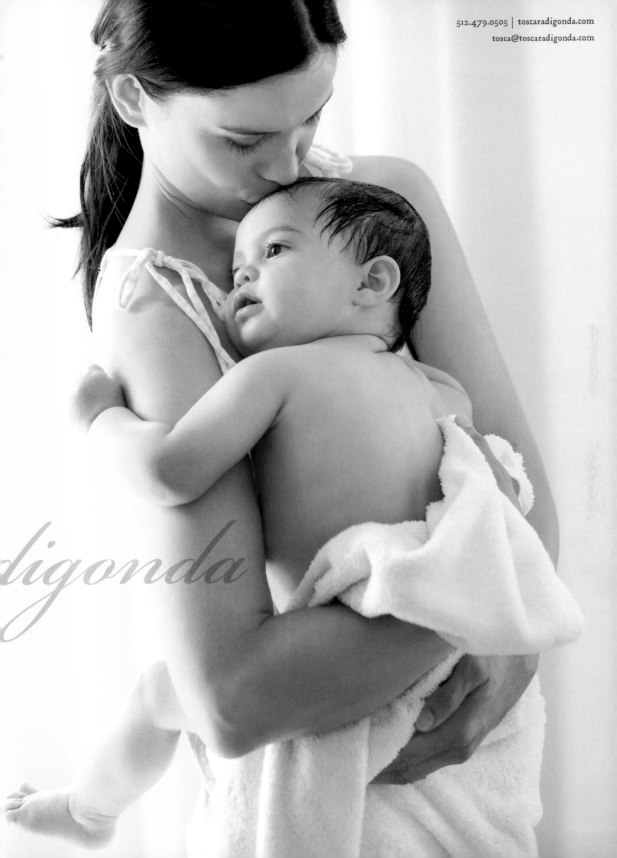

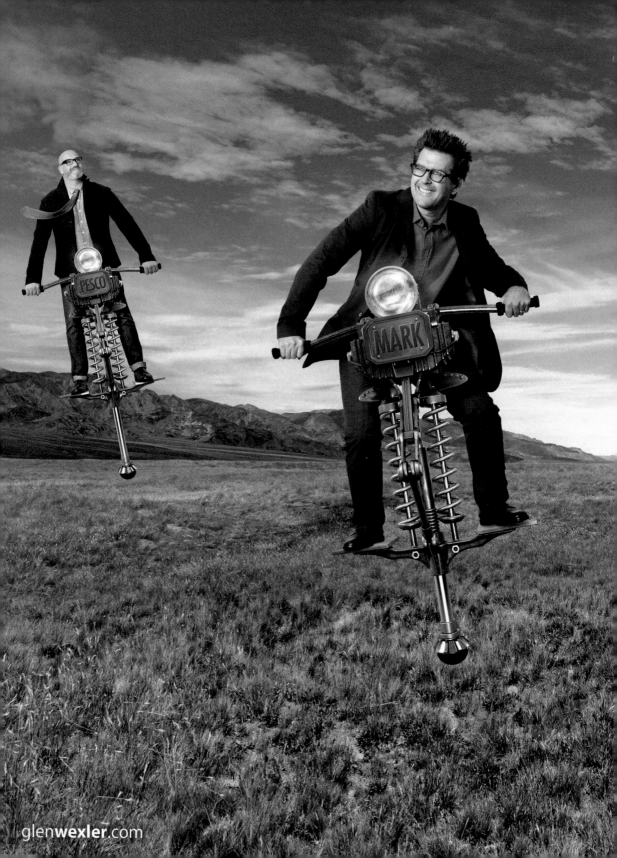

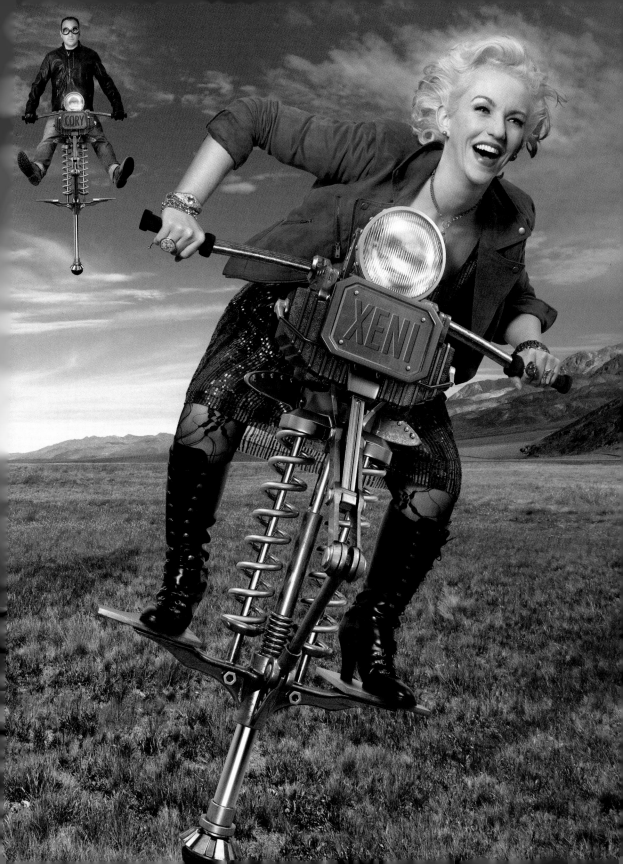

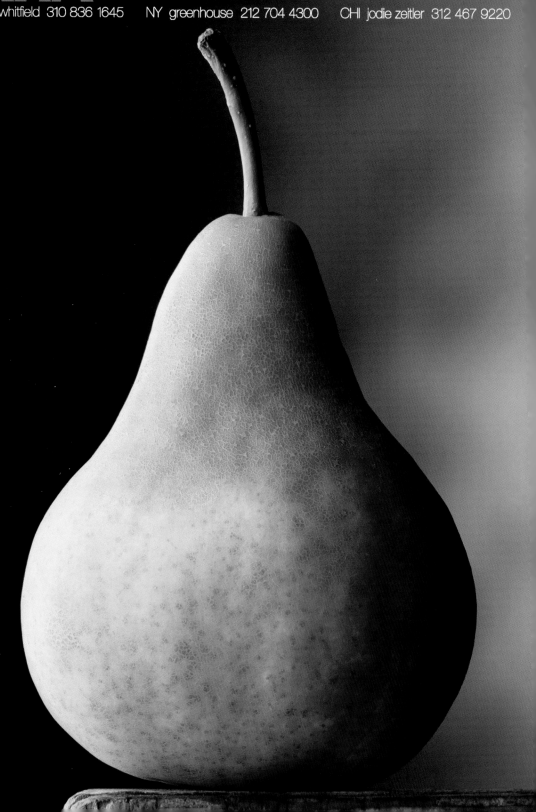

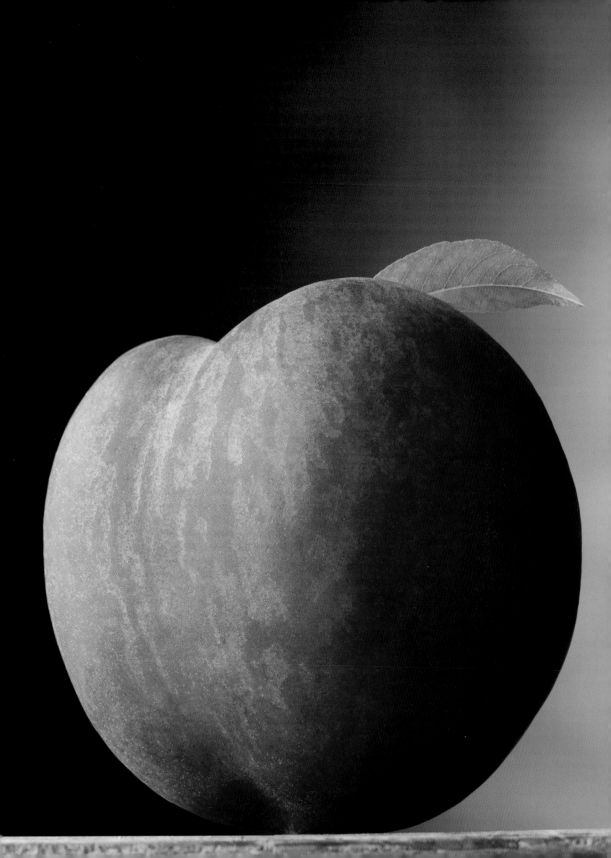

SCIORTINO

Jeff Sciortino Photography
764 N. Milwaukee
Chicago, IL 60622
312.829.6112
www.jeffsciortino.com

Represented by: Jodie Zeitler
312.467.9220
www.jodiezeitler.com

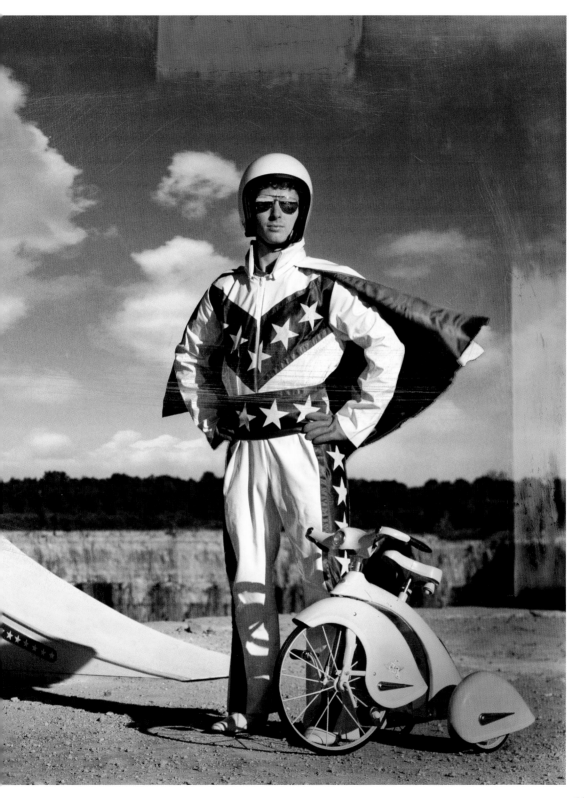

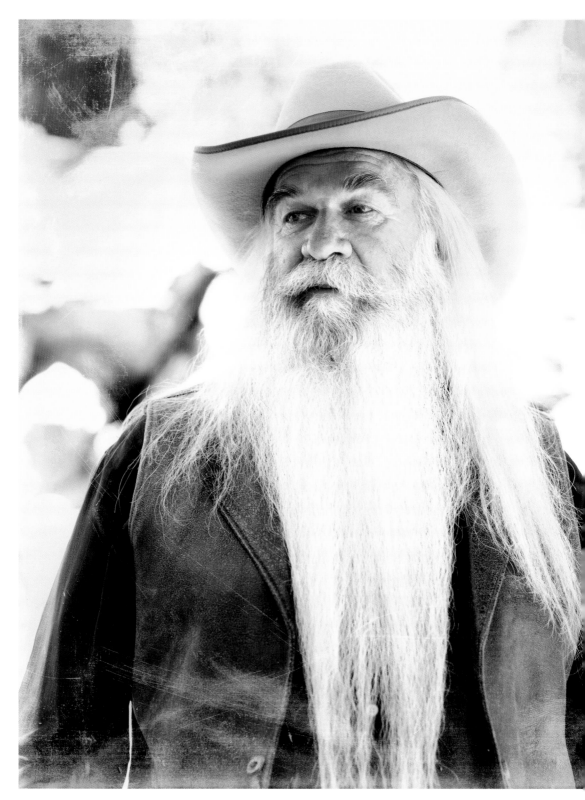

SCIORTINO

Jeff Sciortino Photography
764 N. Milwaukee Ave.
Chicago, IL 60622
312.829.6112
www.jeffsciortino.com

Represented by: Jodie Zeitler
312.467.9220
www.jodiezeitler.com

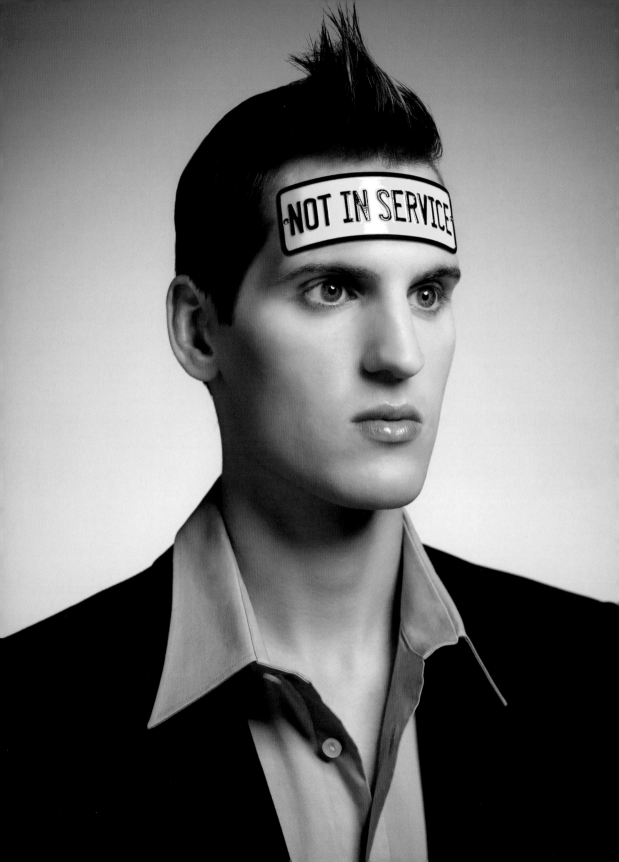

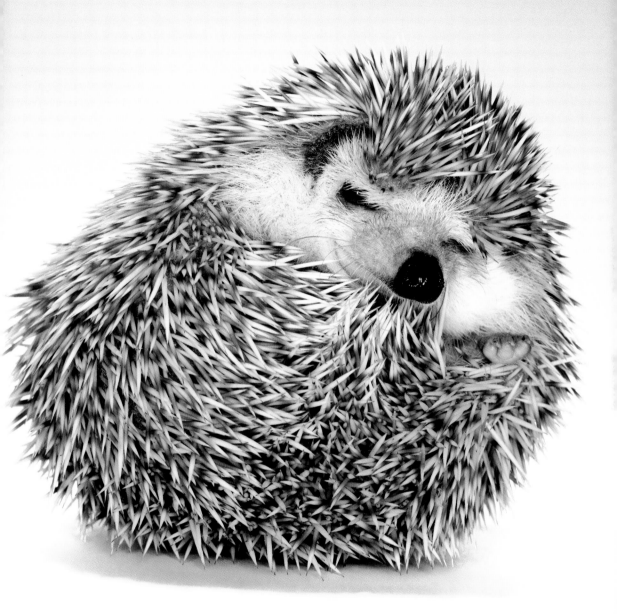

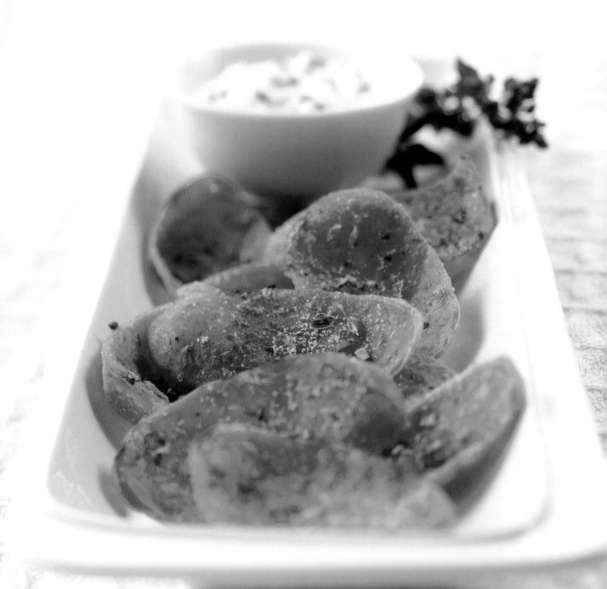

312.751.9630
www.scottpayne.com

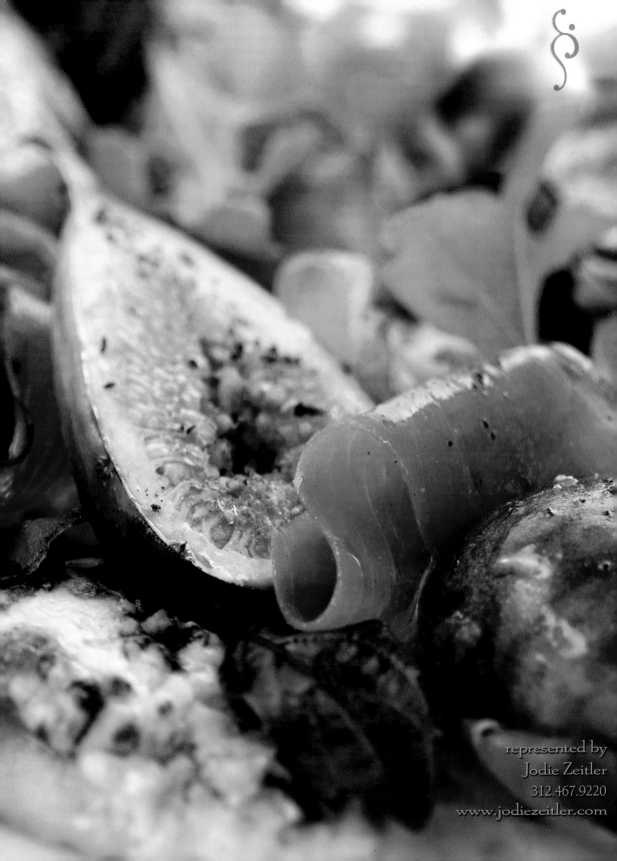

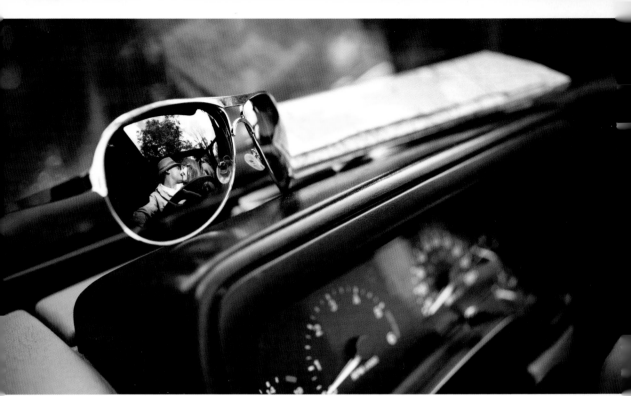

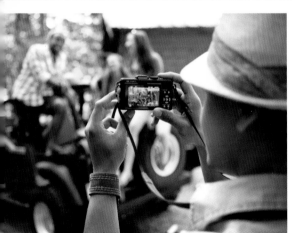

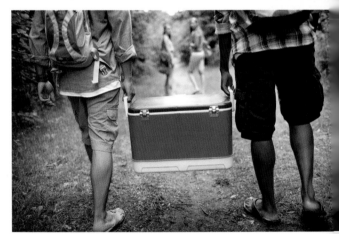

www.colinmcguire.com

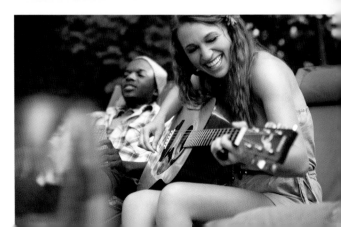

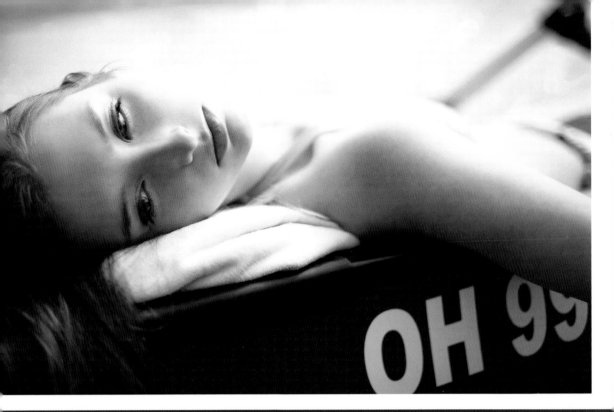

colin mcguire photographs

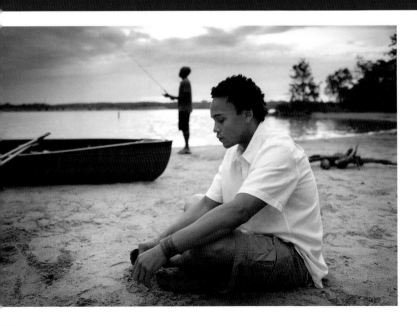

t 614.975.0025

e info@colinmcguire.com

Represented by Jodie Zeitler
312.467.9220
jodie@jodiezeitler.com

145

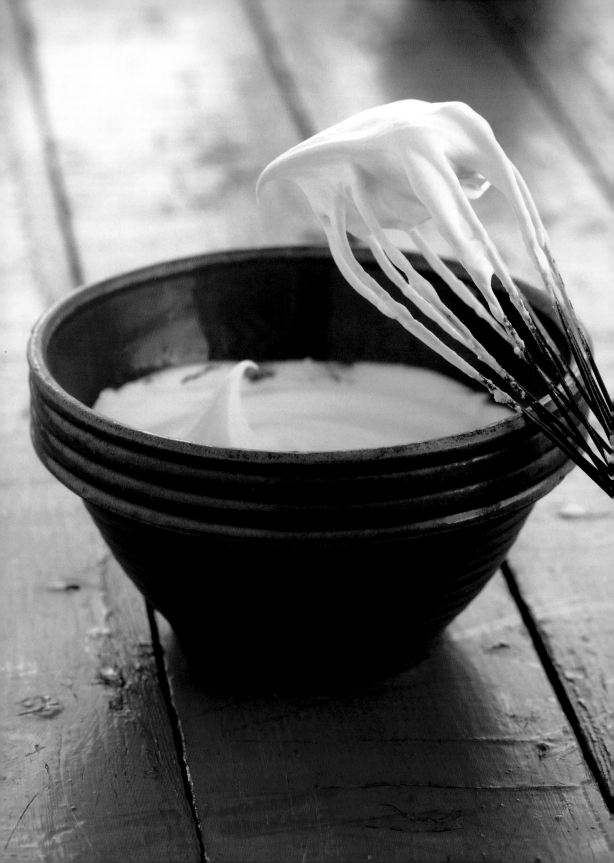

MICHAEL**MAES**

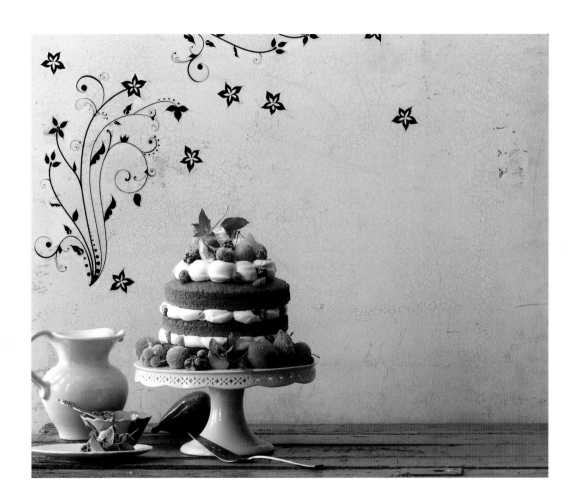

SARAH DERER | EXECUTIVE PRODUCER | T 312 997 2775 | C 312 952 2770
MAESSTUDIO.COM

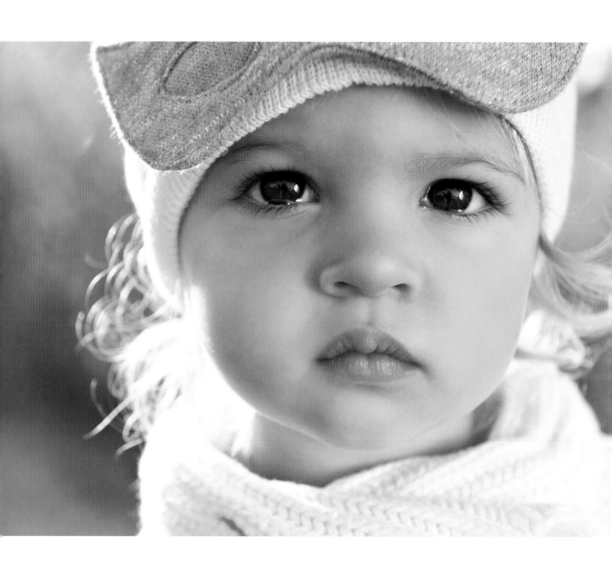

www.andreamandel.com

andrea mandel

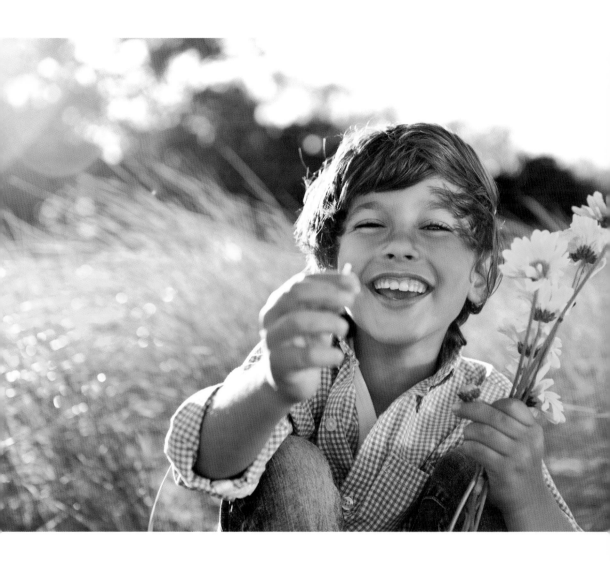

grubman.

Steve Grubman Photography, Inc.
312 226-2272
www.grubman.com
Represented by
Carolyn Somlo Talent 312 209-8042
Stock available

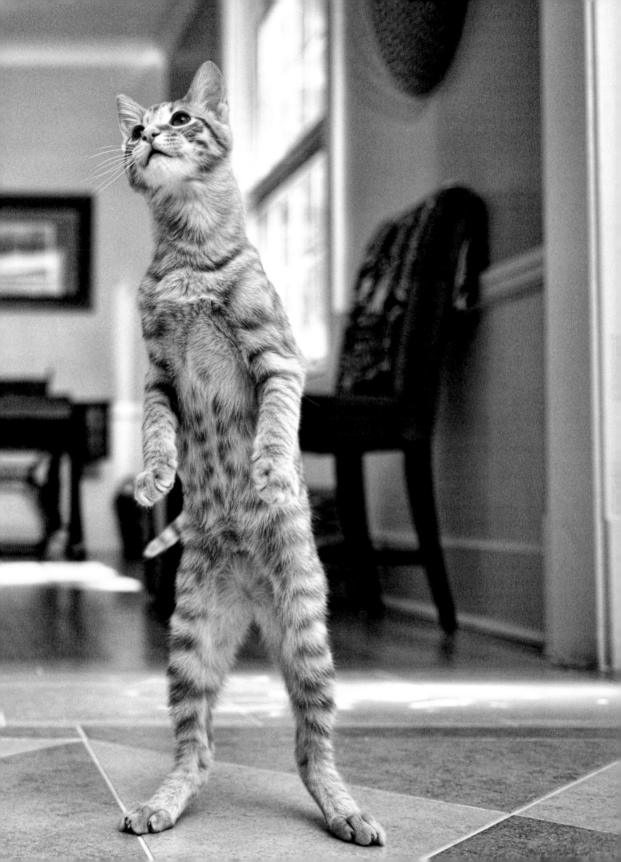

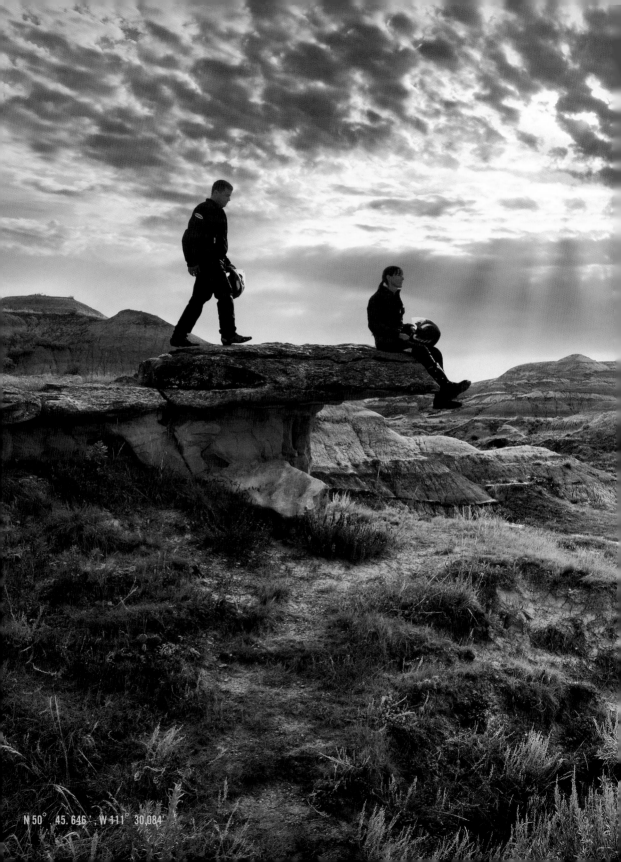

N 50° 45.646' W 111° 30.084'

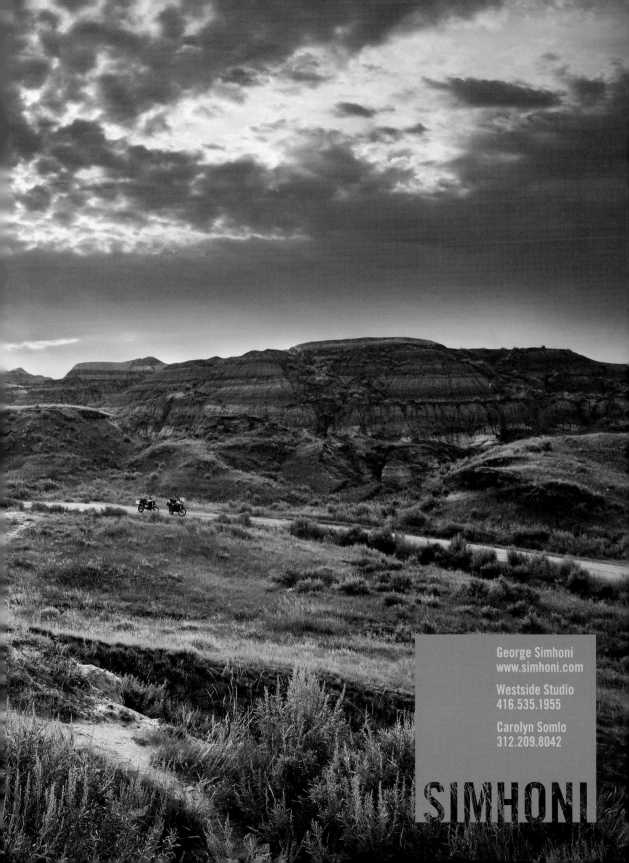

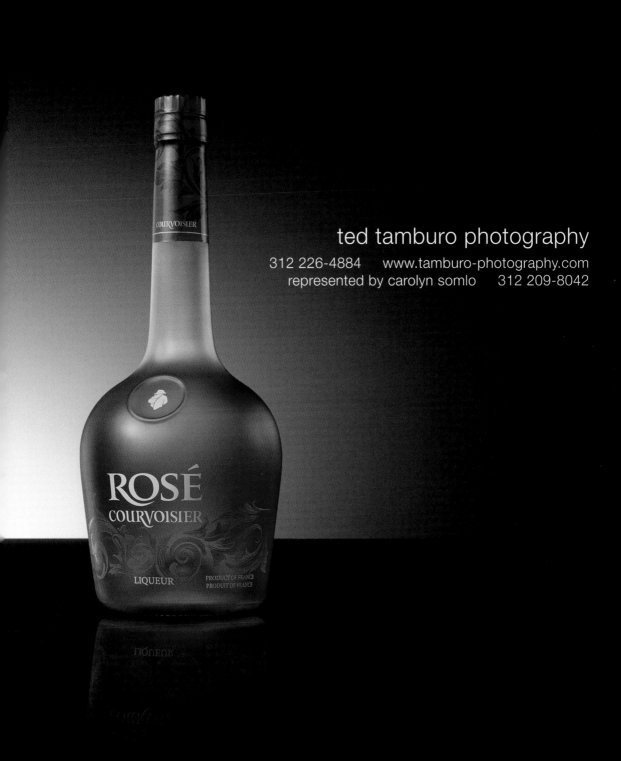

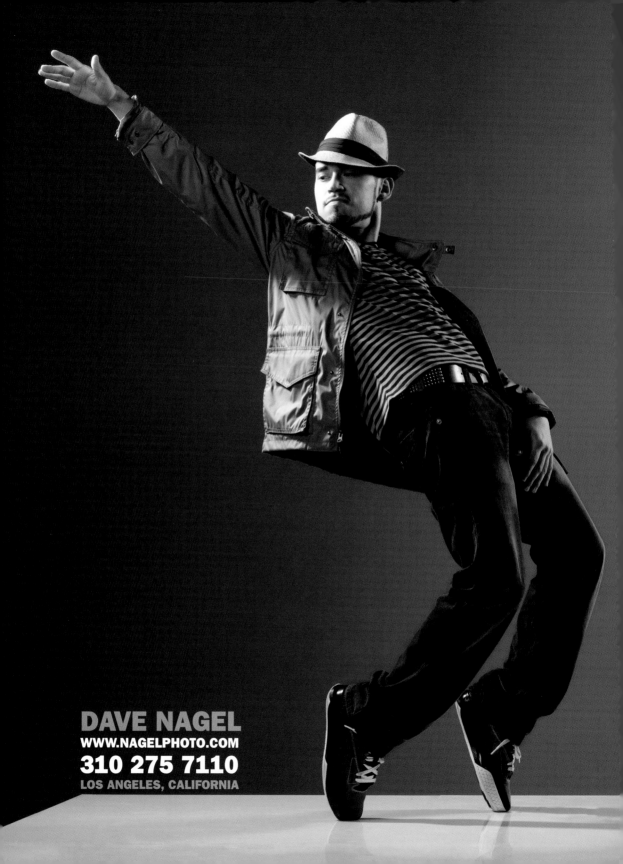

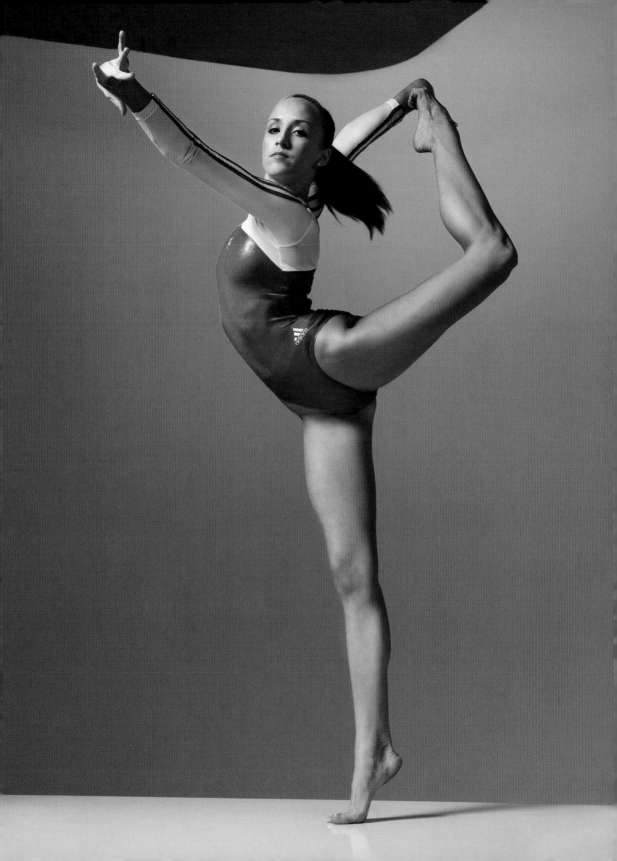

MICHAEL BOONE

PHOTOGRAPHY

312-890-3171

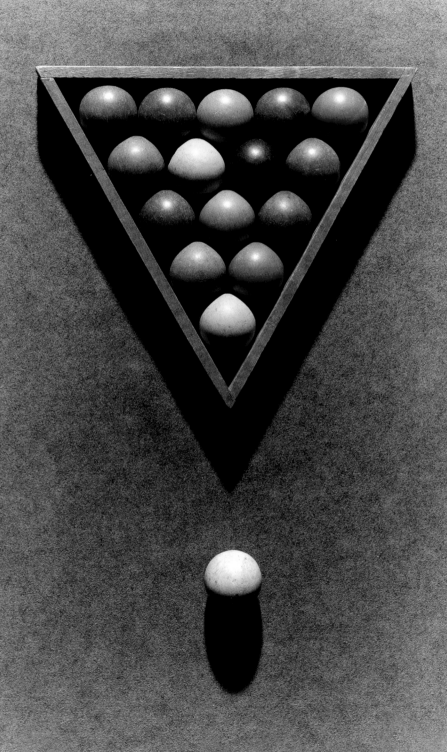

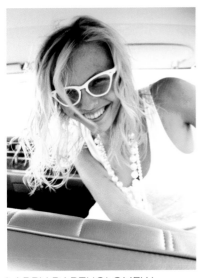

LARRY BARTHOLOMEW

COOLIFE

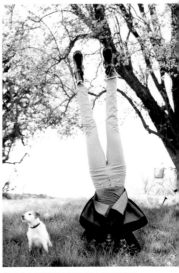

COLETTE DE BARROS

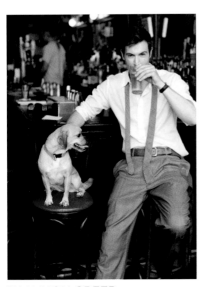

SHANNON GREER

PHILIP HARVEY

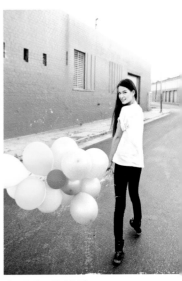

CHRIS KILKUS

Alyssa Pizer
MANAGEMENT

ALYSSAPIZER.COM • ALYSSA@ALYSSAPIZER.COM • 310.440.3930

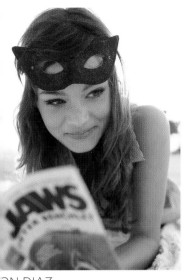

ON DIAZ

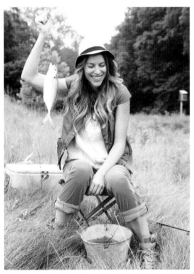

CHEYENNE ELLIS

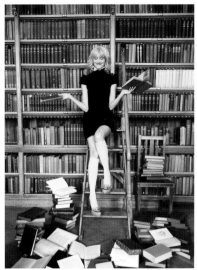

WILLIAM GARRETT

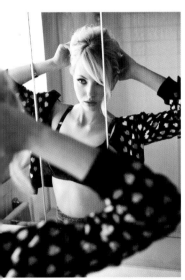

OSEPH MONTEZINOS

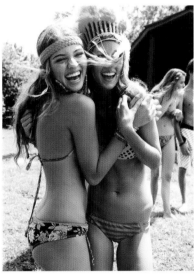

BETH STUDENBERG

Alyssa Pizer
MANAGEMENT

Follow us on:

facebook.com/alyssapizermanagement
twitter.com/alyssapizer
alyssapizer.com/blog/

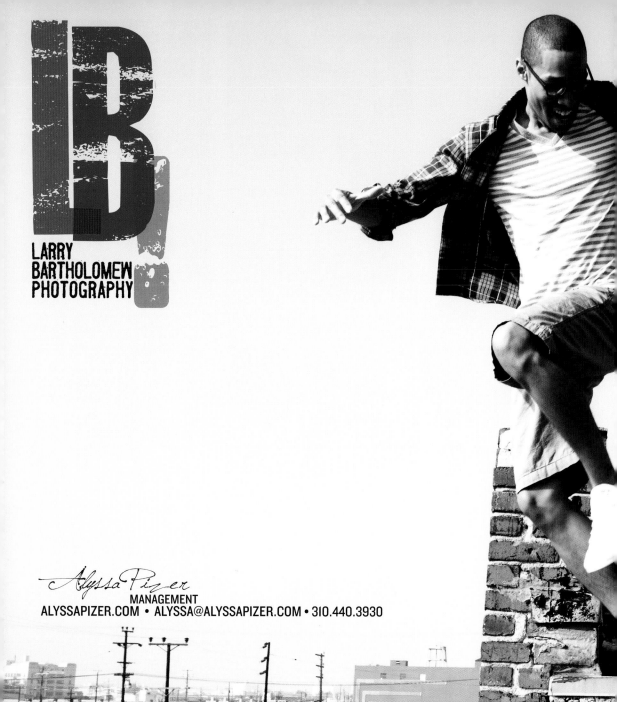

LARRY
BARTHOLOMEW
PHOTOGRAPHY

Alyssa Pizer
MANAGEMENT
ALYSSAPIZER.COM • ALYSSA@ALYSSAPIZER.COM • 310.440.3930

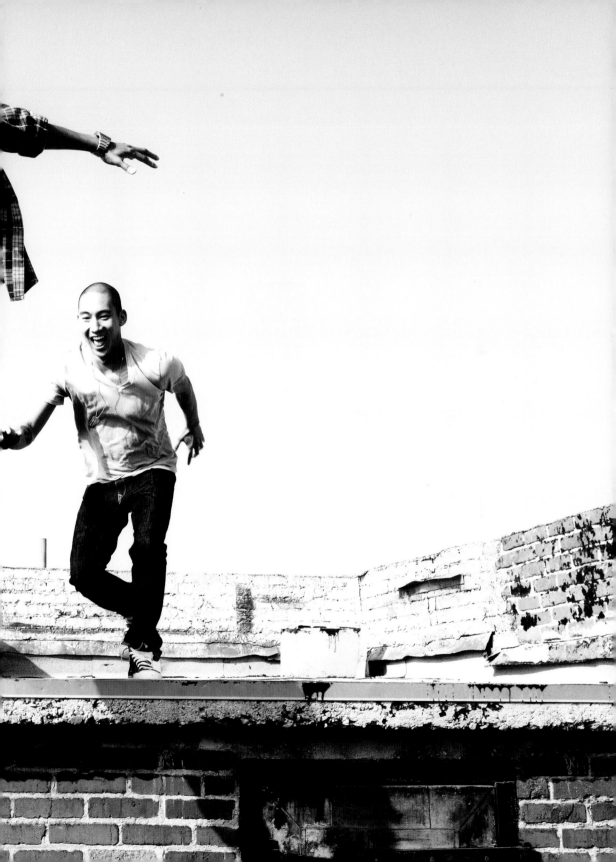

BAUME NETTOYANT

douceur revitalisante
éclat sublimé

revitalizing softness
sublime radiance

Yves Saint Laurent

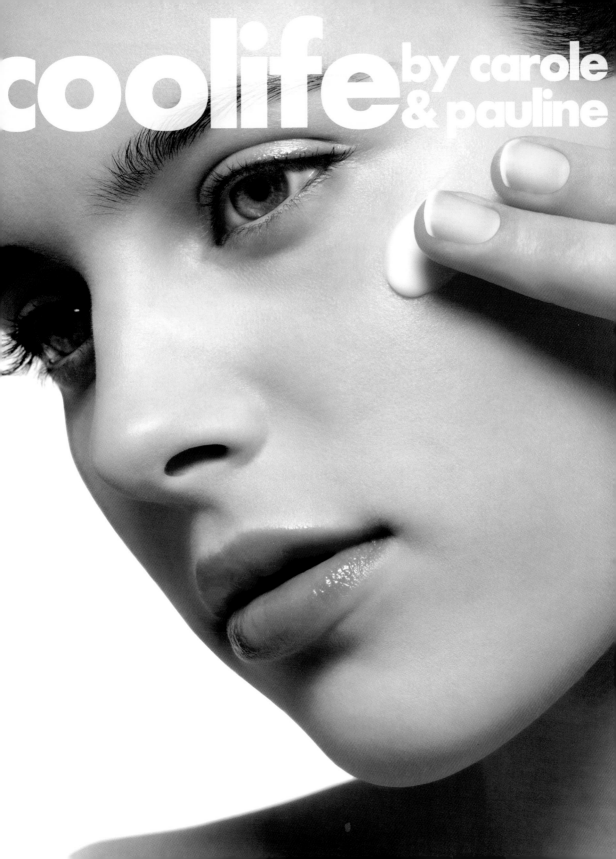

coolife by carole & pauline

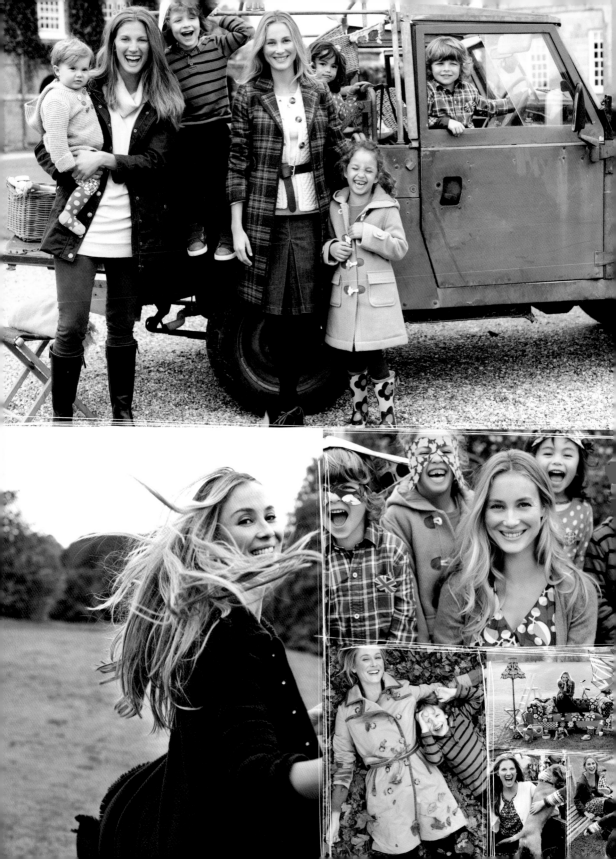

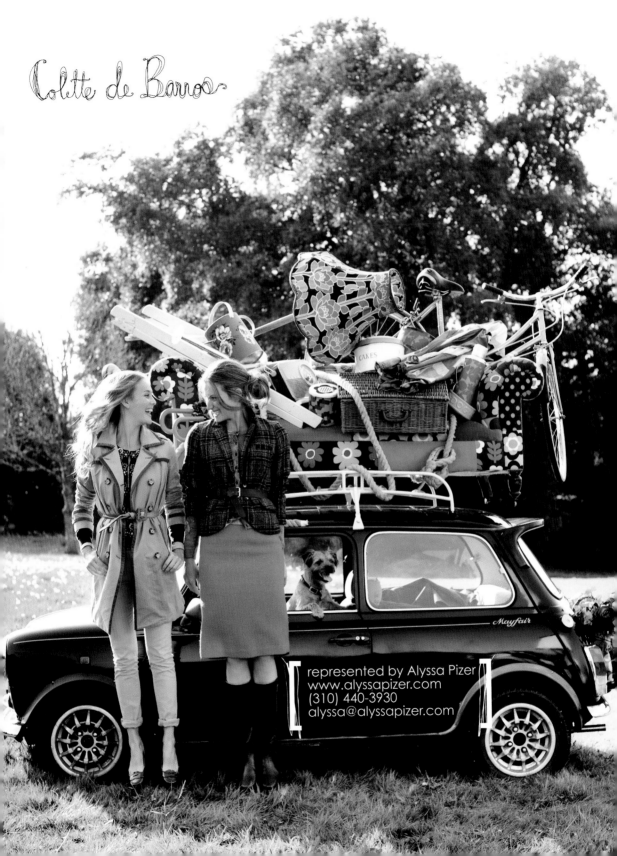

Colette de Barros

represented by Alyssa Pizer
www.alyssapizer.com
(310) 440-3930
alyssa@alyssapizer.com

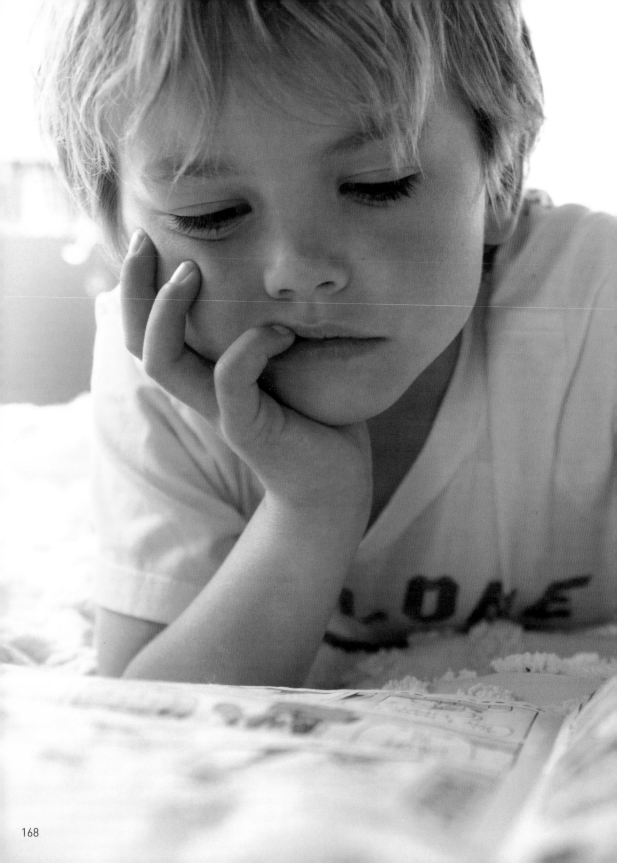

DON DIAZ!

Represented by Alyssa Pizer Management www.alyssapizer.com
(310) 310.440.3930 alyssa@alyssapizer.com

CHEYENNE ELLIS PHOTOGRAPHY

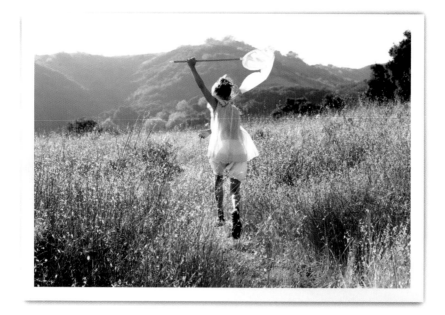

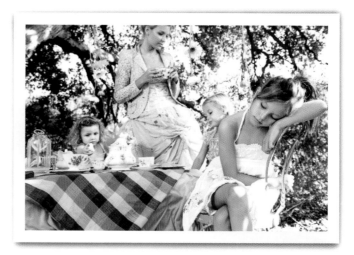

WWW.CHEYENNEELLIS.COM

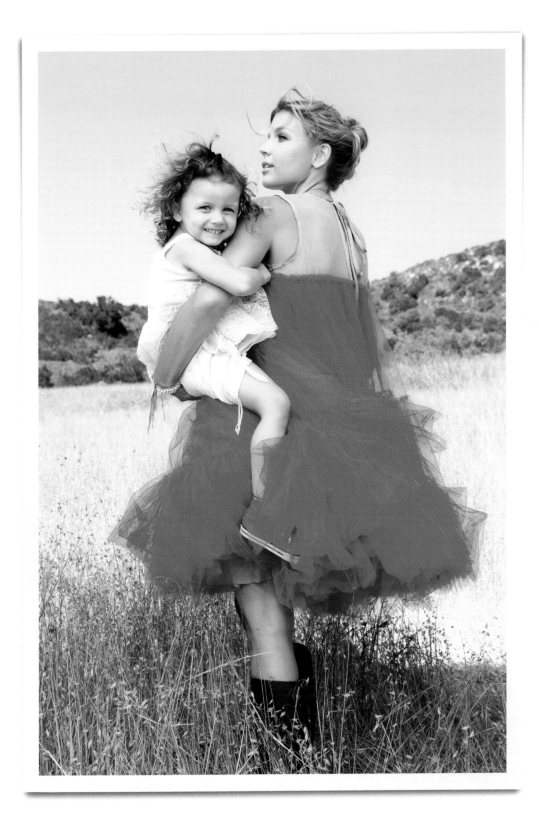

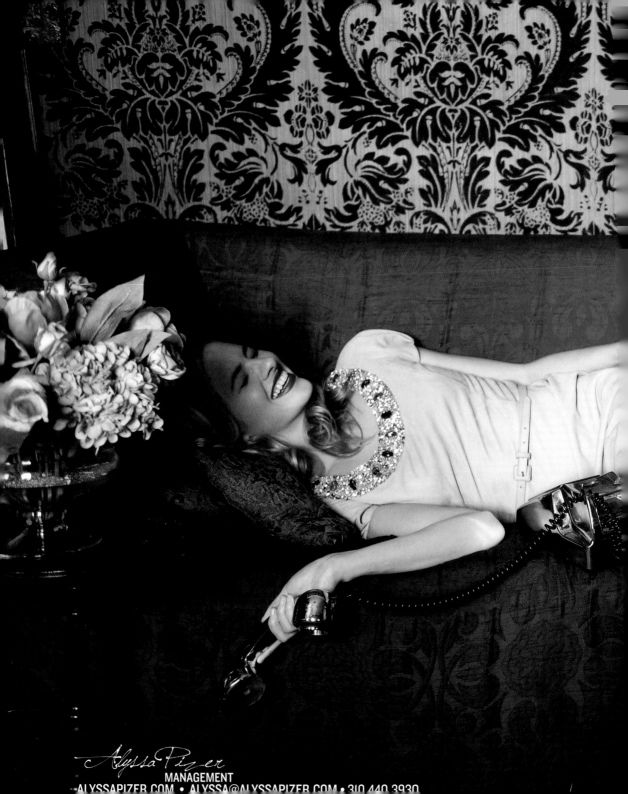

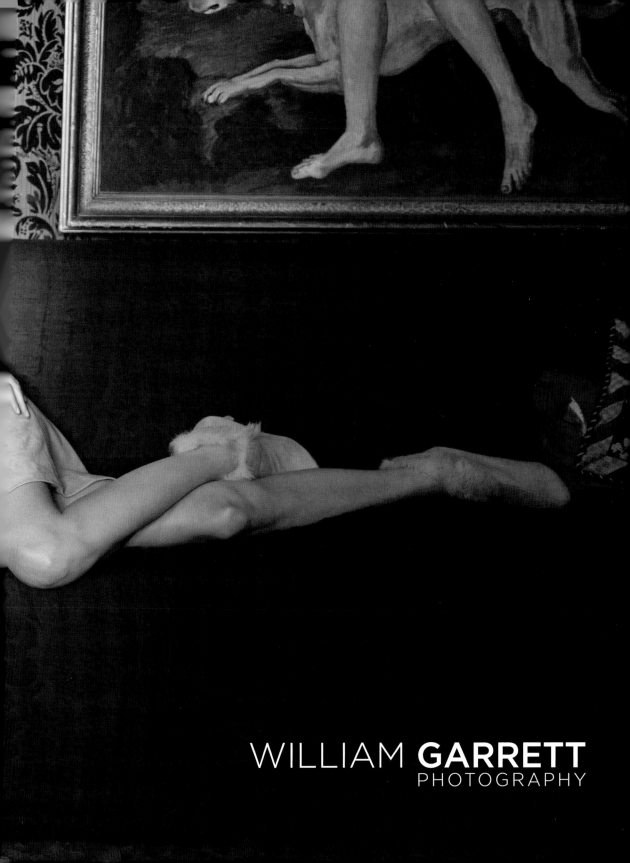

WILLIAM **GARRETT**
PHOTOGRAPHY

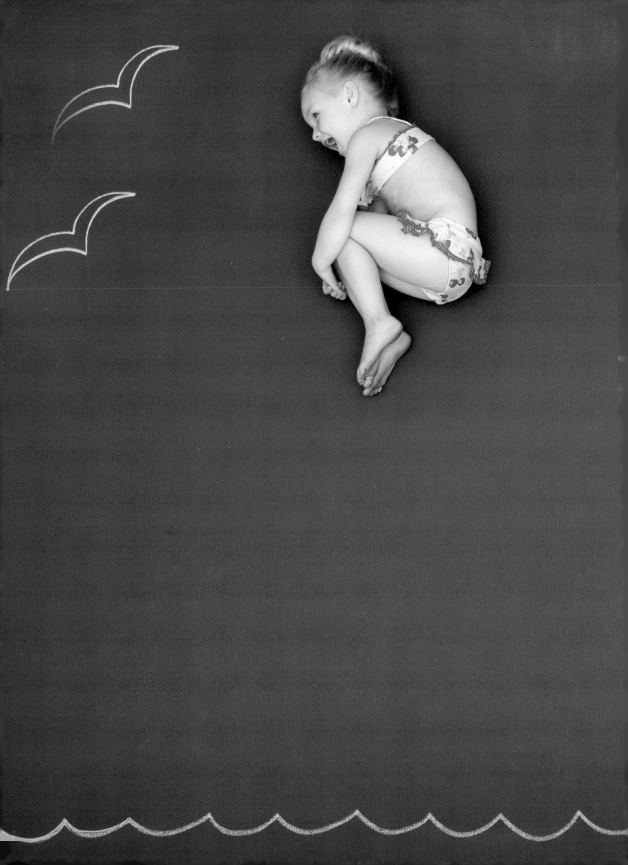

SHANNON_greer_ **PHOTOGRAPHY**

alyssa pizer management
www.alyssapizer.com
310.440.3930
alyssa@alyssapizer.com

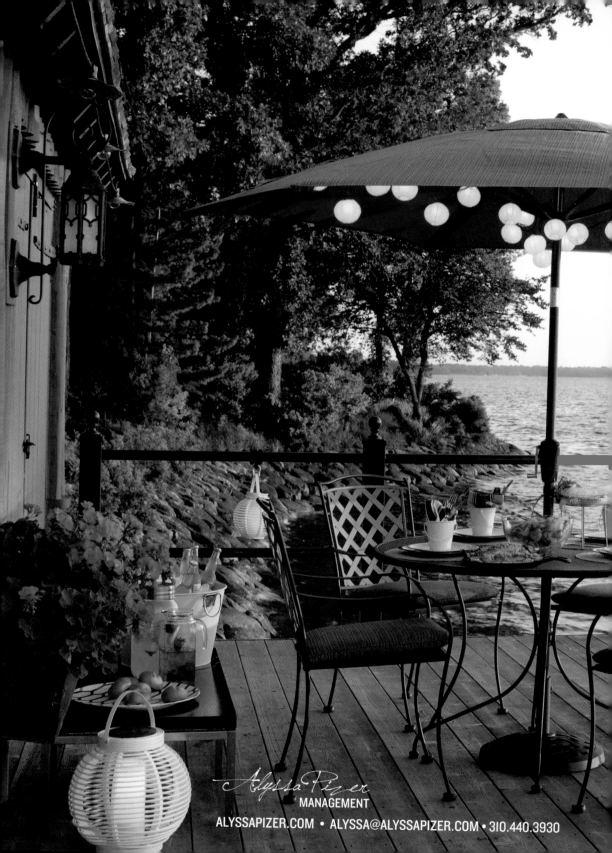

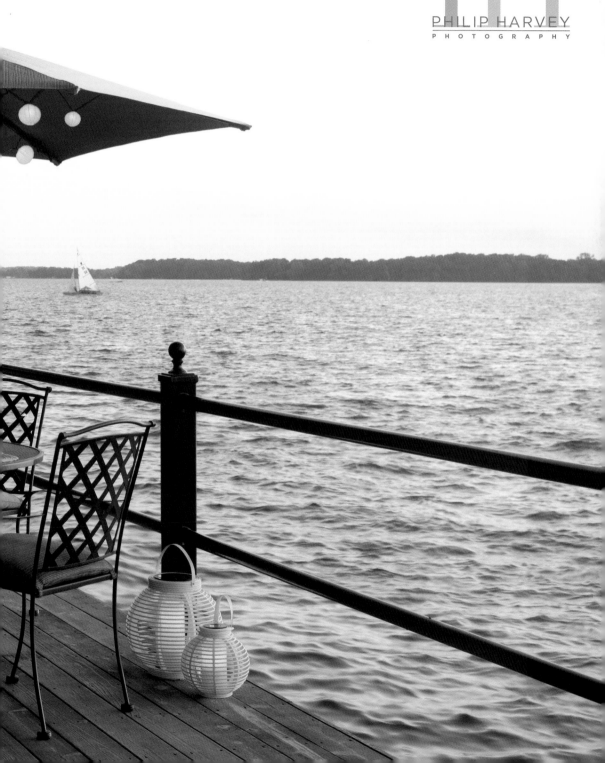

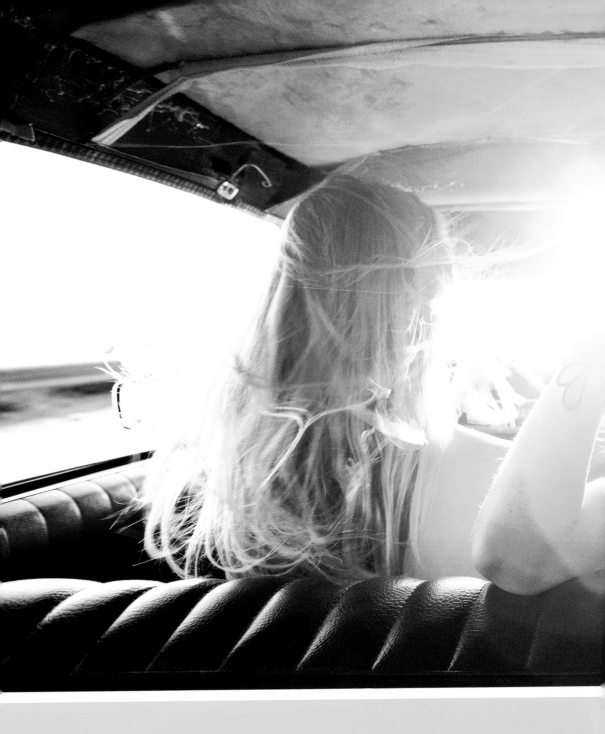

REPRESENTED BY / ALYSSA PIZER MANAGEMENT

ALYSSAPIZER.COM / 310 440 3930
ALYSSA@ALYSSAPIZER.COM

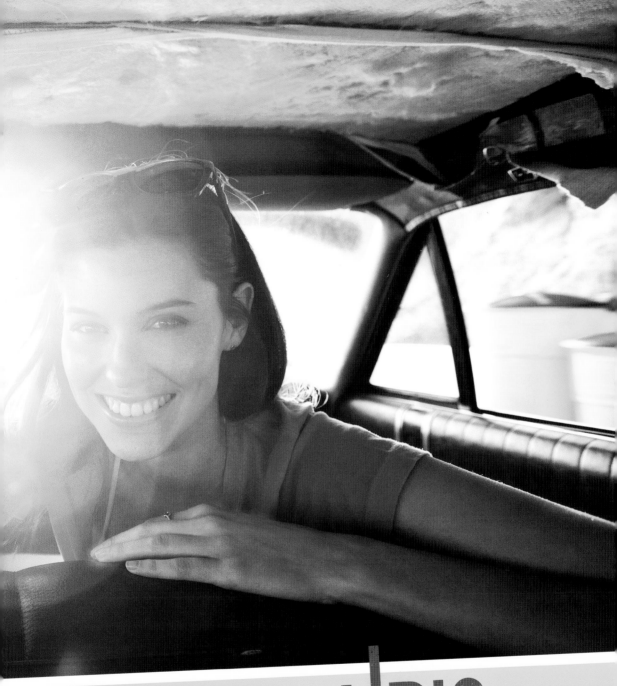

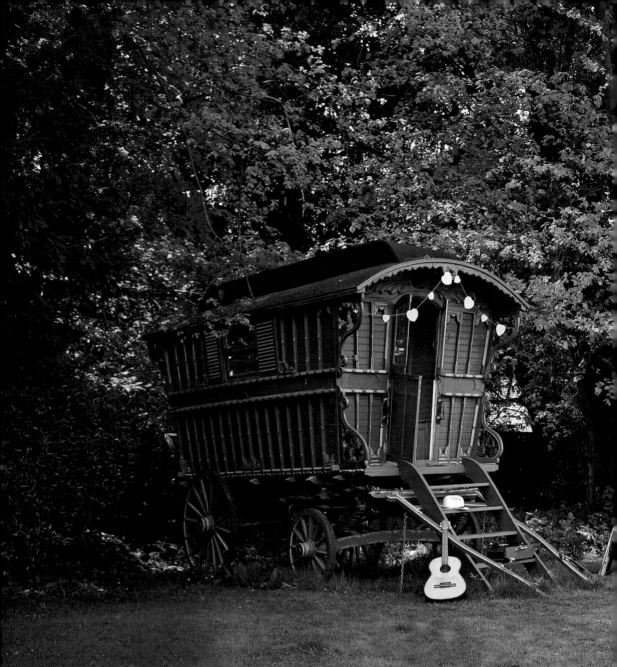

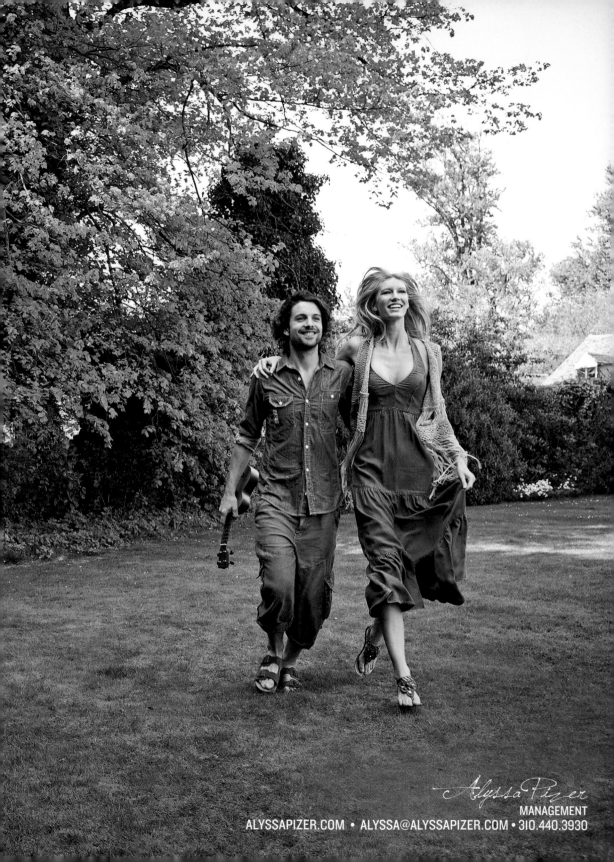

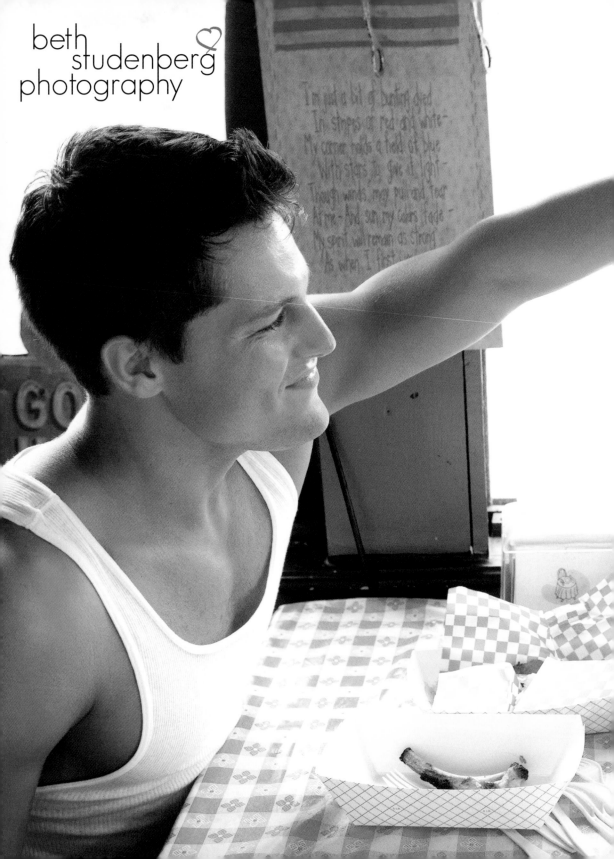

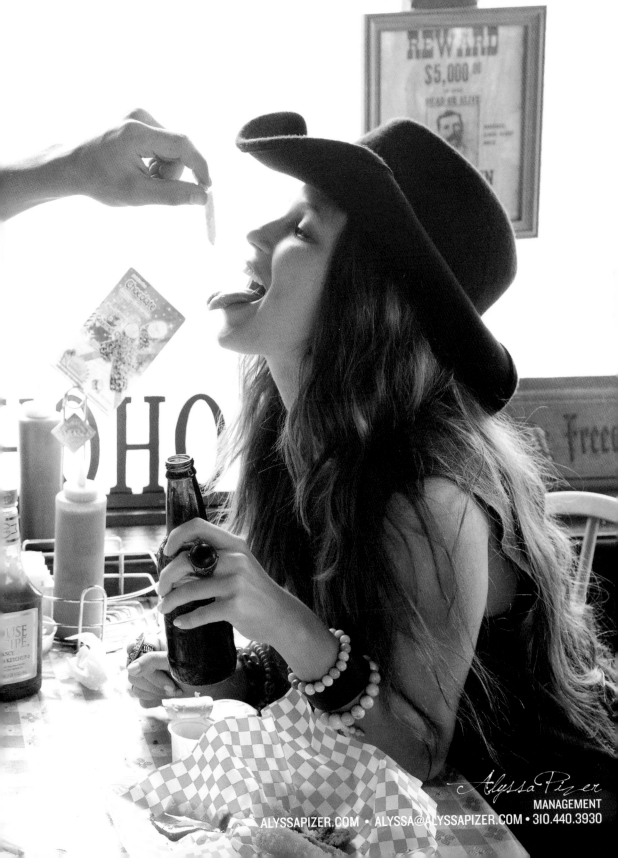

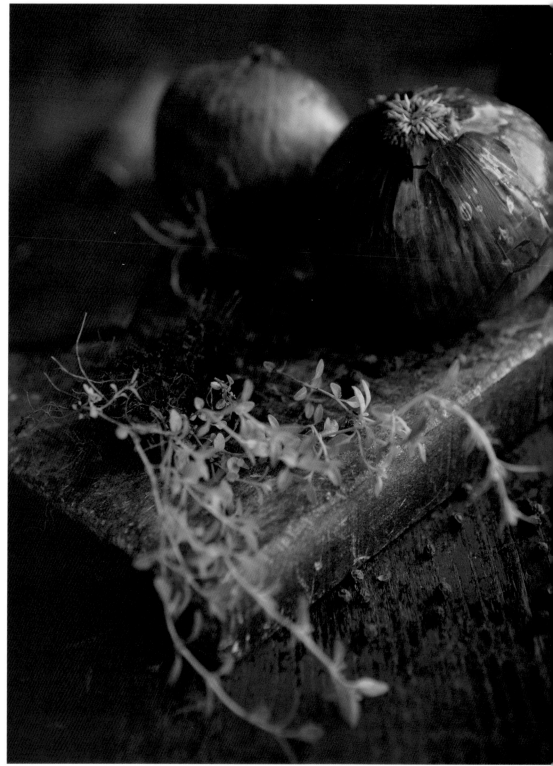

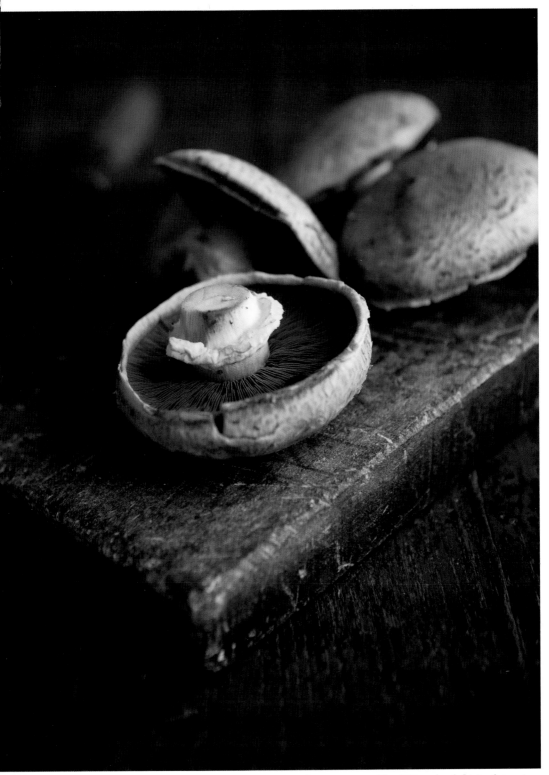

185

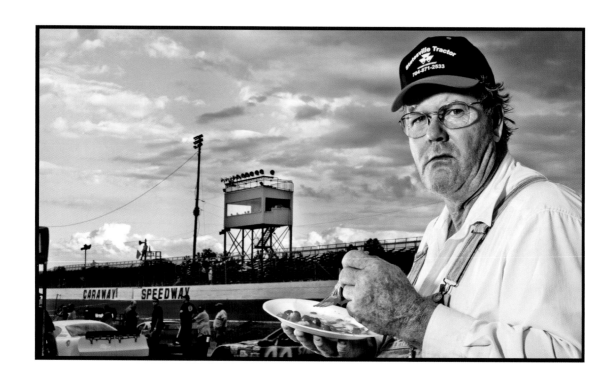

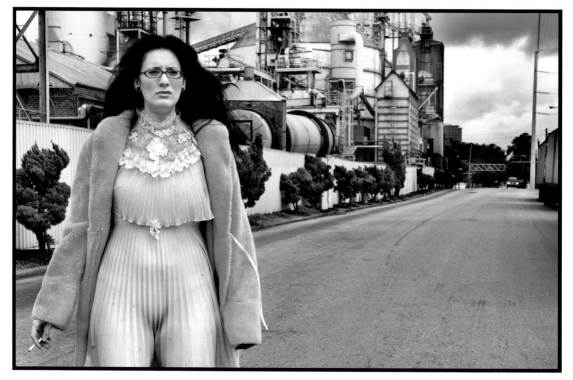

BRYAN REGAN PHOTOGRAPHY · 919-829-0960 · bryanreganphotography.com
represented by Wonderful Machine

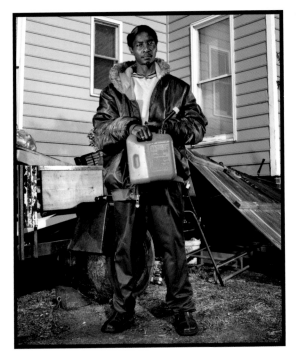

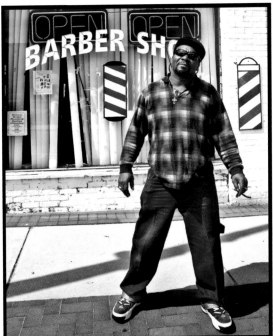

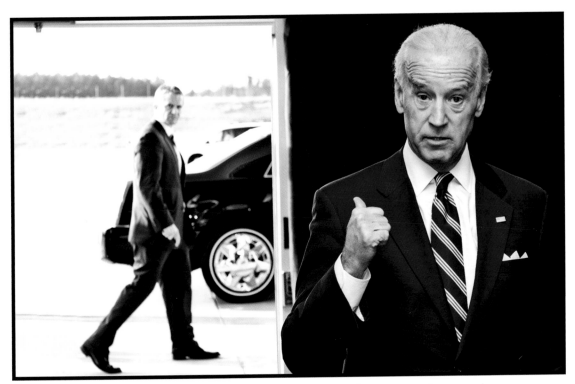

BRYAN REGAN PHOTOGRAPHY · 919-829-0960 · bryanreganphotography.com
represented by Wonderful Machine

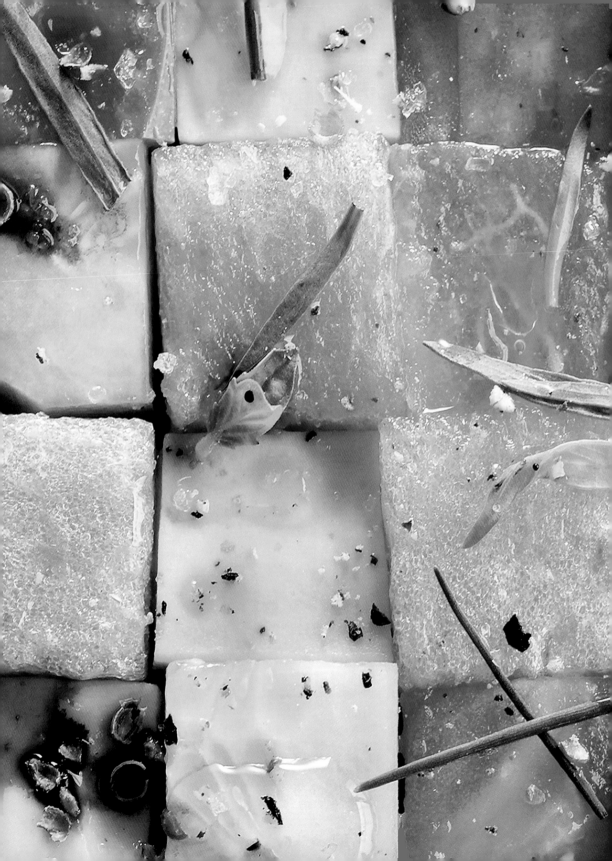

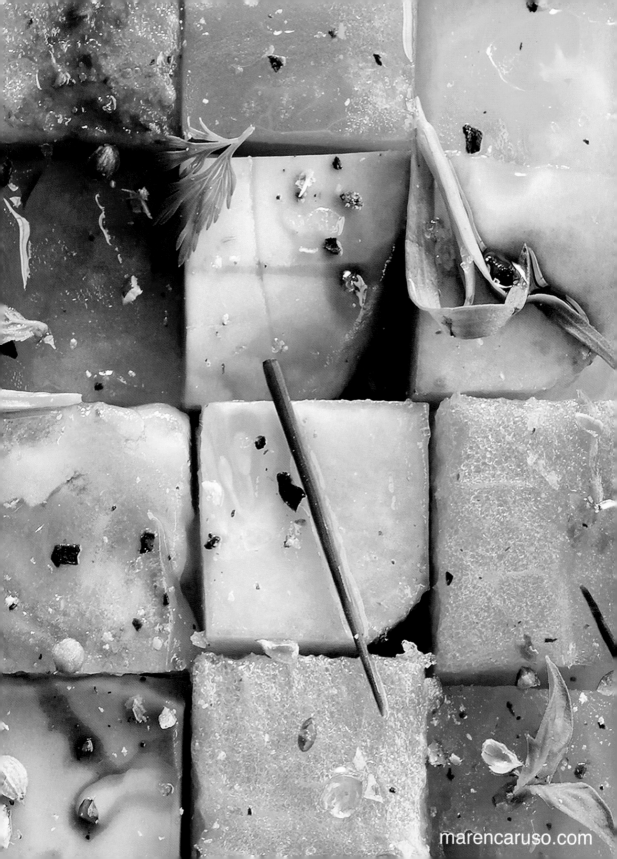

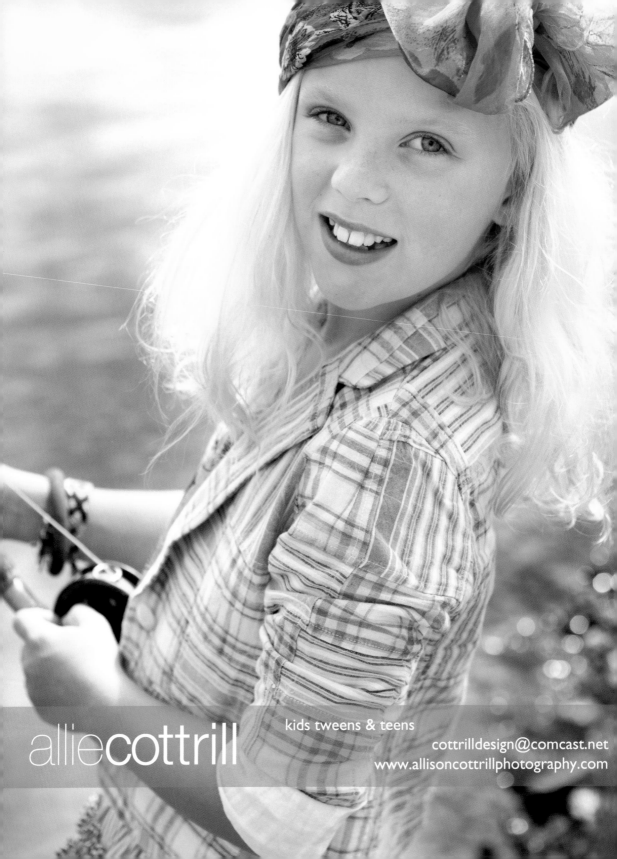

alliecottrill

kids tweens & teens

cottrilldesign@comcast.net
www.allisoncottrillphotography.com

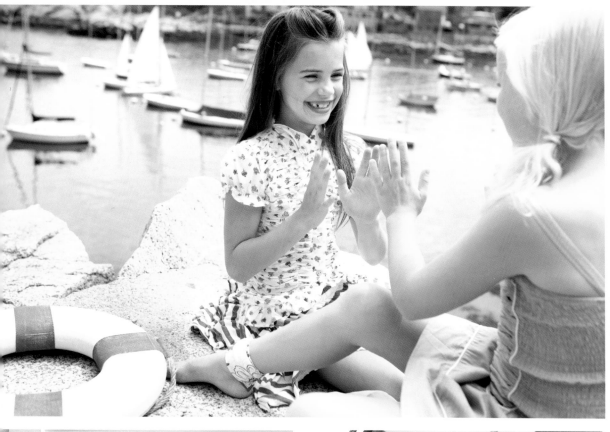

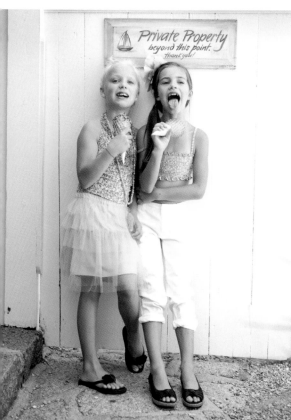

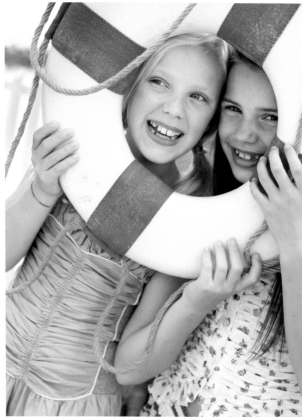

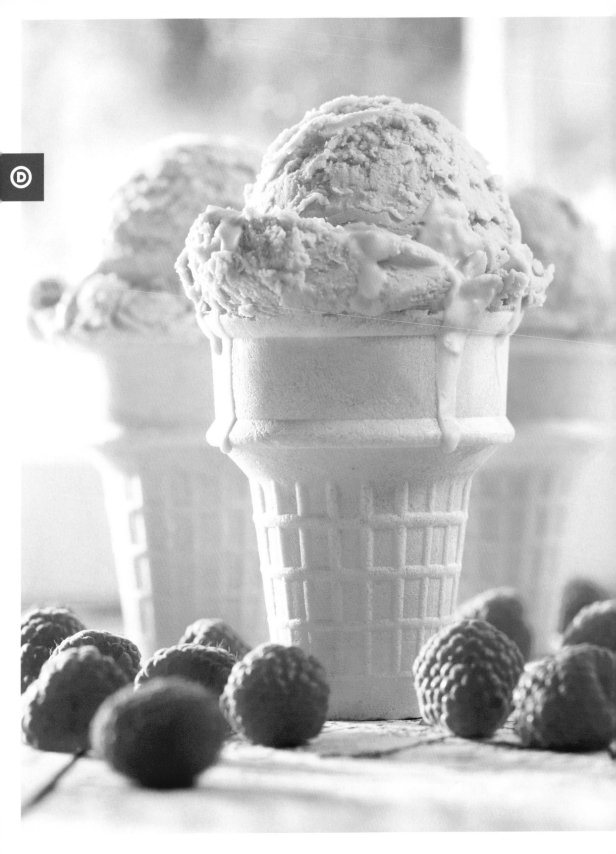

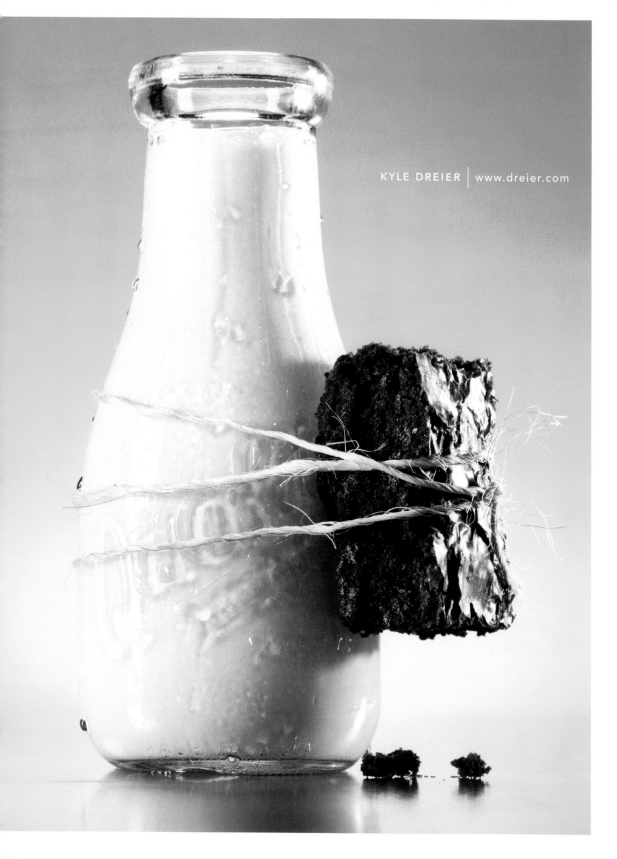

KYLE DREIER | www.dreier.com

POBY
PHOTOGRAPHER - DIRECTOR

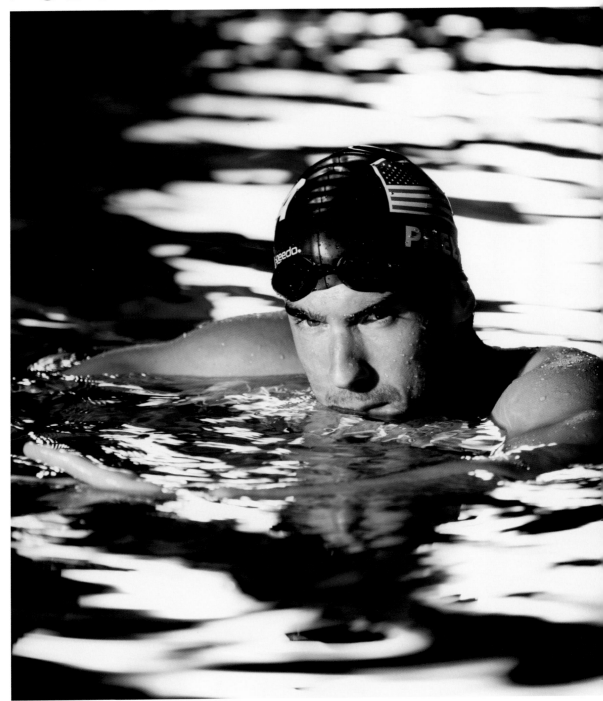

WWW.POBY.NET

USA: CPi REPS PAM@CPi-REPS.COM 212.683.1455
EUROPE: FROEHLICH MANAGEMENT FROEHLICH@FILM-MANAGEMENT +49.69.2710.8960

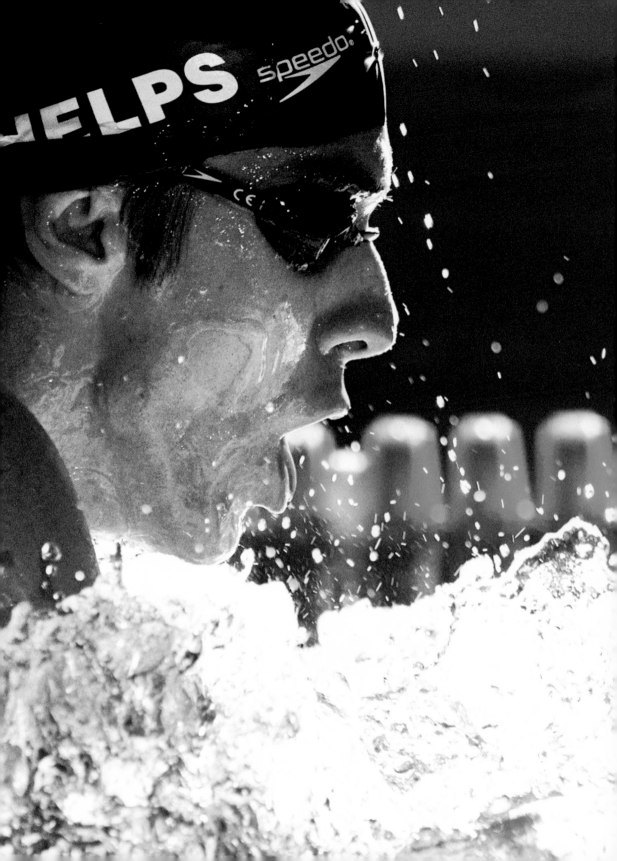

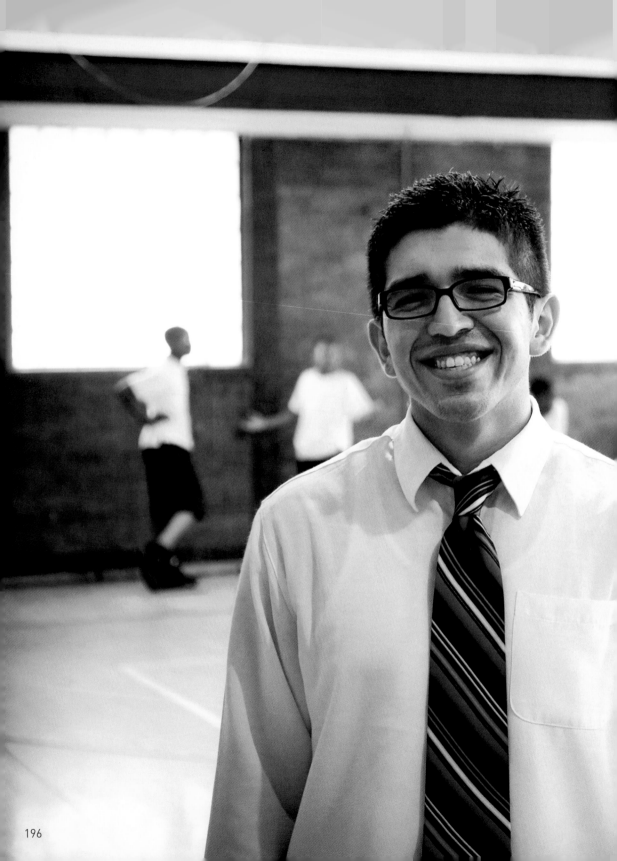

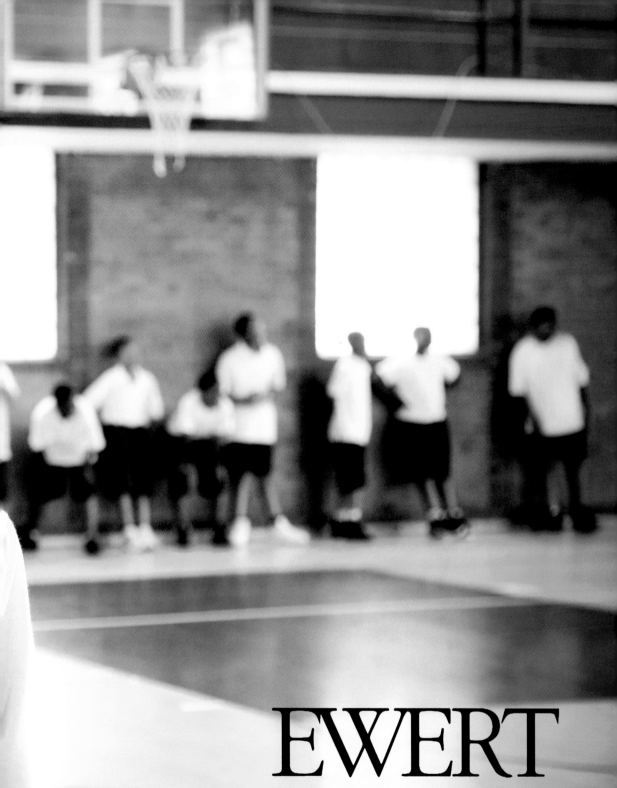

EWERT

kate & company

katherine hennessy
617.549.9872
katecompany@gmail.com
www.kate-company.com

rodney rascona
topher cox
carrie prophett
john earle
joshua weinfeld
eric kulin
jim scherer

▼ erickulin.com

▼ rascona.com

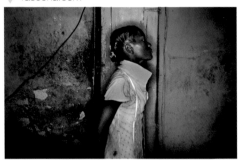

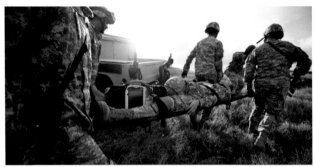

▲ tophercox.com

▲ jimscherer.com

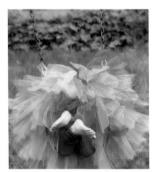

▲ carrieprophett.com

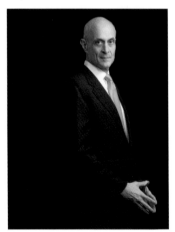

▲ johnearlephoto.com

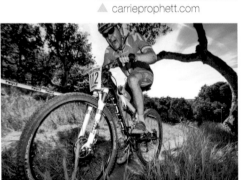

▲ joshuaweinfeld.com

kate & company

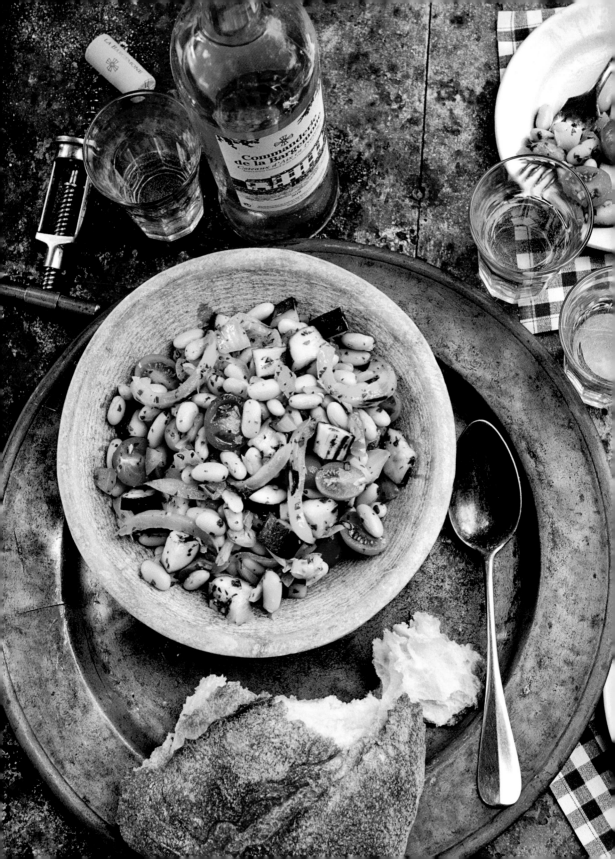

JIM SCHERER

PHOTOGRAPHY

www.jimscherer.com

Represented by Kate & Company 617.549.9872 kate@jimscherer.com

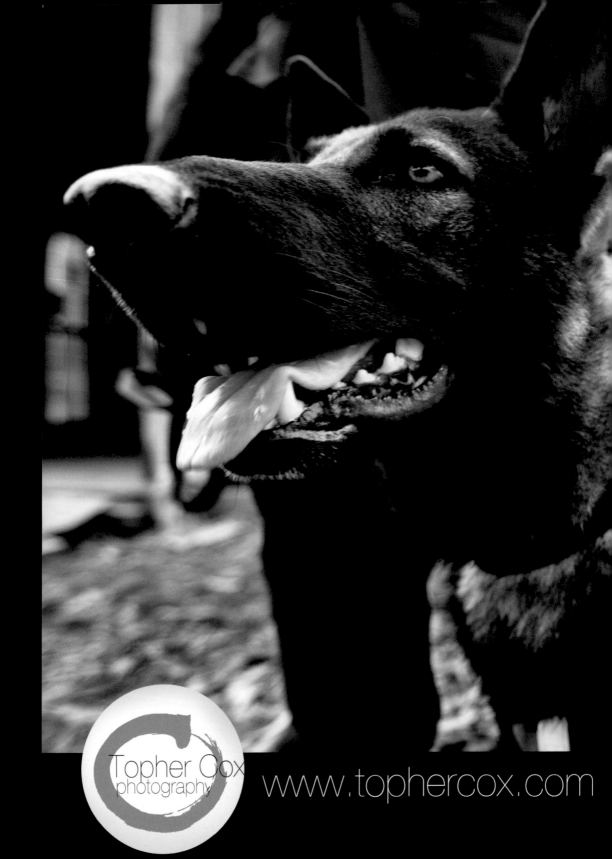

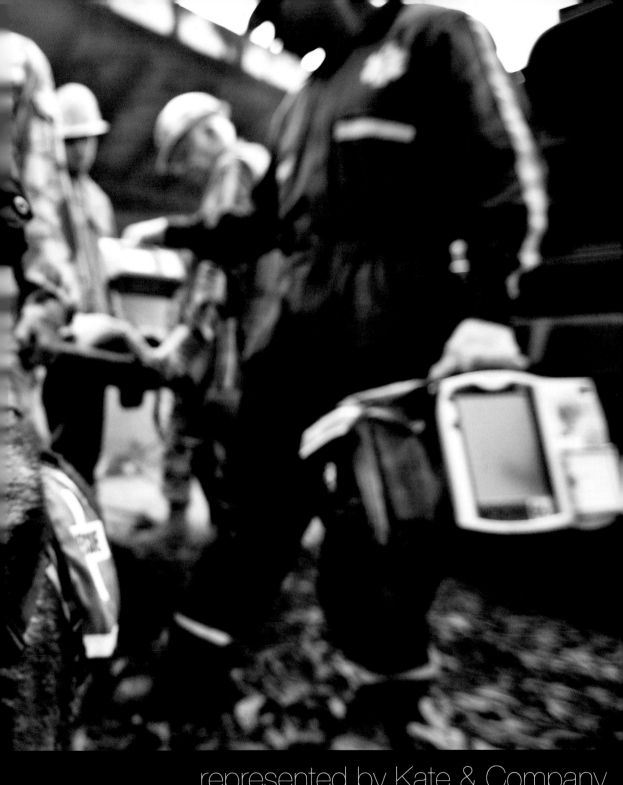

represented by Kate & Company
www.kate-company.com
617-549-9872

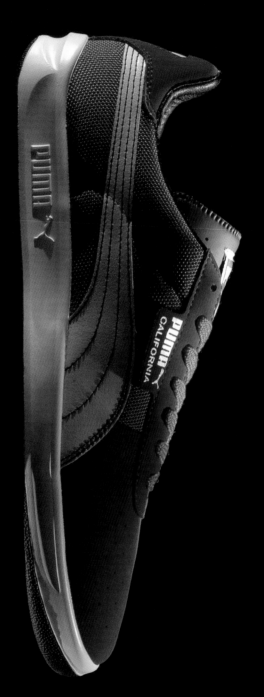

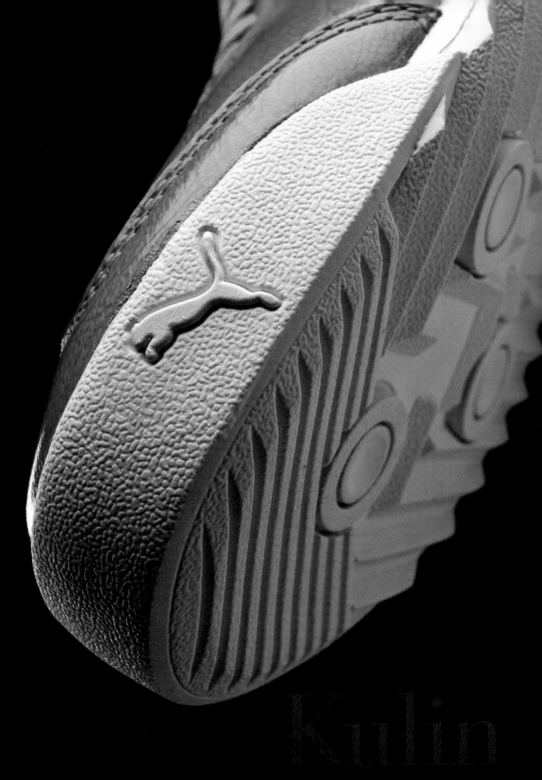

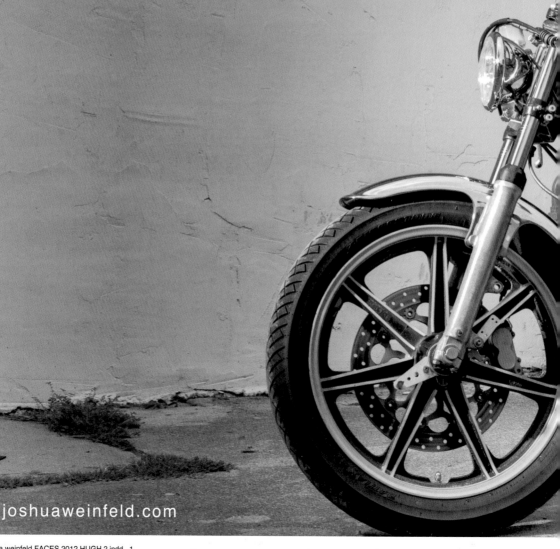

joshua *weinfeld*

p h o t o g r a p h e r

music

faces

wanderlust

athletics

joshuaweinfeld.com

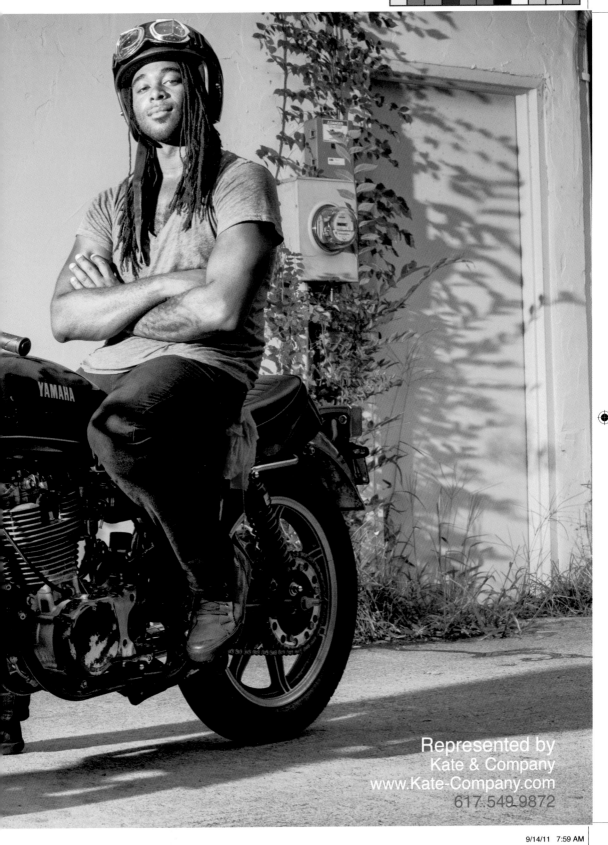

Represented by
Kate & Company
www.Kate-Company.com
617.549.9872

9/14/11 7:59 AM

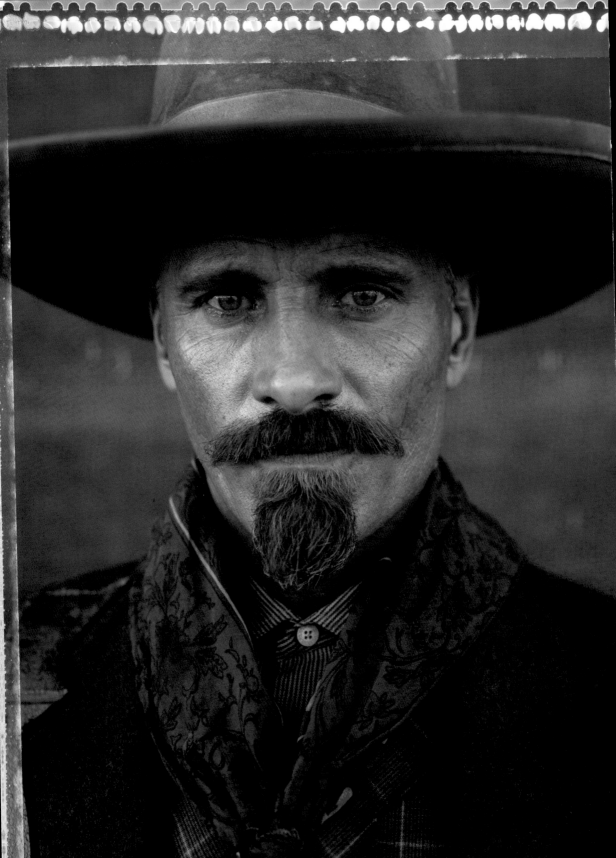

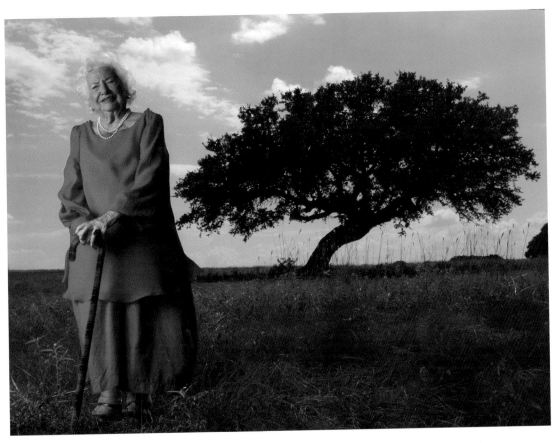

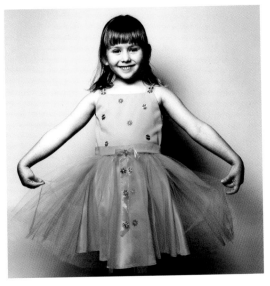

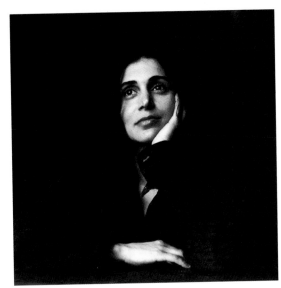

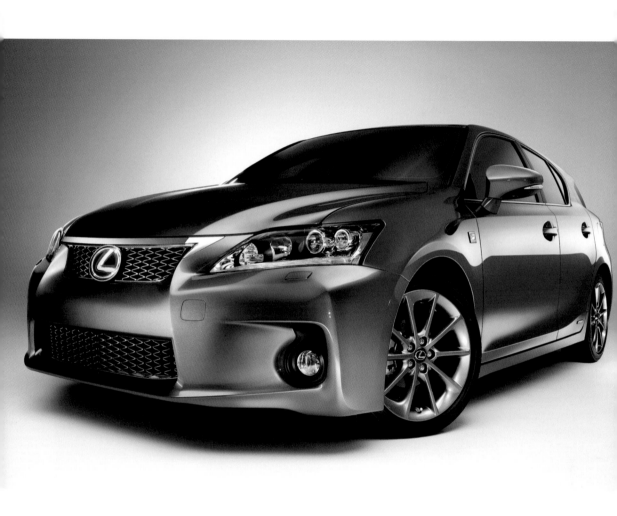

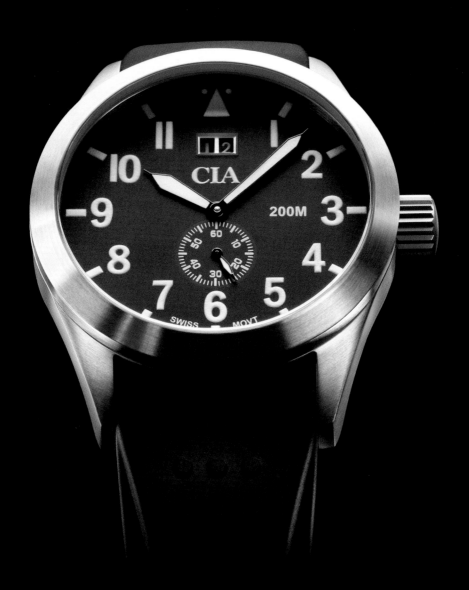

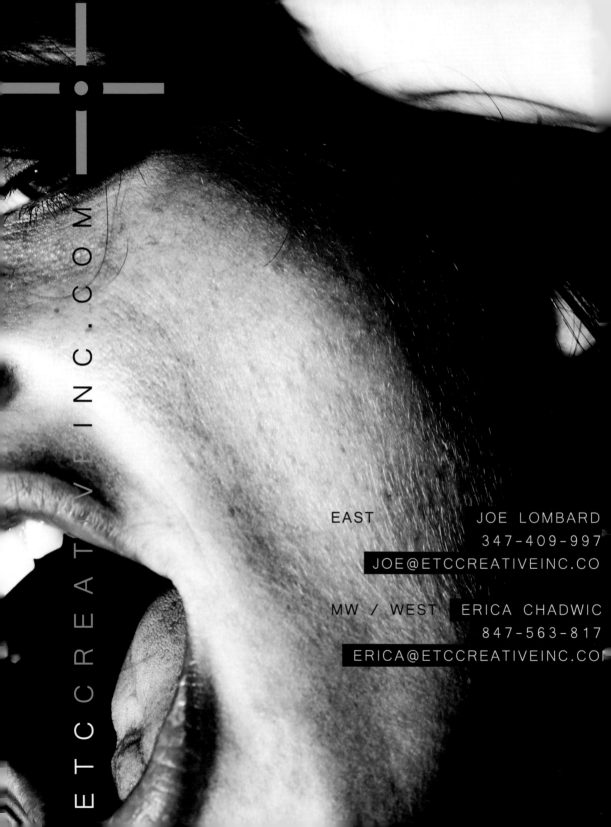

ETCCREATIVEINC.COM

EAST JOE LOMBARD
 347-409-997
JOE@ETCCREATIVEINC.CO

MW / WEST ERICA CHADWIC
 847-563-817
ERICA@ETCCREATIVEINC.CO

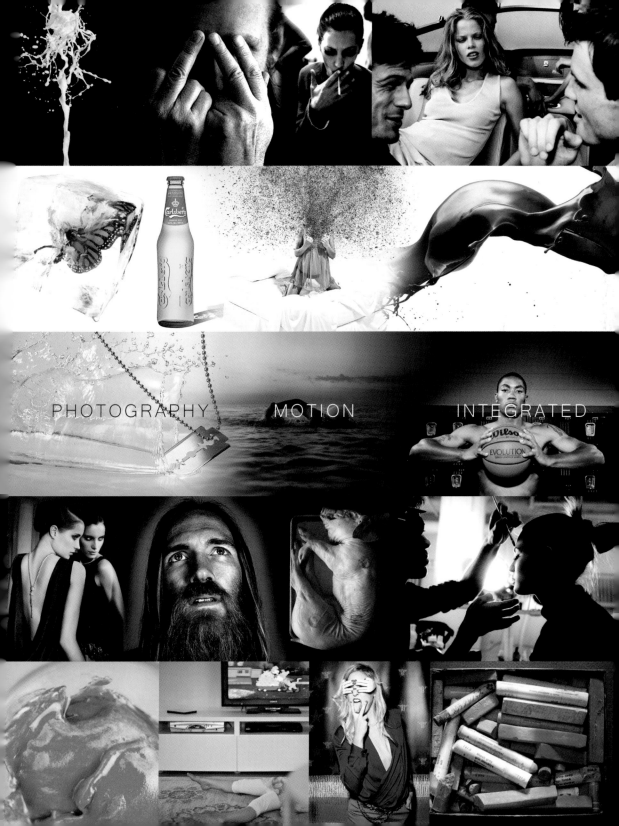

PHOTOGRAPHY MOTION INTEGRATED

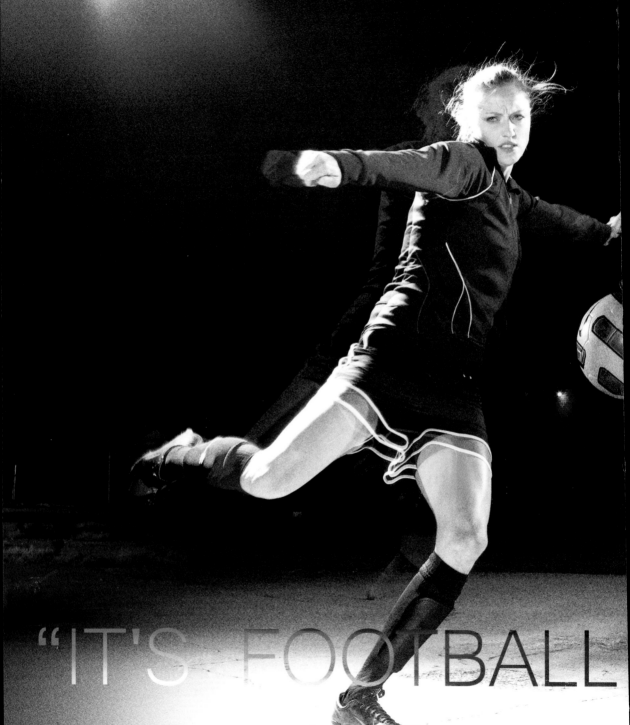

THOMAS CHADWICK

"IT'S FOOTBALL

NOT SOCCER"

WWW.ETCCREATIVEINC.COM – EAST: 347-409-9973 – MW/WEST: 847-563-8178

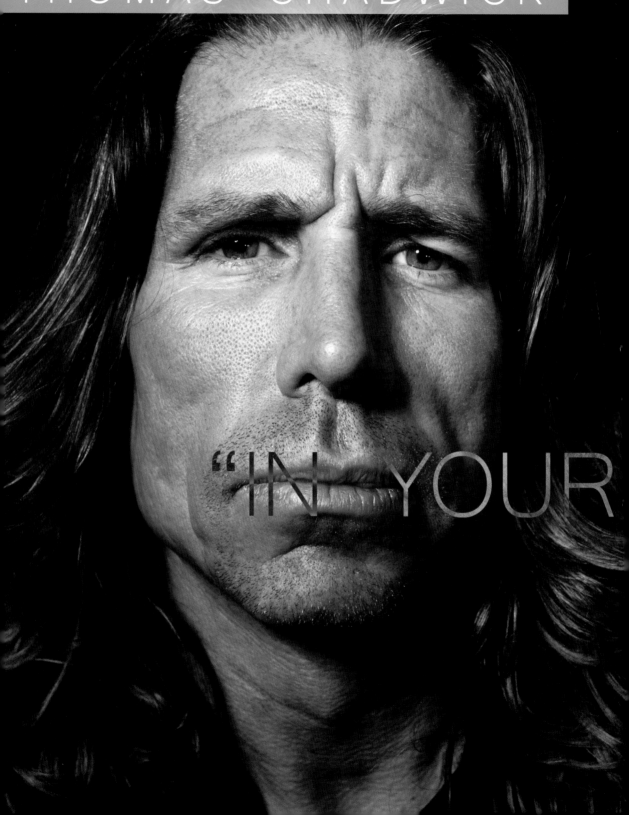

THOMAS CHADWICK

"IN YOUR

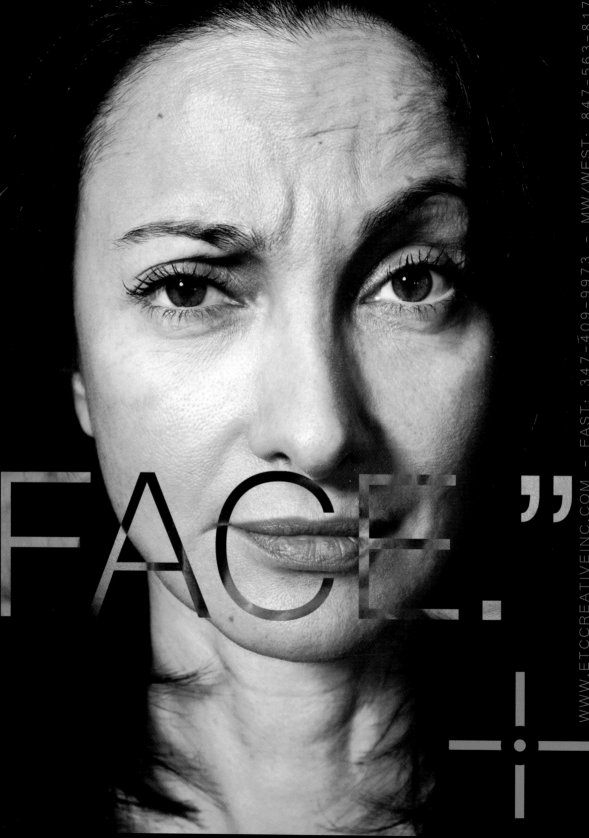

FACE."

WWW.ETCCREATIVEINC.COM - EAST: 347-409-9973 - MW/WEST: 847-563-817

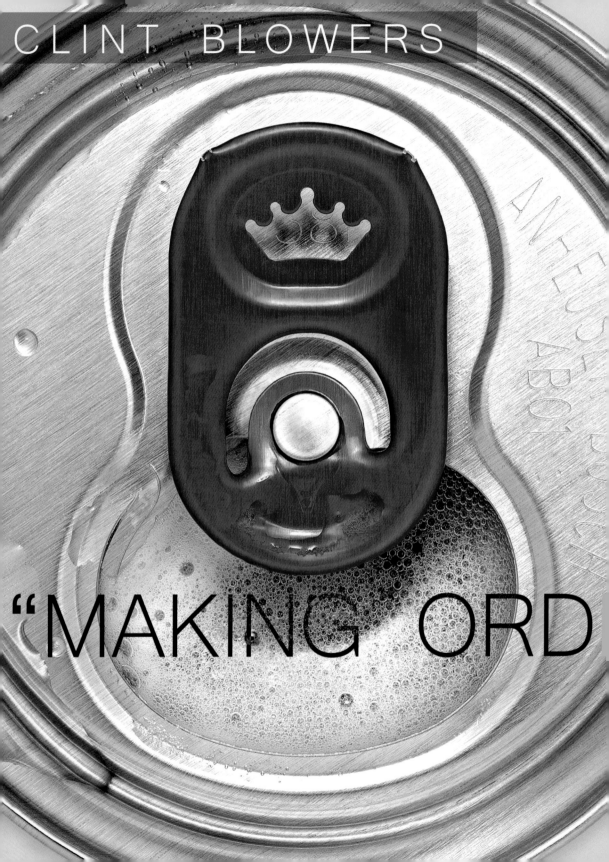

ARY BADASS"

PASSION

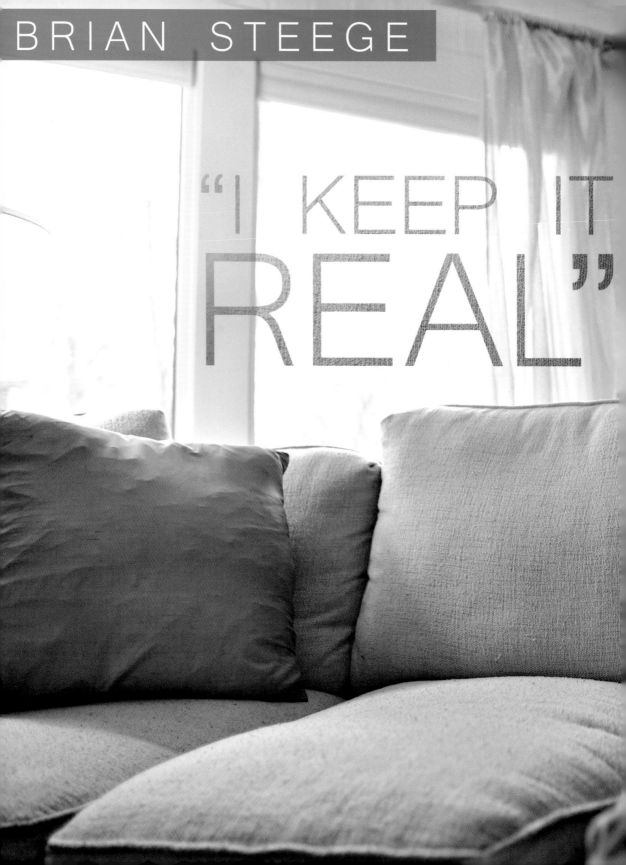

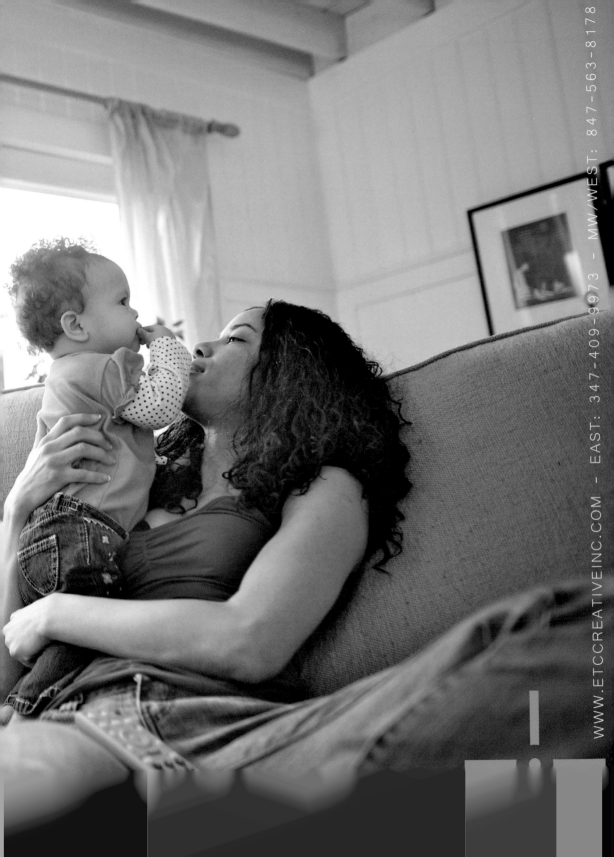

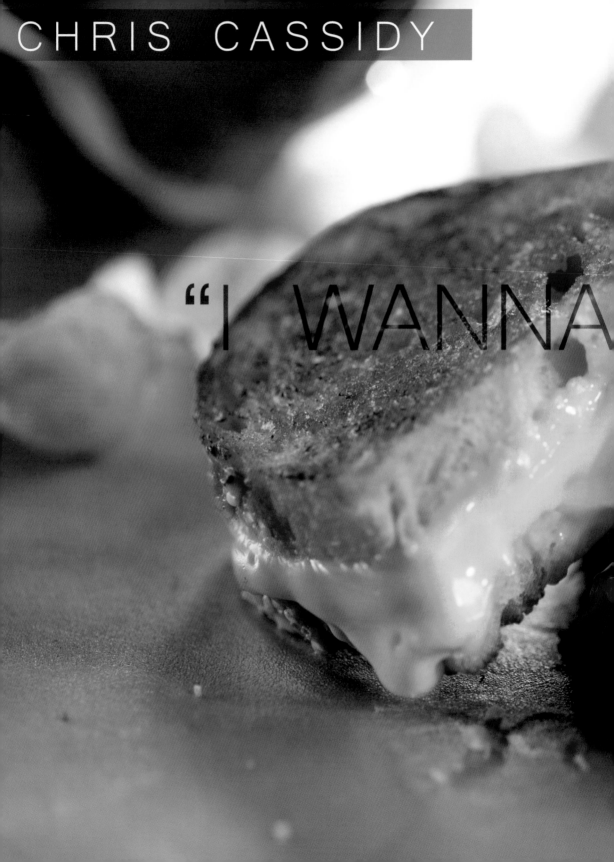

CHRIS CASSIDY

"I WANNA

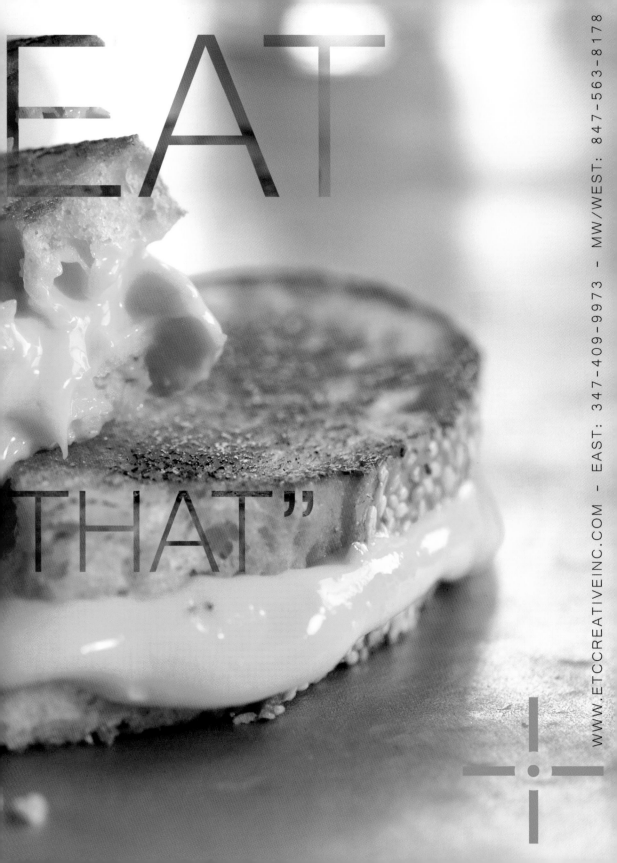

EAT

"THAT"

WWW.ETCCREATIVEINC.COM – EAST: 347-409-9973 – MW/WEST: 847-563-8178

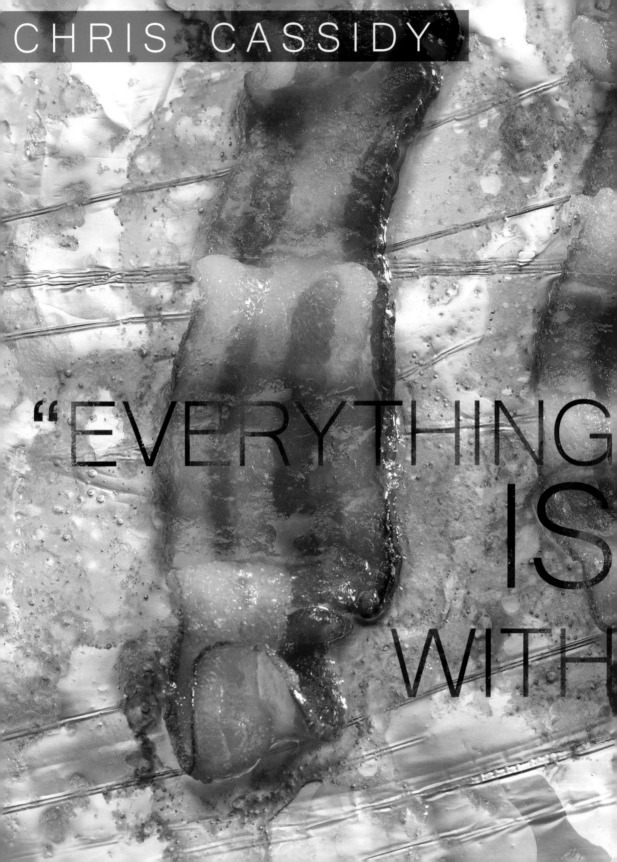

"EVERYTHING

IS

WITH

BETTER BACON"

WWW.ETCCREATIVEINC.COM – EAST: 347-409-9973 – MW/WEST: 847-563-8178

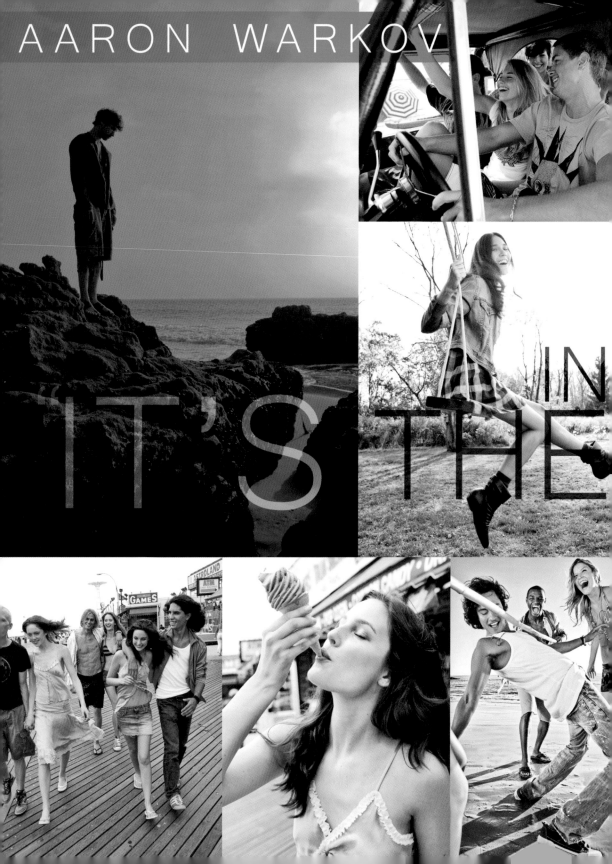

AARON WARKOV

"IT'S

IN THE

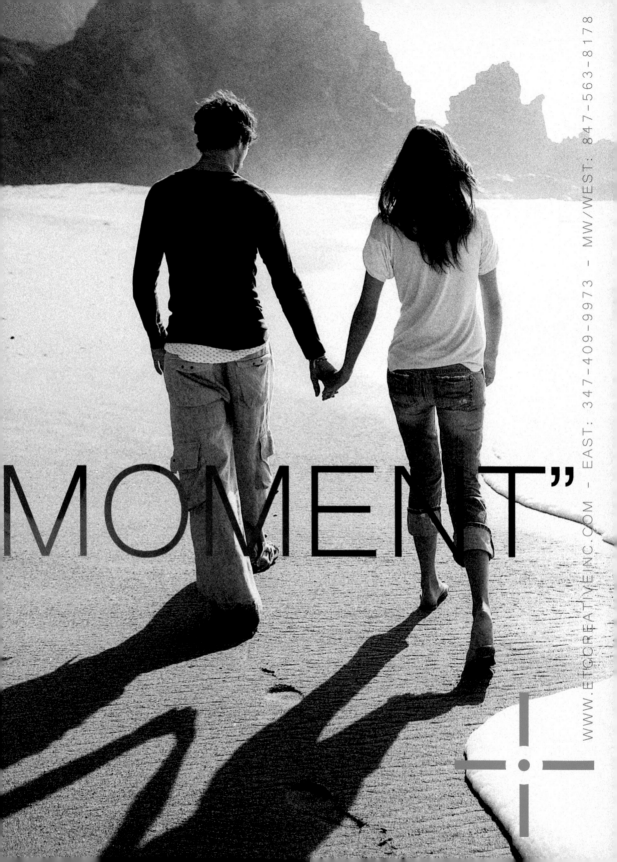

MOMENT"

"I'M 93% RODEO CLOWN,

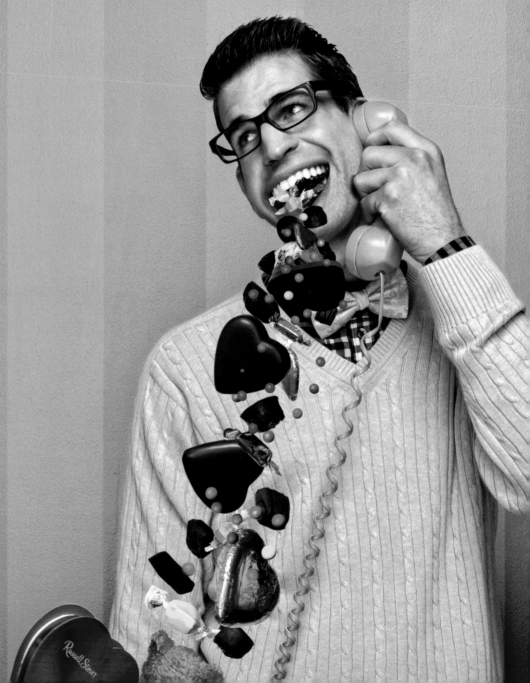

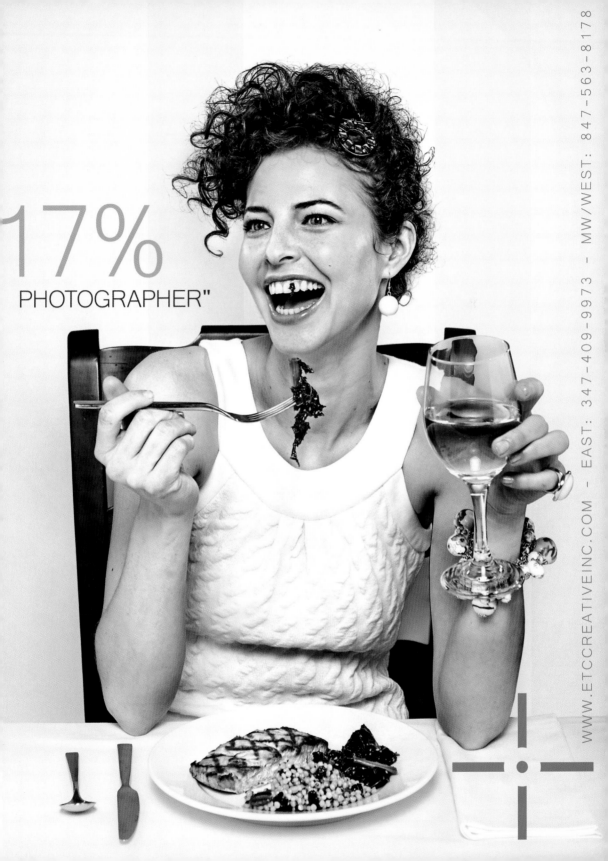

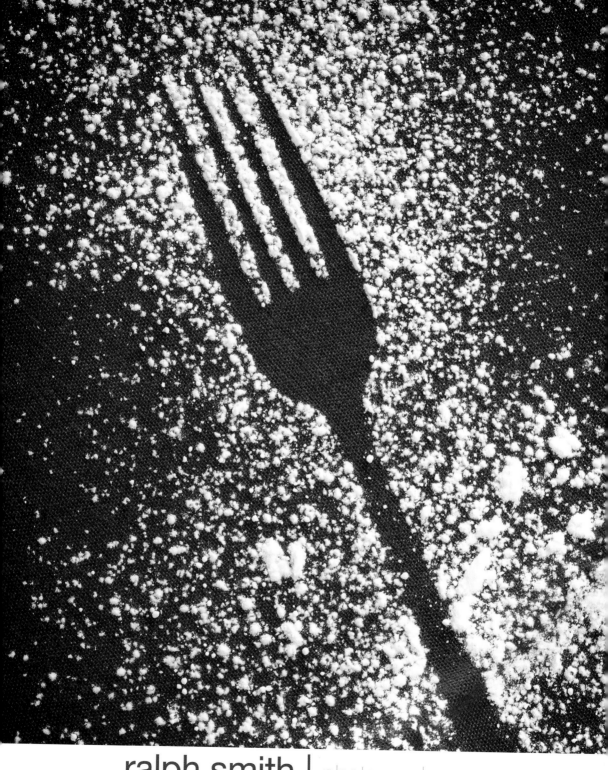

ralph smith | photographer

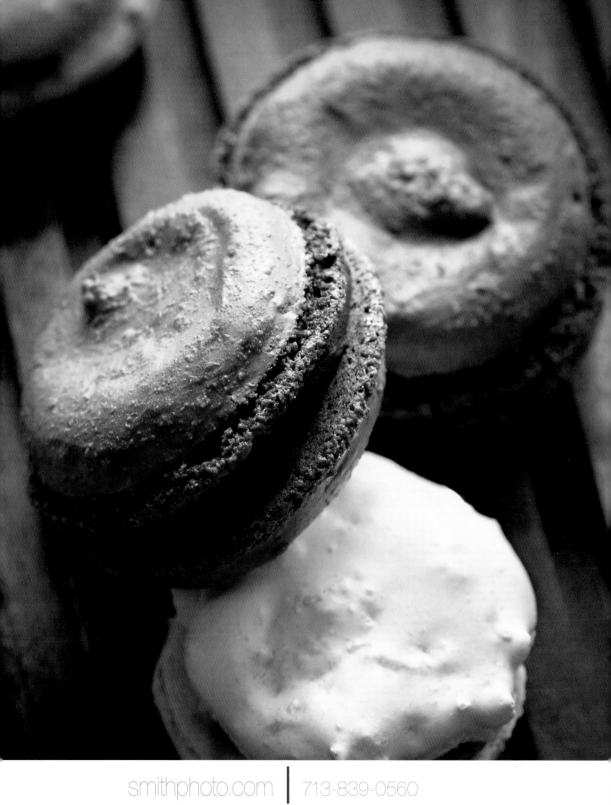

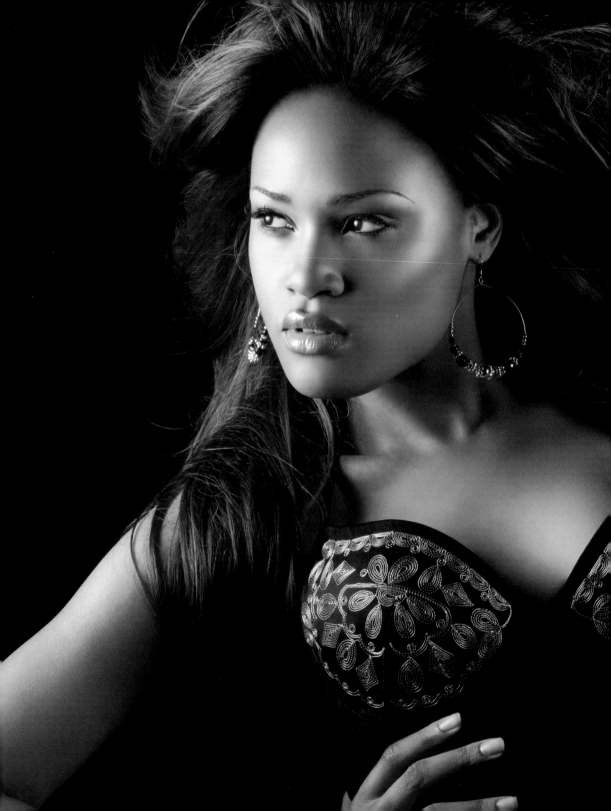

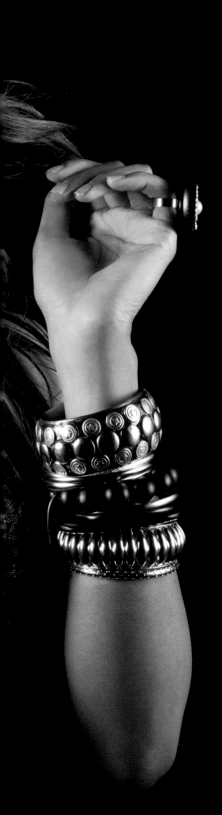

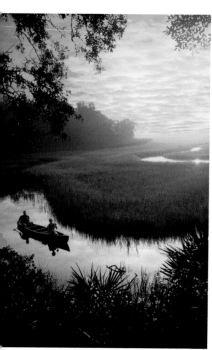
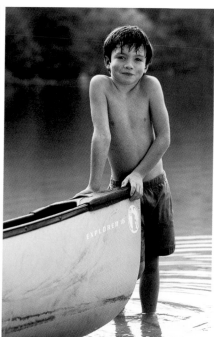
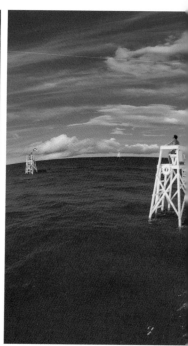

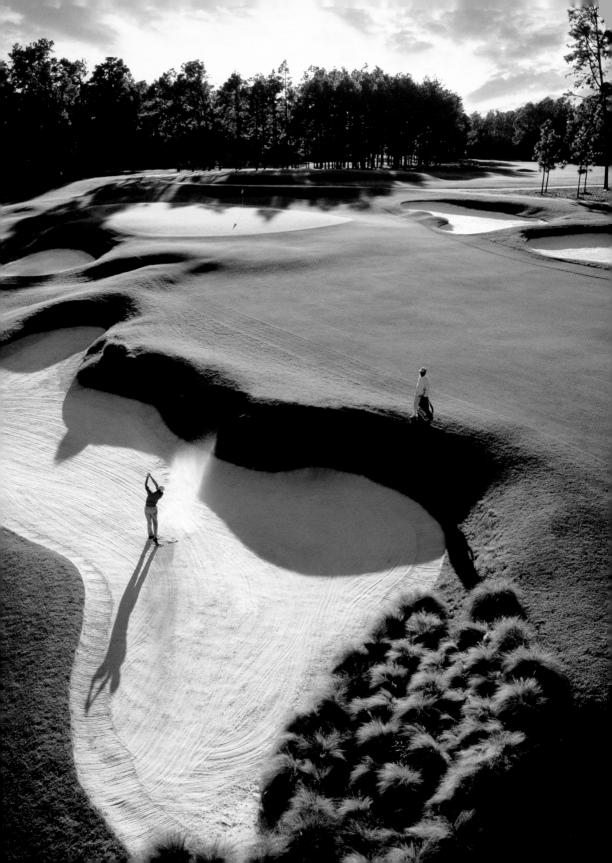

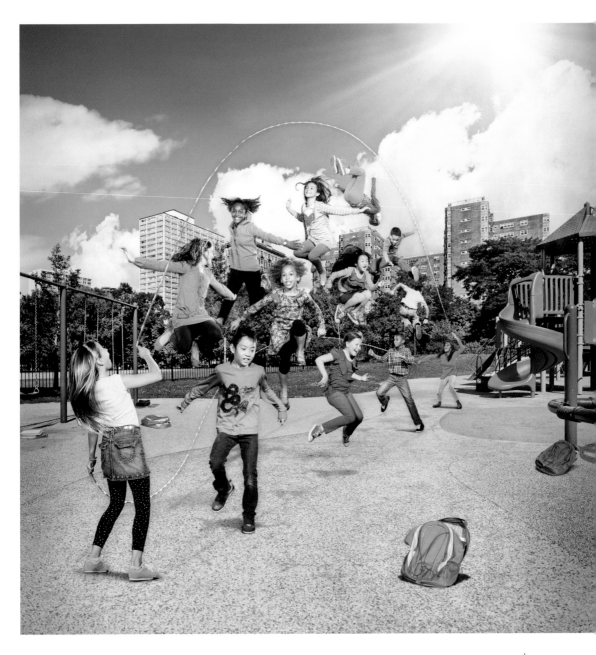

Sean Williams
312.421.0100
seanwill.com

S/W

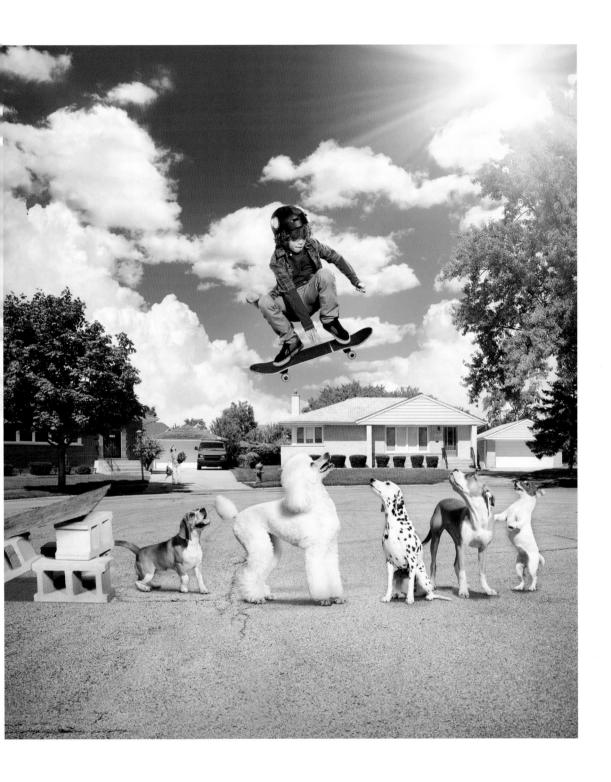

emissary

photography
WINKLER + NOAH
TIM TADDER
MARK LUINENBURG
DAVE JORDANO
DAN GOLDBERG

illustration
PAUL SOMERS
KEVIN SOMERS

LIZ BAUGHER
EMISSARYARTISTS.COM
773.489.9888

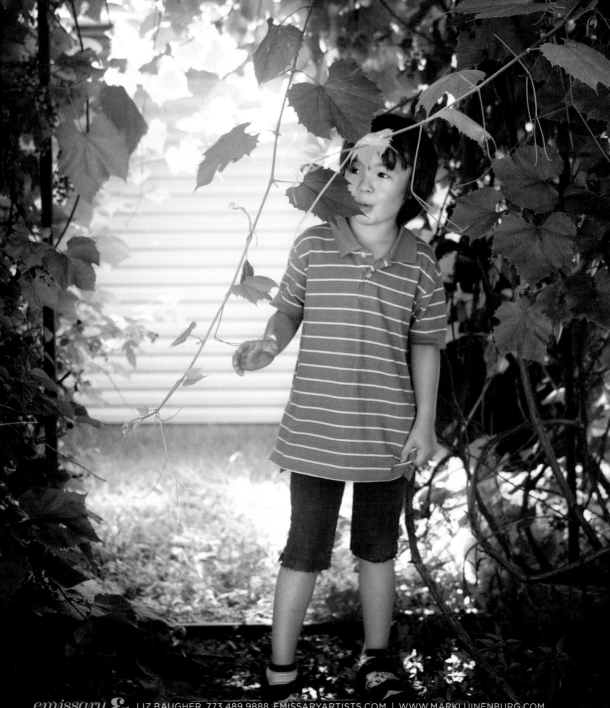

Mark Luinenburg

emissary & | LIZ BAUGHER 773.489.9888 EMISSARYARTISTS.COM | WWW.MARKLUINENBURG.COM

Dan Goldberg

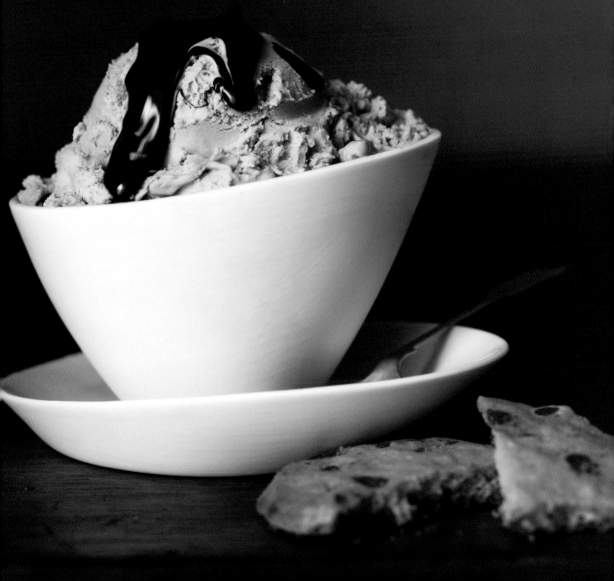

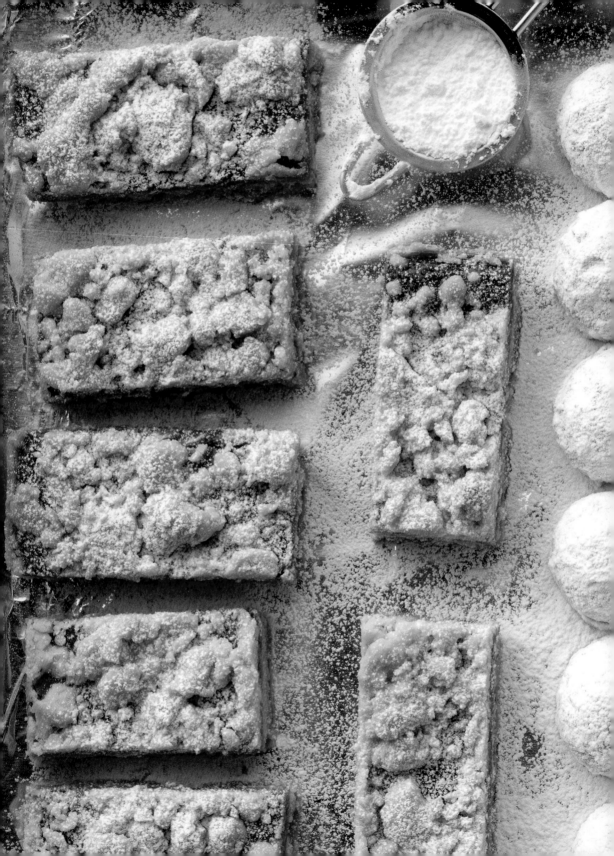

Dan Goldberg

emissary & LIZ BAUGHER 773.489.9888 EMISSARYARTISTS.COM | GOLDBERGPHOTOGRAPHY.COM

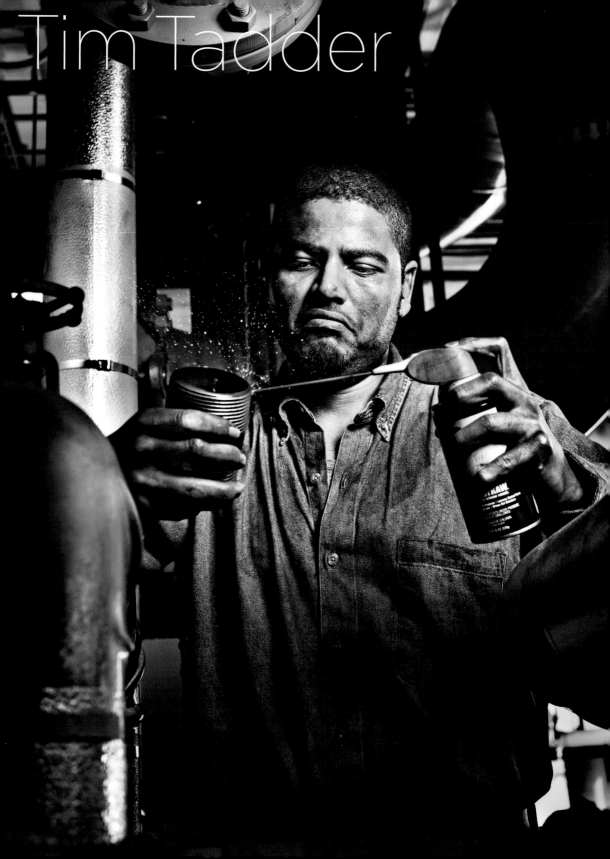

Tim Tadder

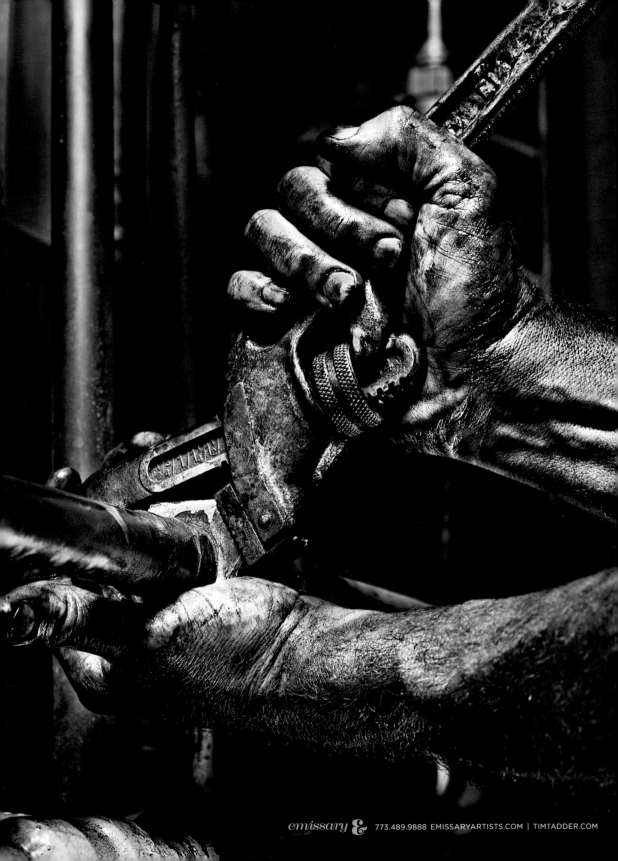

Winkler + Noah

emissary

photography
WINKLER + NOAH
TIM TADDER
MARK LUINENBURG
DAVE JORDANO
DAN GOLDBERG

illustration
PAUL SOMERS
KEVIN SOMERS

LIZ BAUGHER
EMISSARYARTISTS.COM
773.489.9888

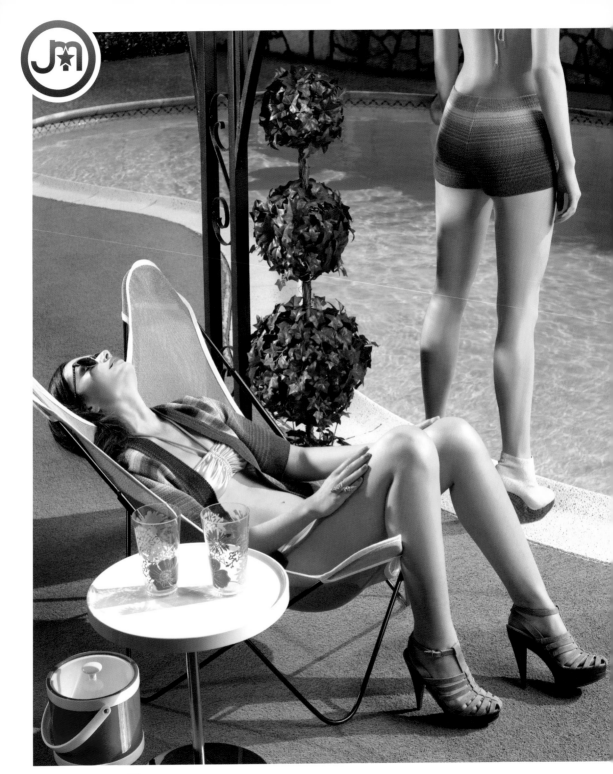

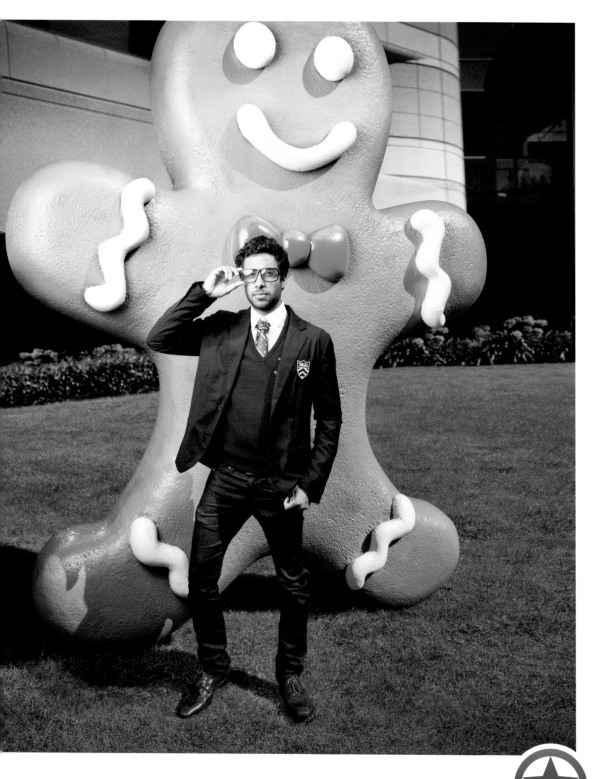

DENNIS WELSH

PHOTOGRAPHY and MOTION WWW.DENNISWELSH.COM (207) 846-1130

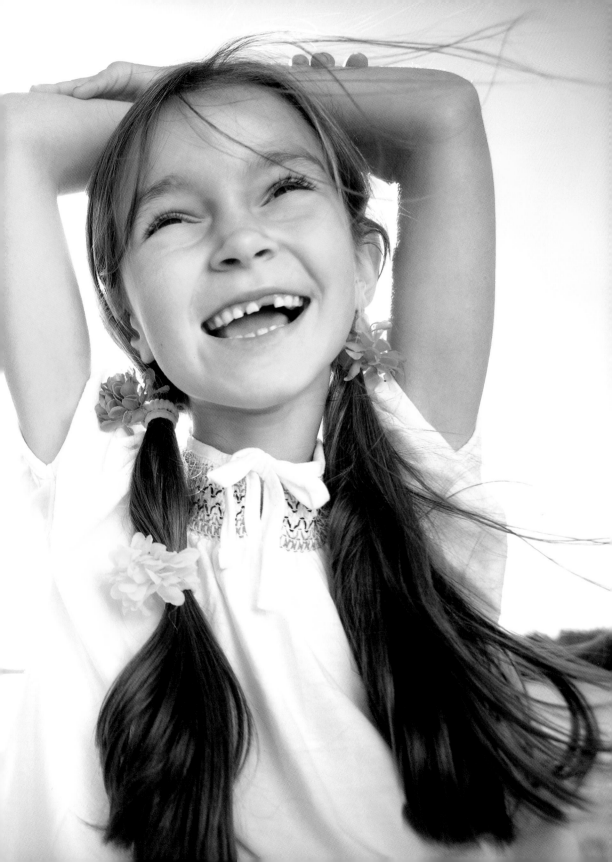

SANDRO

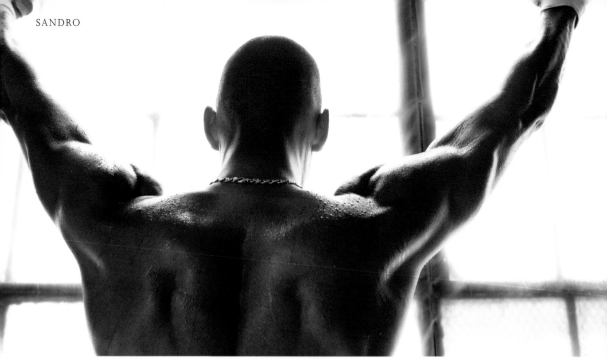

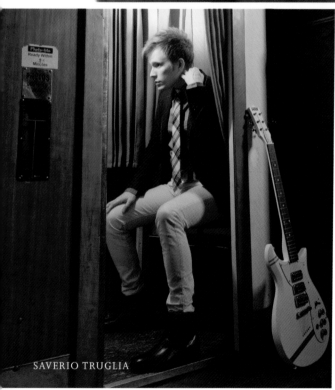

SAVERIO TRUGLIA

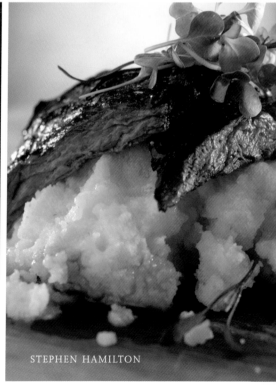

STEPHEN HAMILTON

S|&|C

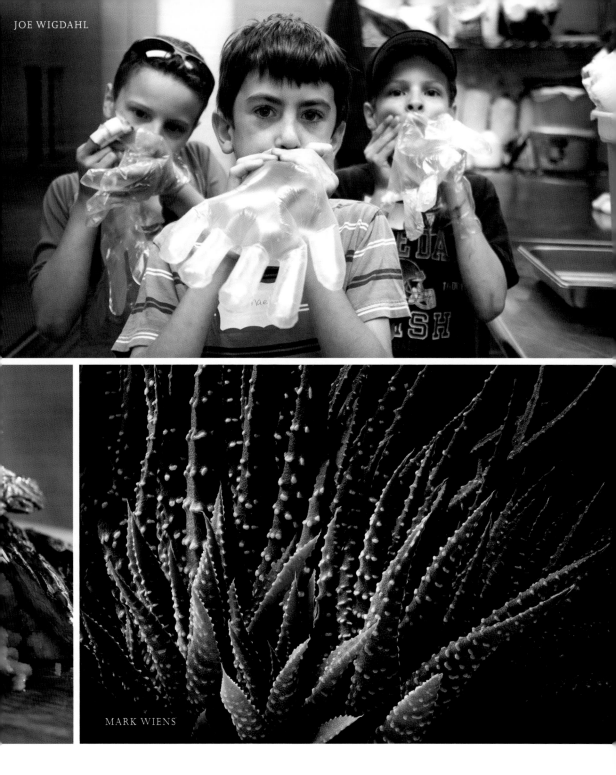

JOE WIGDAHL

MARK WIENS

schumann & company / 312.925.1530 / www.schumannco.com

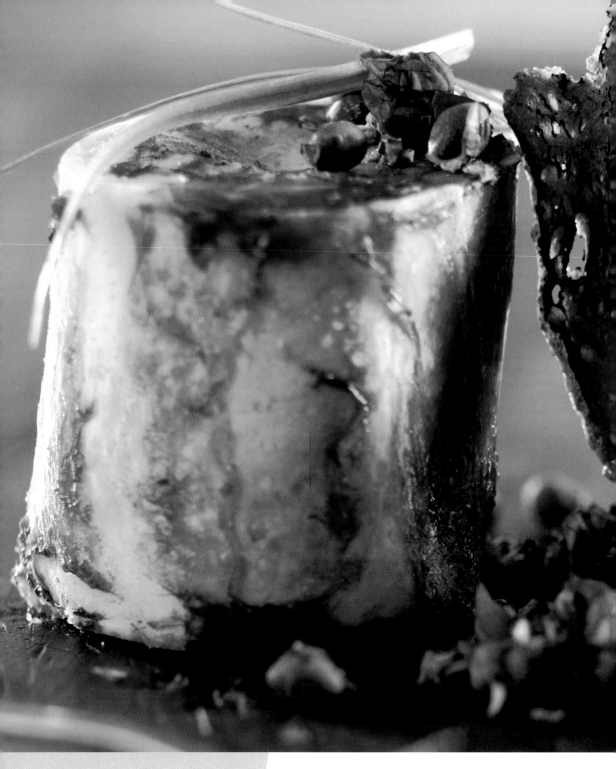

S|&|C STEPHEN HAMILTON

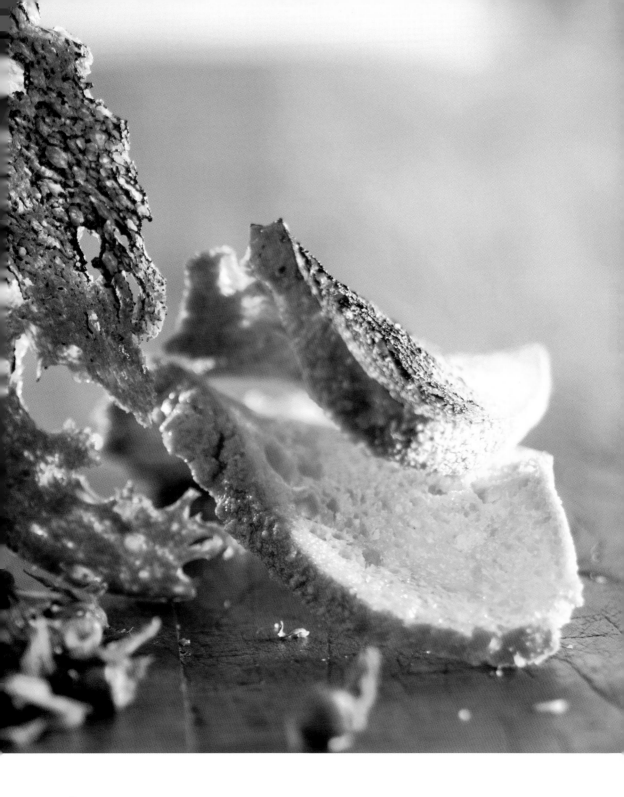

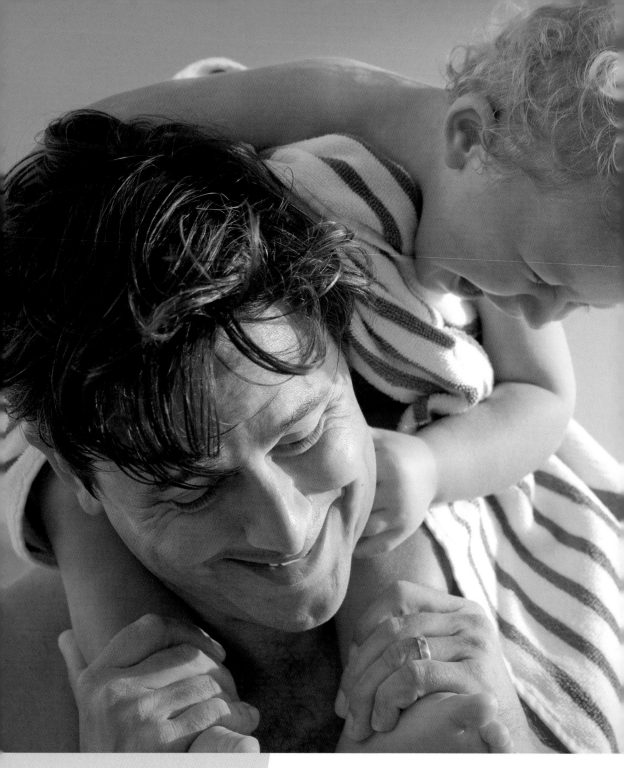

S|&|C

TERRY VINE

schumann & company / 312.925.1530 / www.schumannco.com

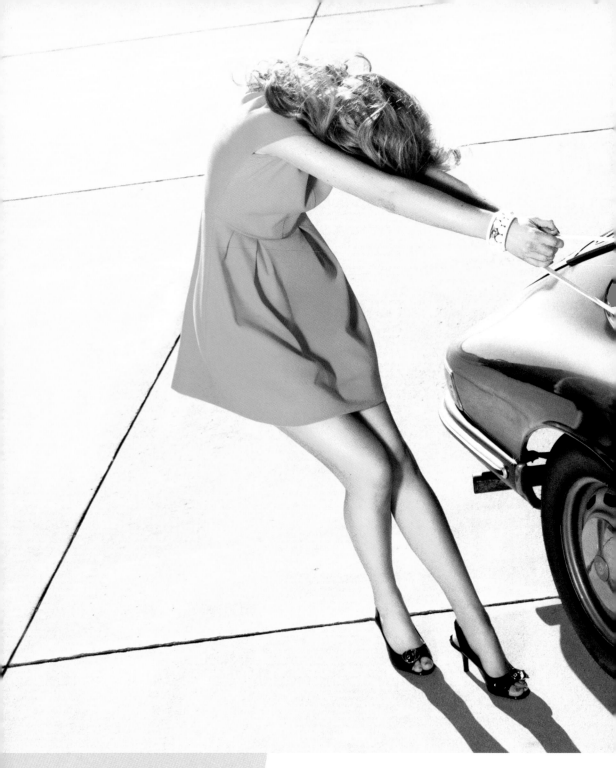

S|&|C SAVERIO TRUGLIA

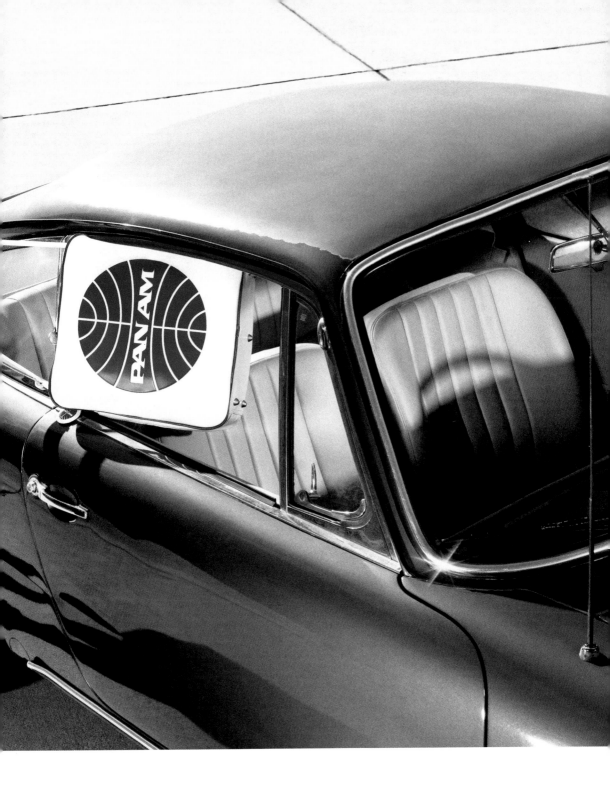

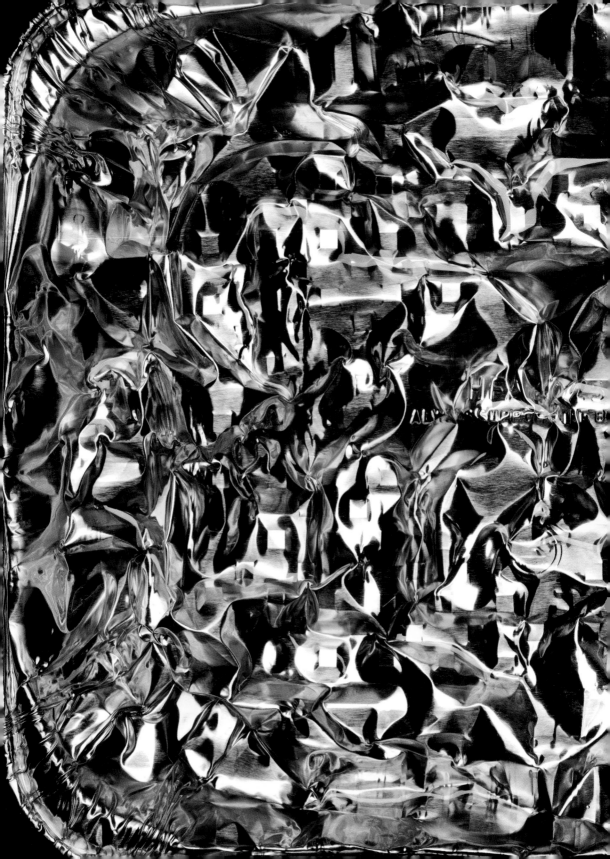

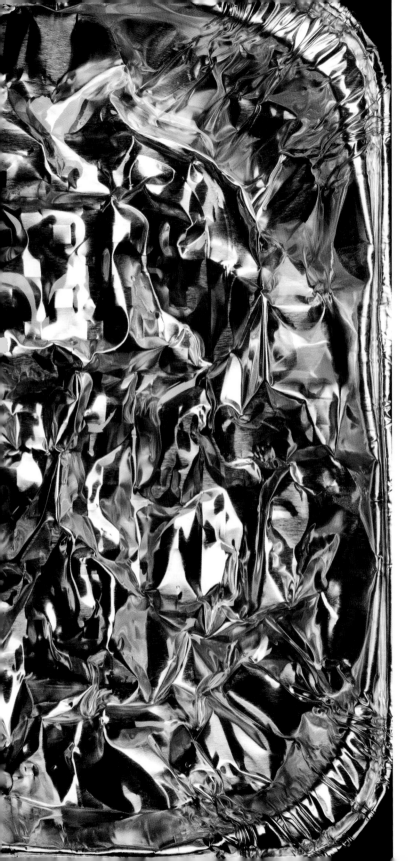

S / & / C

MARK WIENS

schumann & company / 312.925.1530 / www.schumannco.com

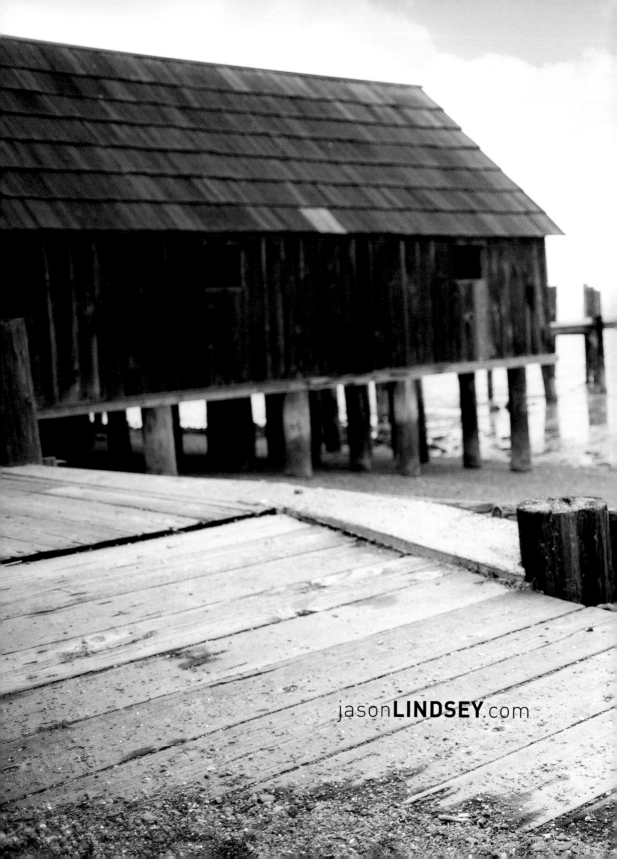

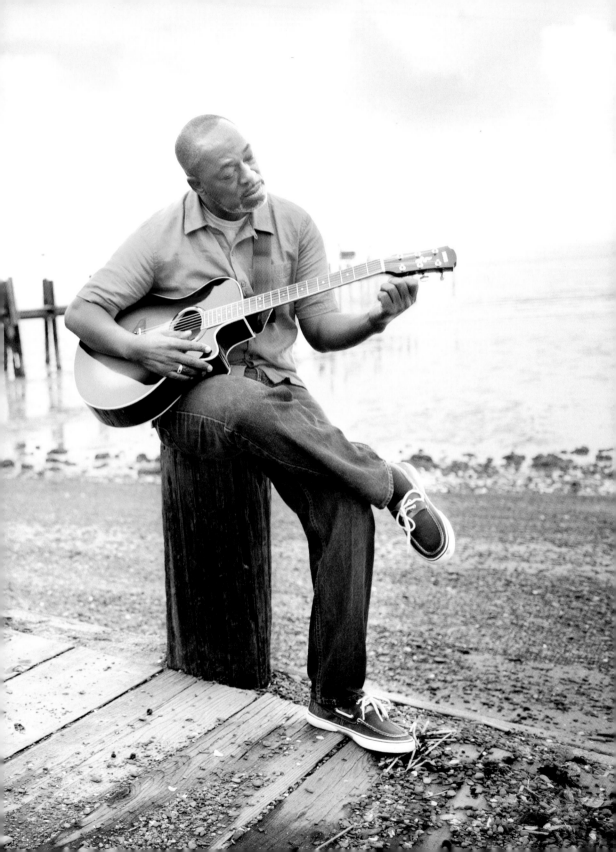

jason**LINDSEY**.com

DIRECTOR and PHOTOGRAPHER | 800-898-7617

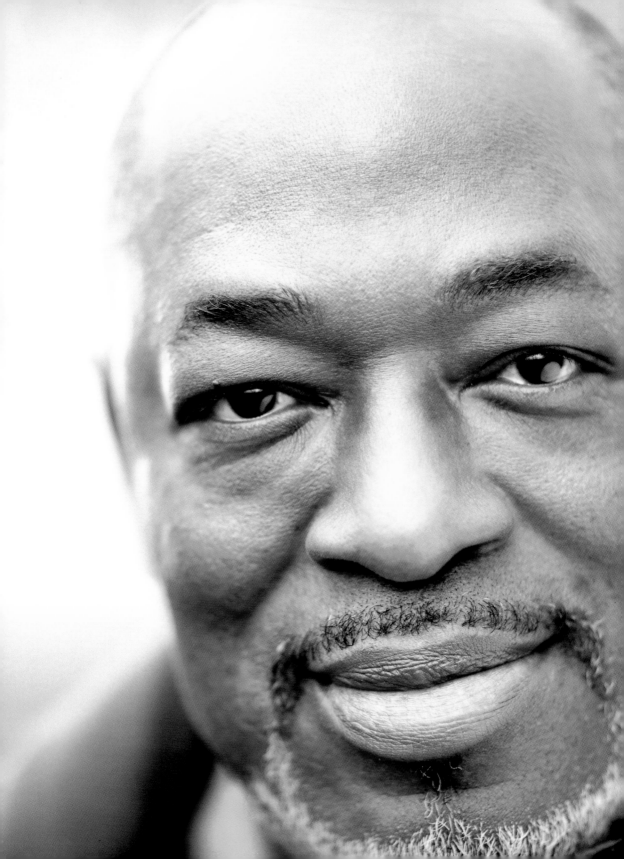

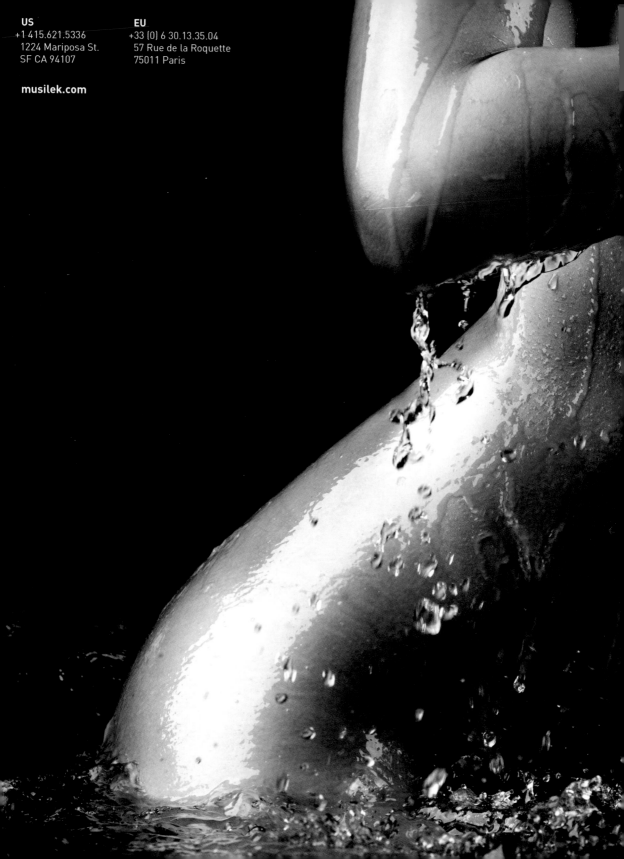

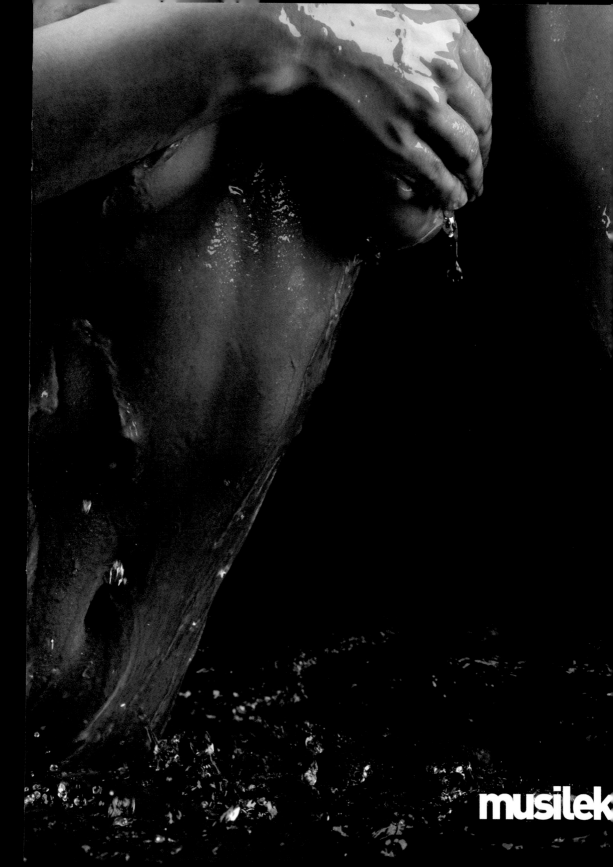

musilek

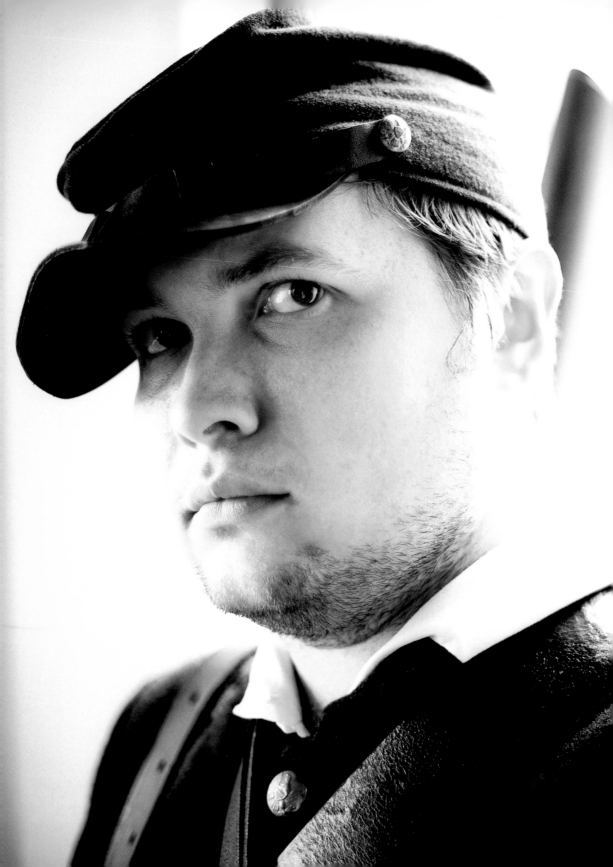

LÜNING/PHOTO

luningphoto.com 312.953.0869

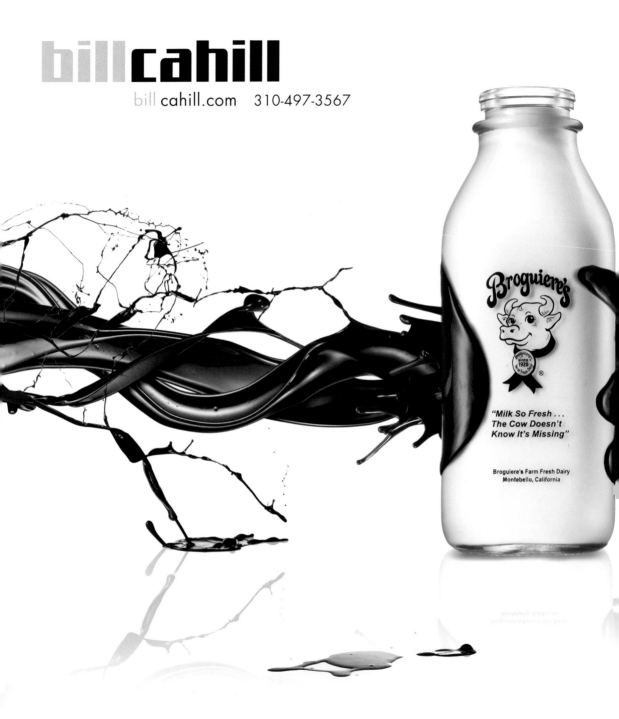

billcahill

billcahill.com 310-497-3567

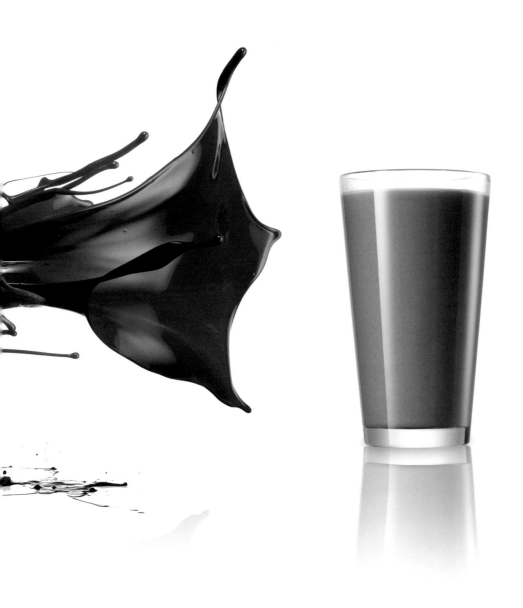

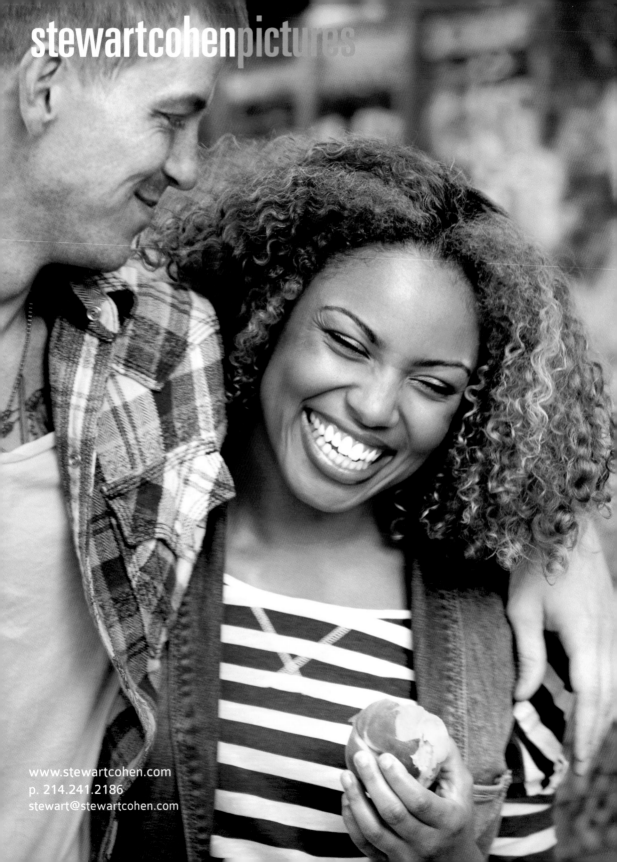

stewartcohen**pictures**

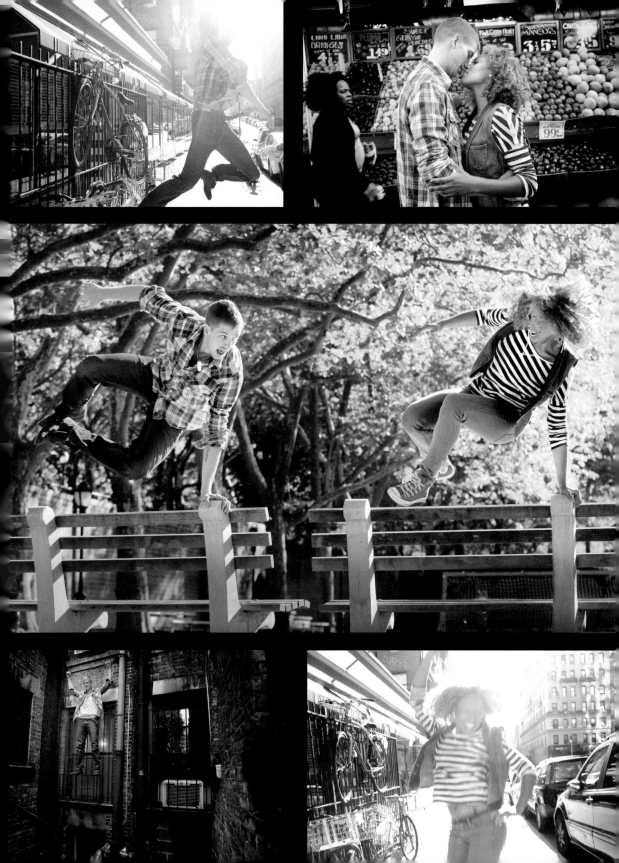

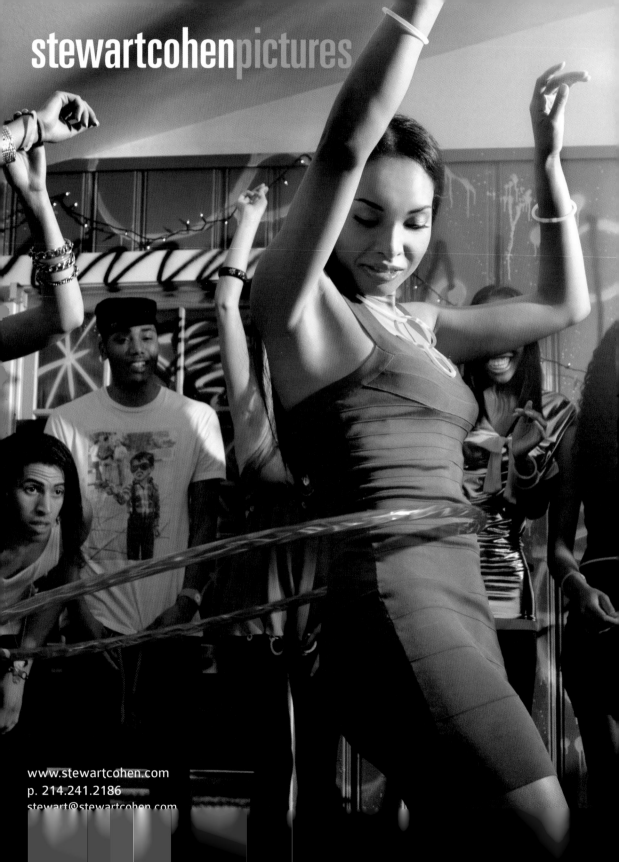

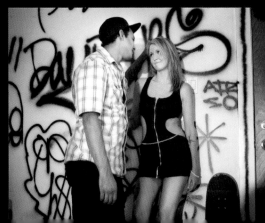

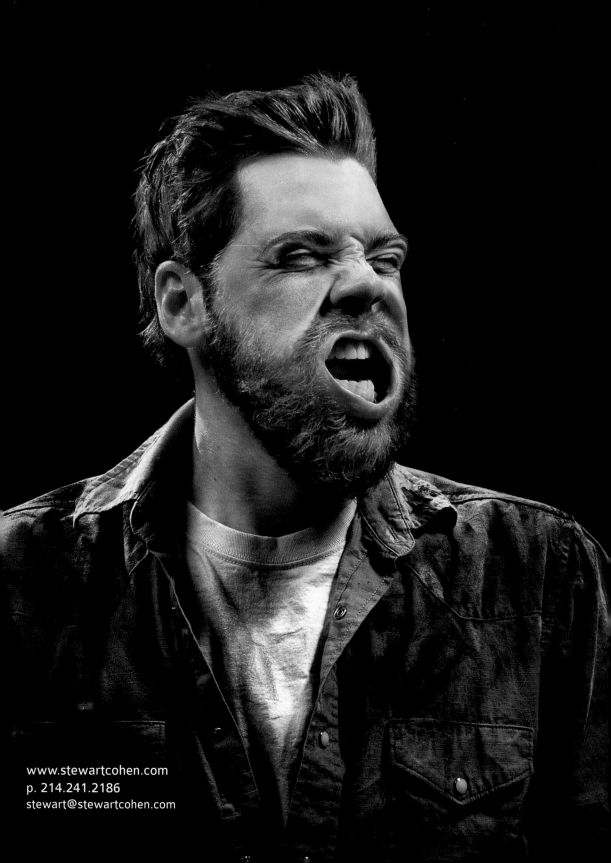

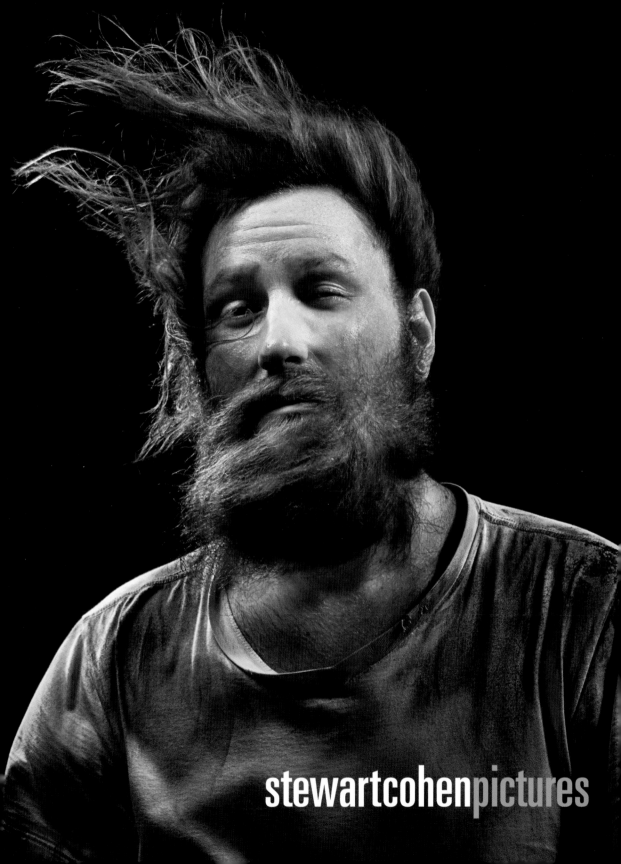

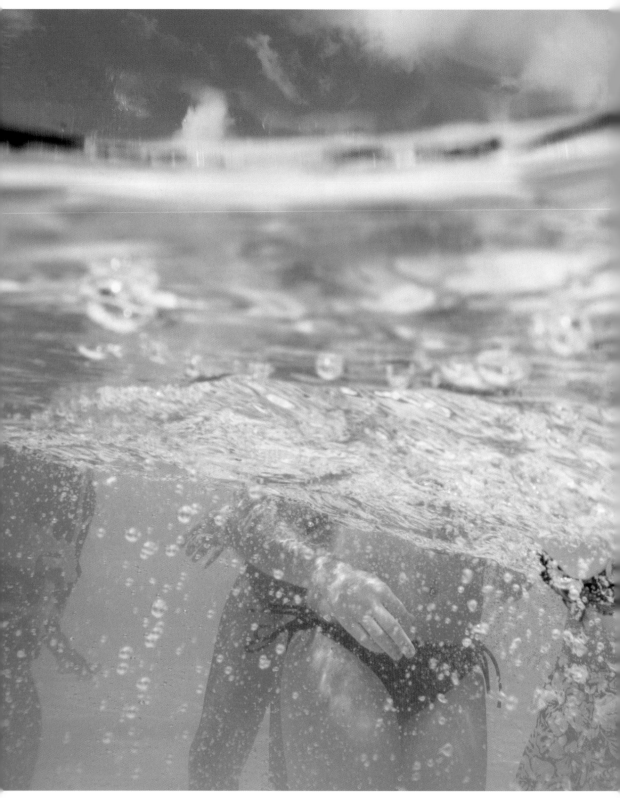

STEVE
LESNICK

PHOTOGRAPHY

stevelesnick.com
agent:dougtruppe.com

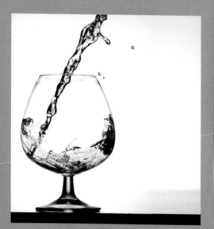

Henrique Bagulho

Sue Barr

David Bishop

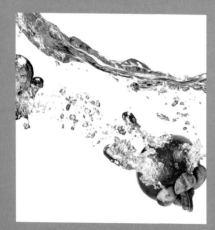

Kan Nakai

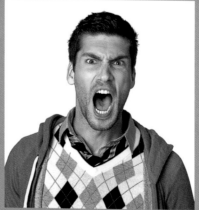

Robert Randall

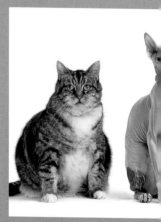

Gandee Vasan

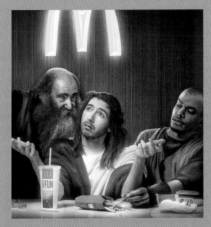

Clor

Darrell Eager

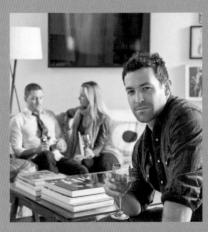

Michael Weschler

Bret Wills

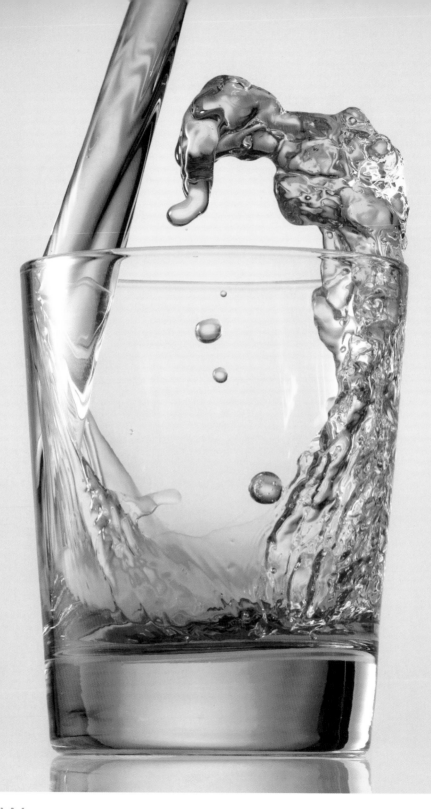

WSW creative 212-431-4480 | wswcreative.com | henriquebagulho.com

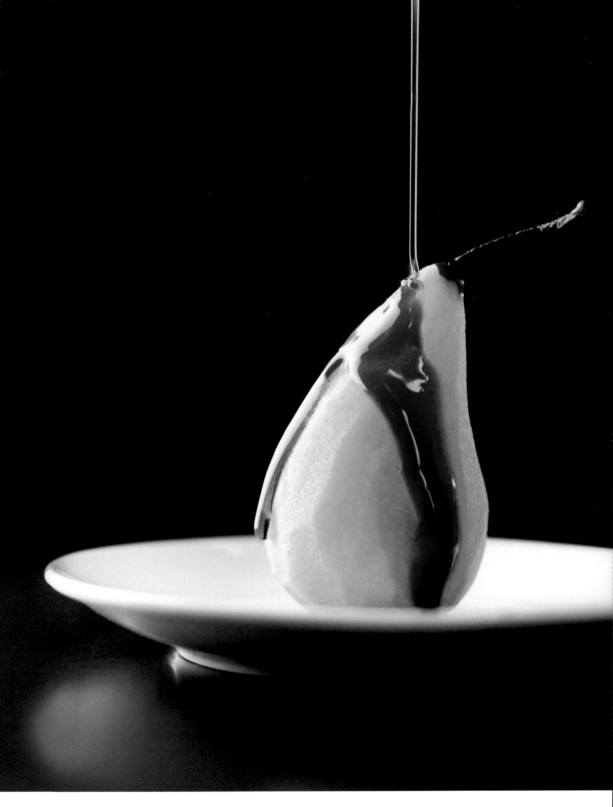

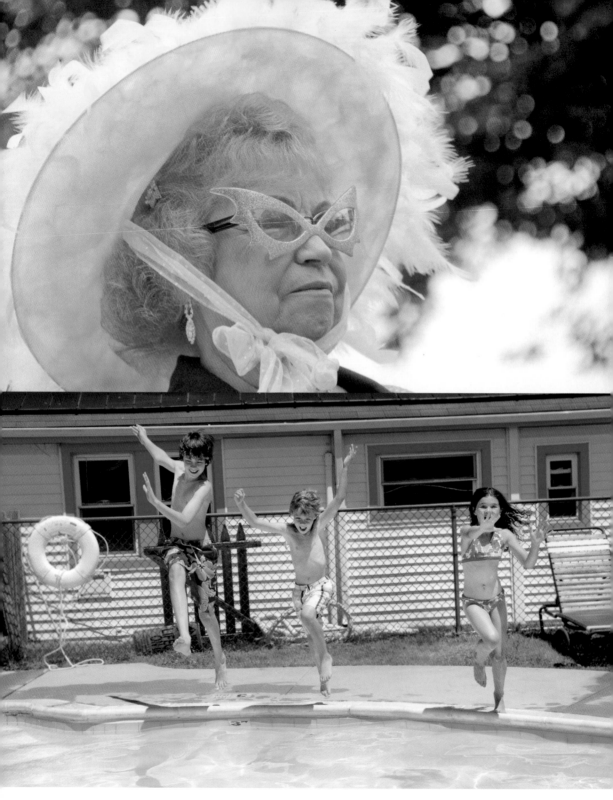

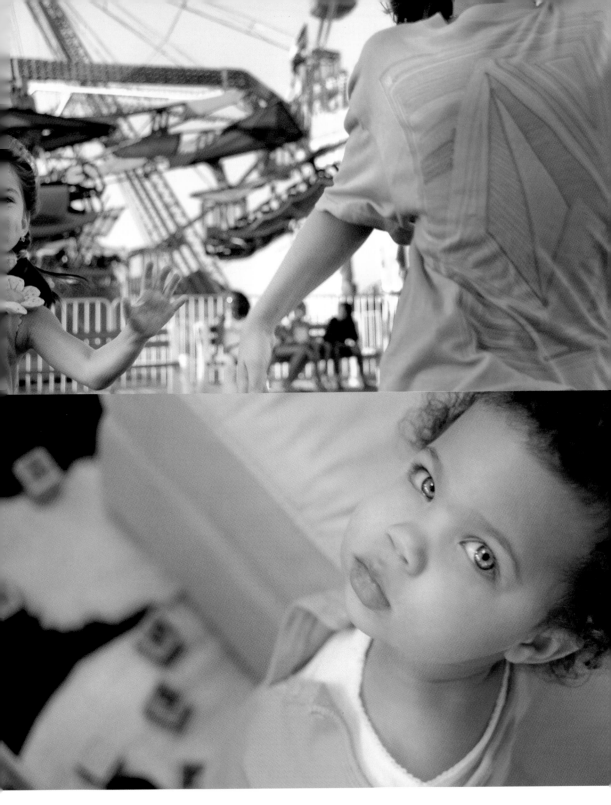

SUE BARR

DAVID BISHOP

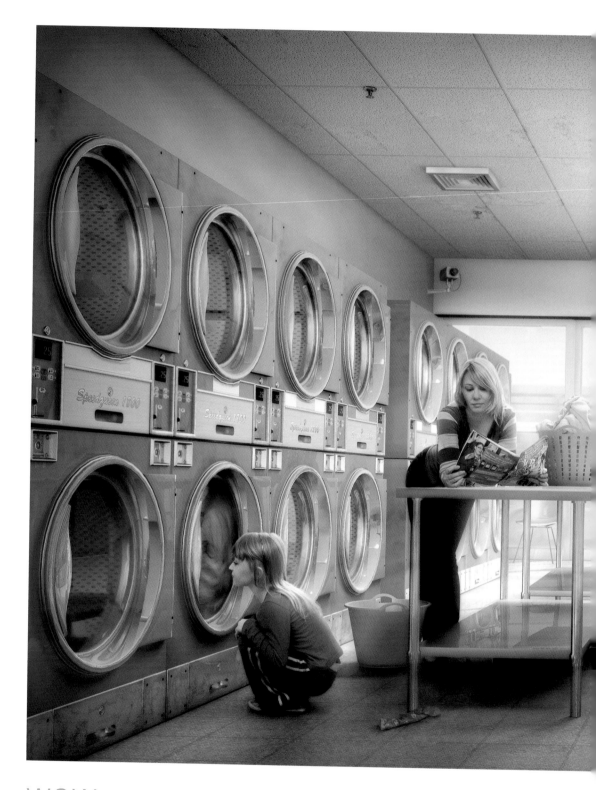

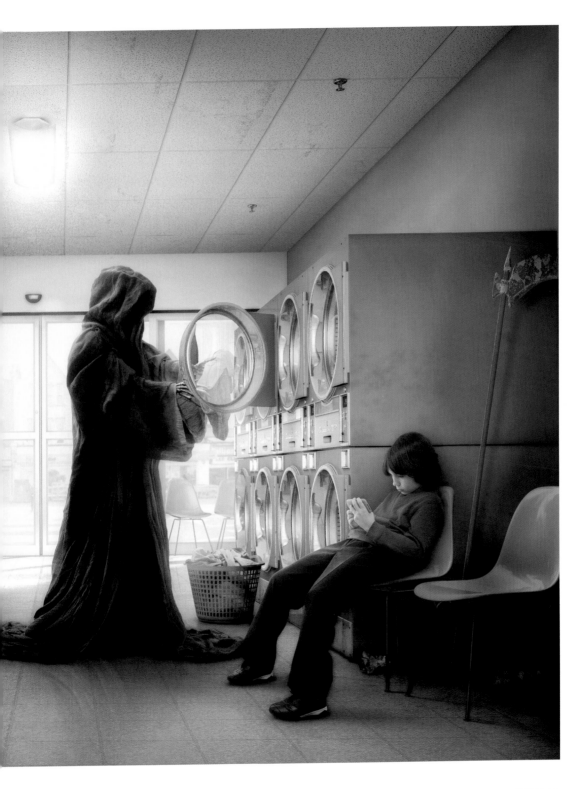

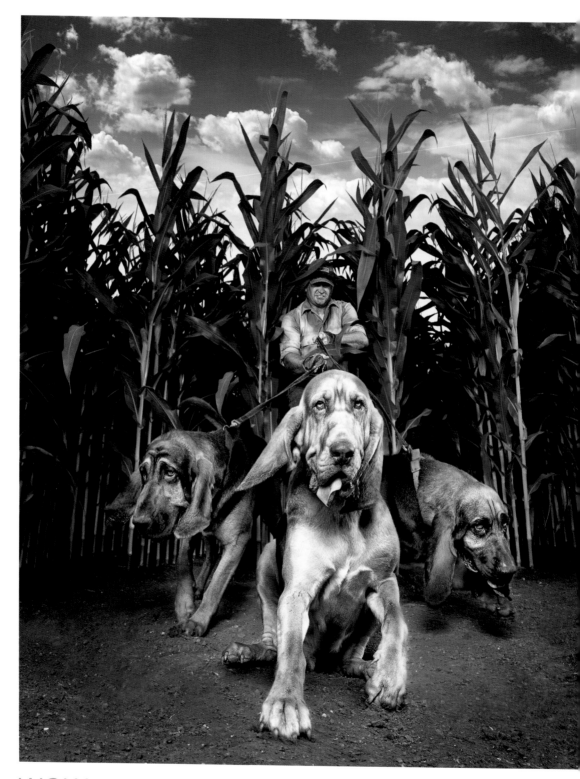

WSW East: Represented by WSW Creative | 212-431-4480 | robert-randall.co

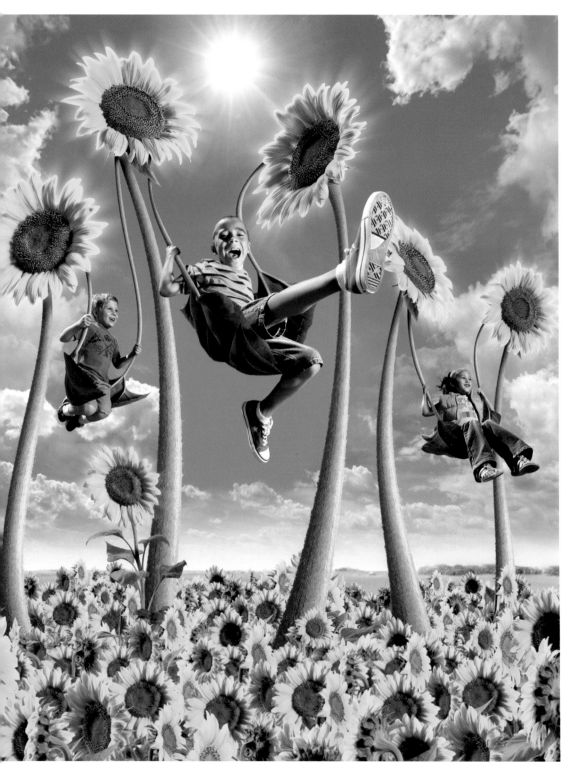

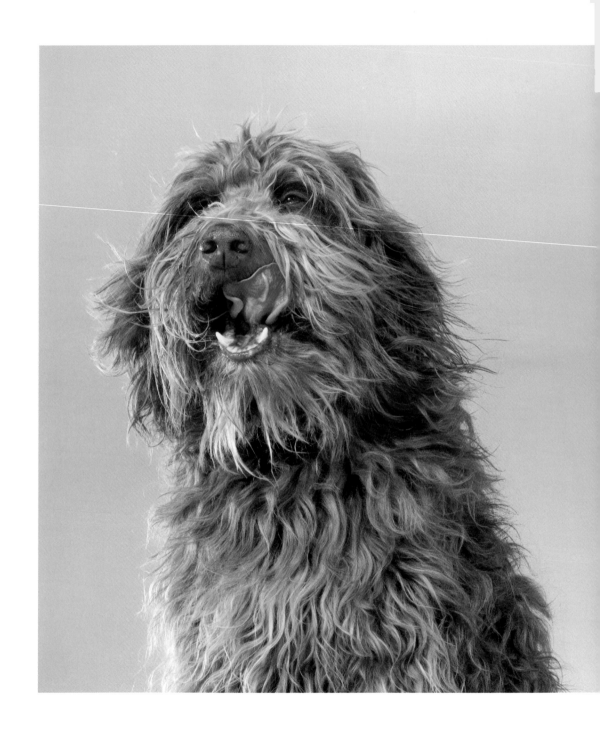

WS+W creative 212-431-4480 | wswcreative.com | gandeevasan.com

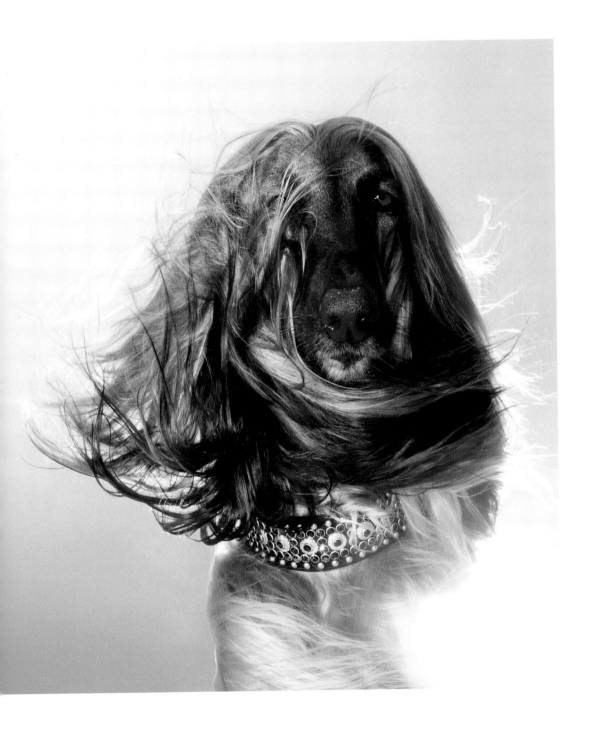

GANDEE VASAN

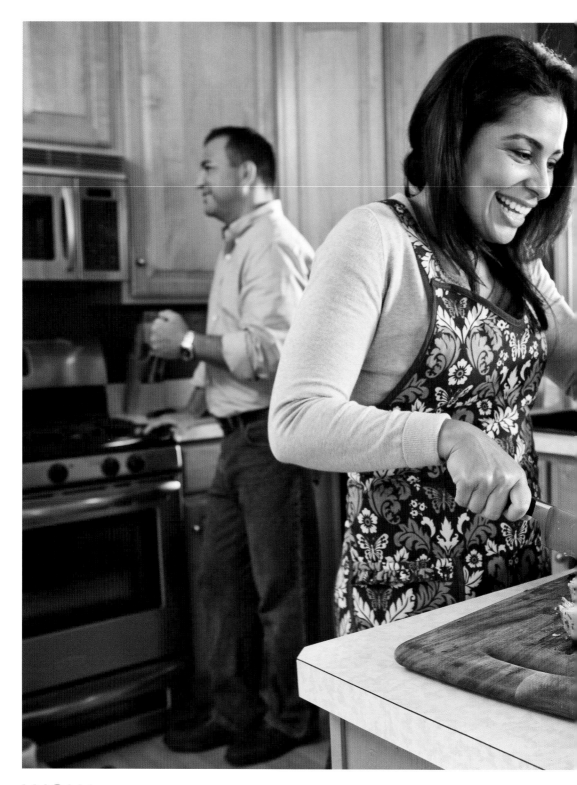

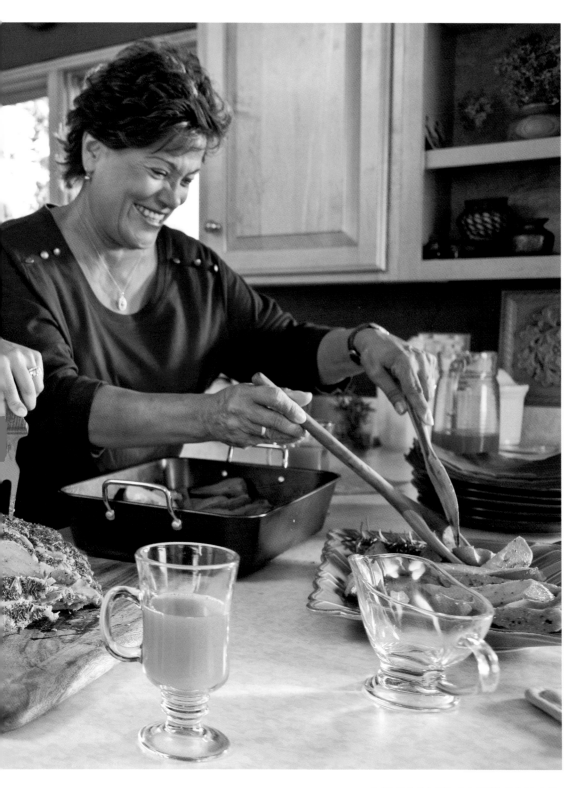

MICHAEL WESCHLER

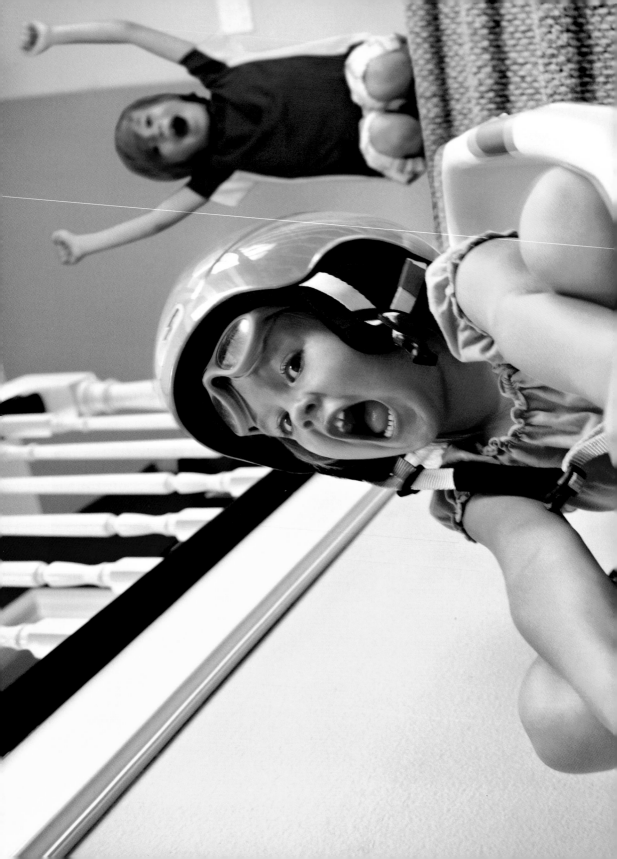

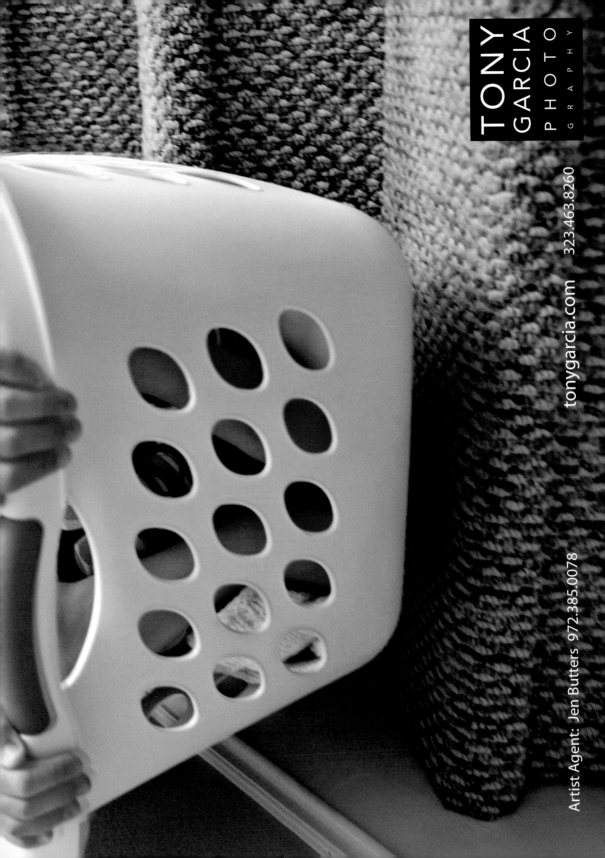

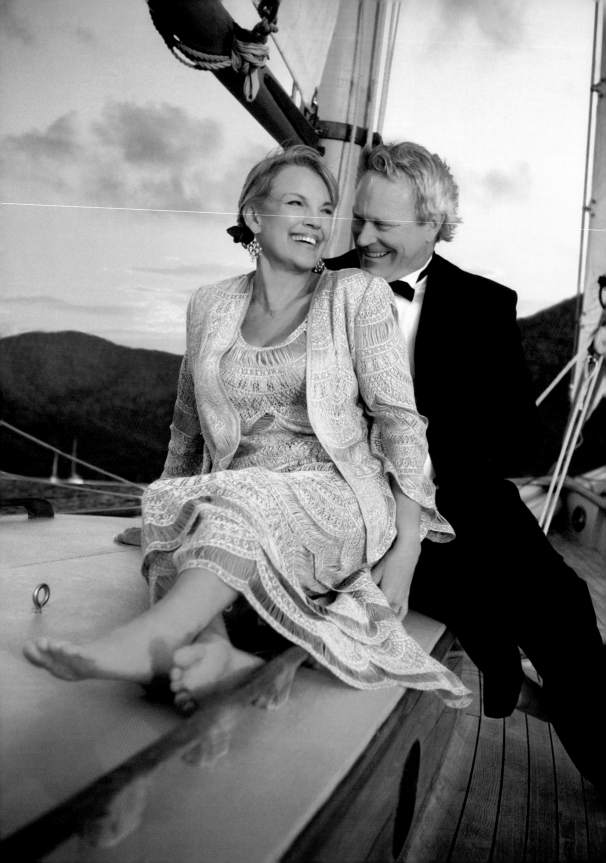

JIMMY WILLIAMS

PHOTOGRAPHY

Life

Luxe

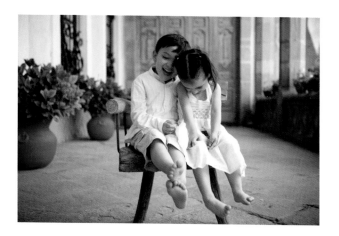

Faces

Places

www.JimmyWilliamsPhotography.com

919-832-5971

M REPRESENTS, INC. 212 840 8100

ACT TWO|UM/CGI & Retouching JIM HUIBREGTSE/Still Life & Liquids
ALICE BLUE/CGI & Illustration GARY SALTER/Conceptual & Humor
JENNY RISHER/Beauty, Fashion, & Portrait JULIE GANG/Kids-Babies
DENIS WAUGH/Locations & People RAY MASSEY/Liquids-Splash
JAMES PORTO/Photo-Illustration CONRAD PIEPENBURG/Automotive
FERNANDO MILANI/Beauty-Hair, Skin & Body/MREPRESENTS.COM

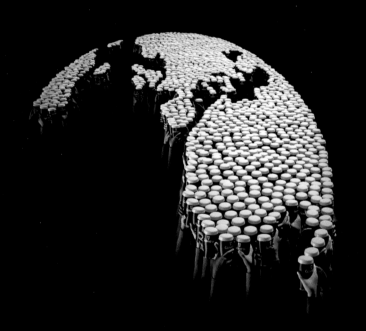

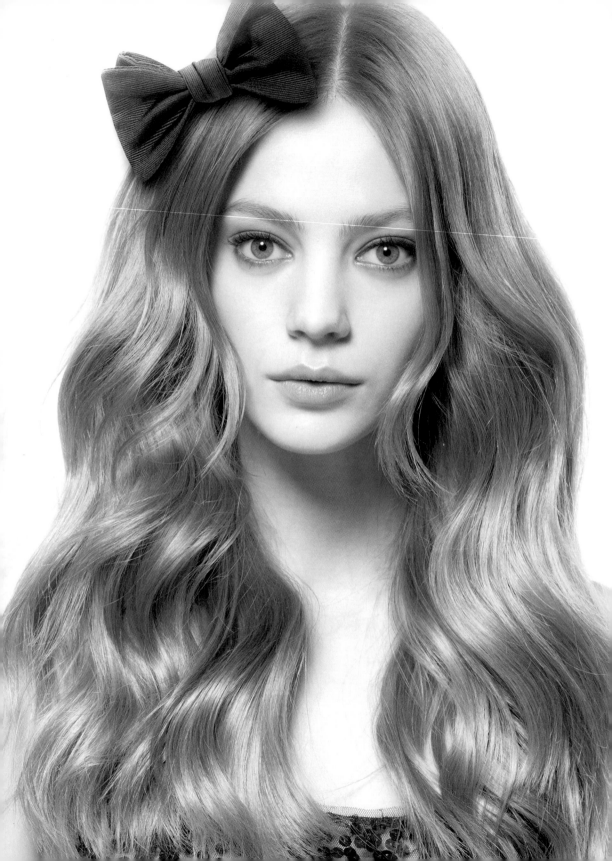

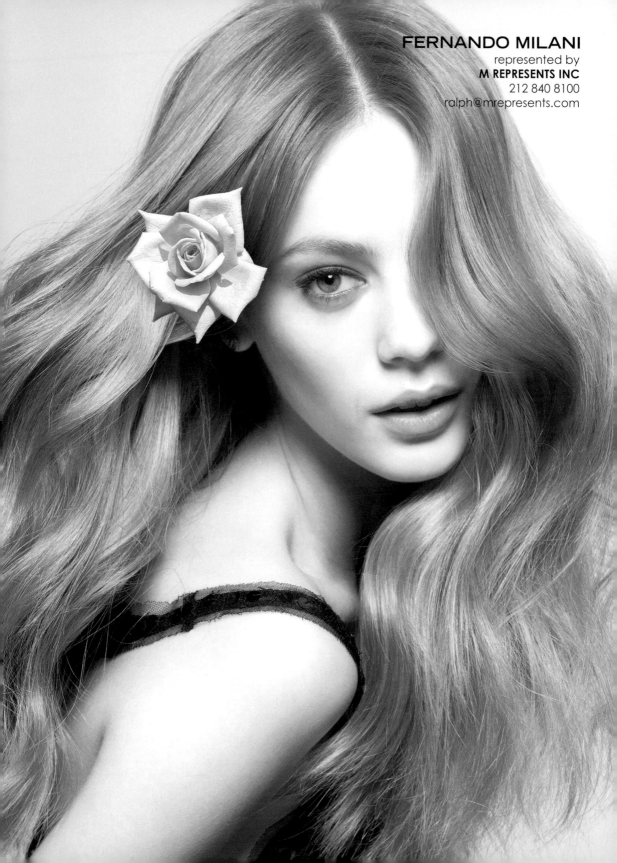

FERNANDO MILANI
represented by
M REPRESENTS INC
212 840 8100
ralph@mrepresents.com

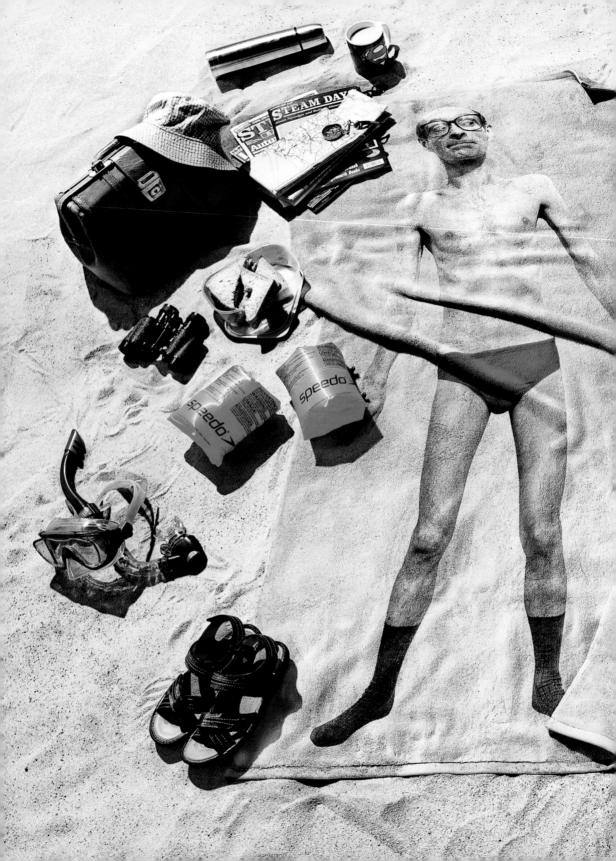

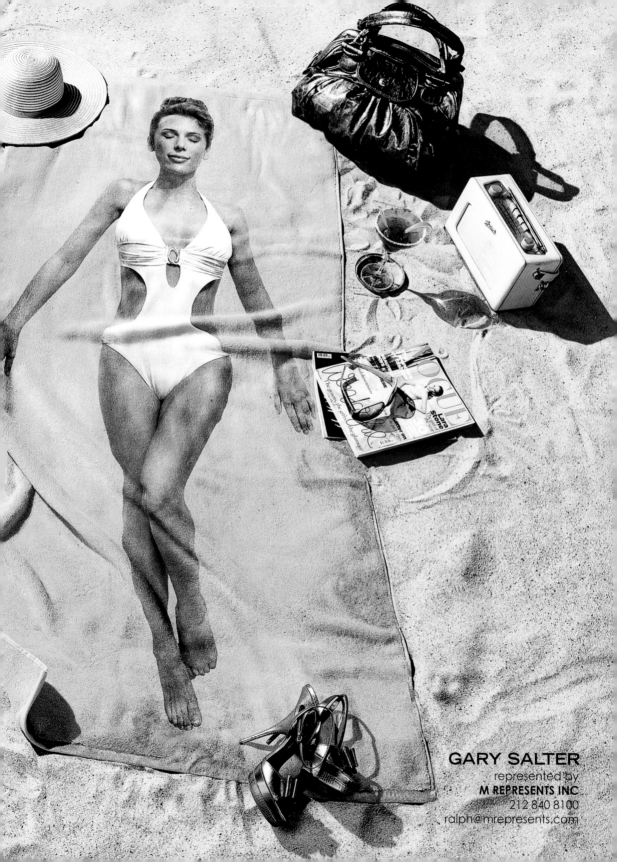

GARY SALTER
represented by
M REPRESENTS INC
212 840 8100
ralph@mrepresents.com

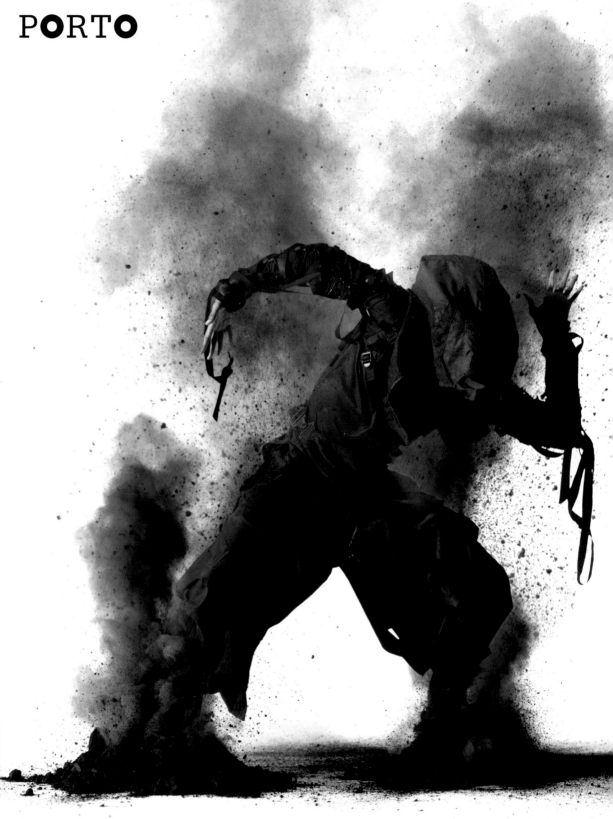

James Porto

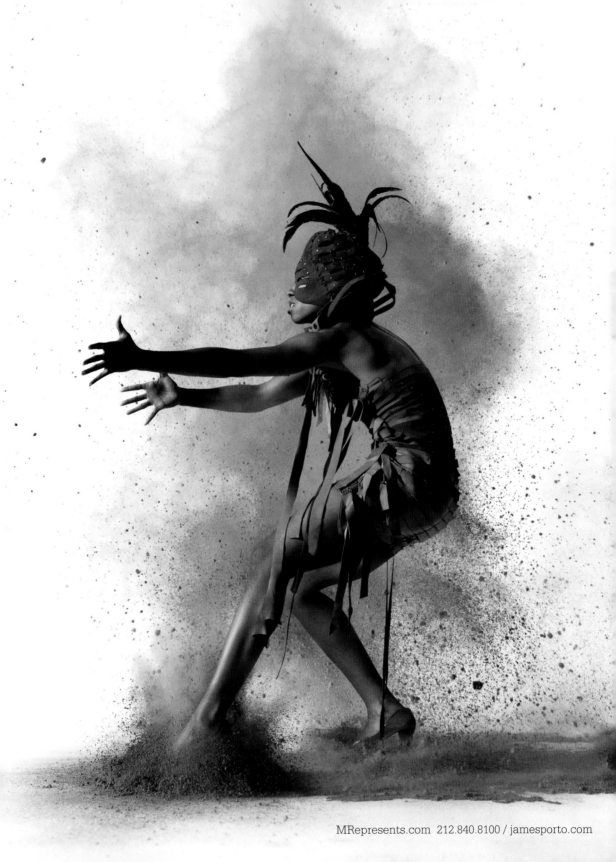

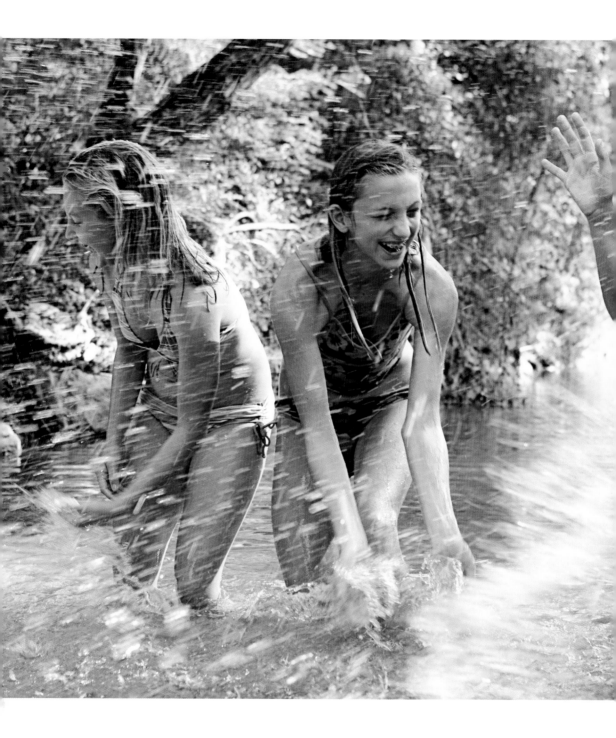

vgpictures.com 214.284.0018
represented by Those 3 Reps 800.579.0807

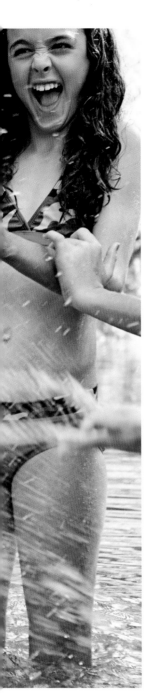

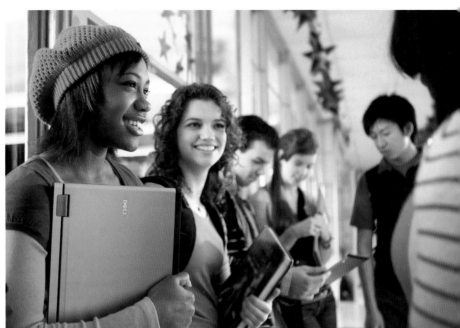

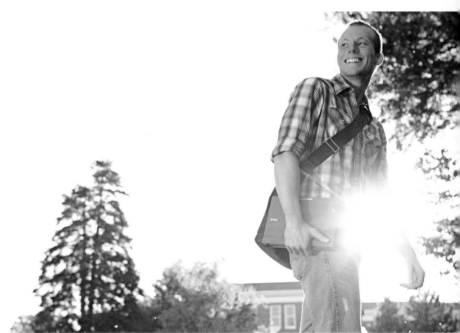

Vanessa Gavalya
PICTURES

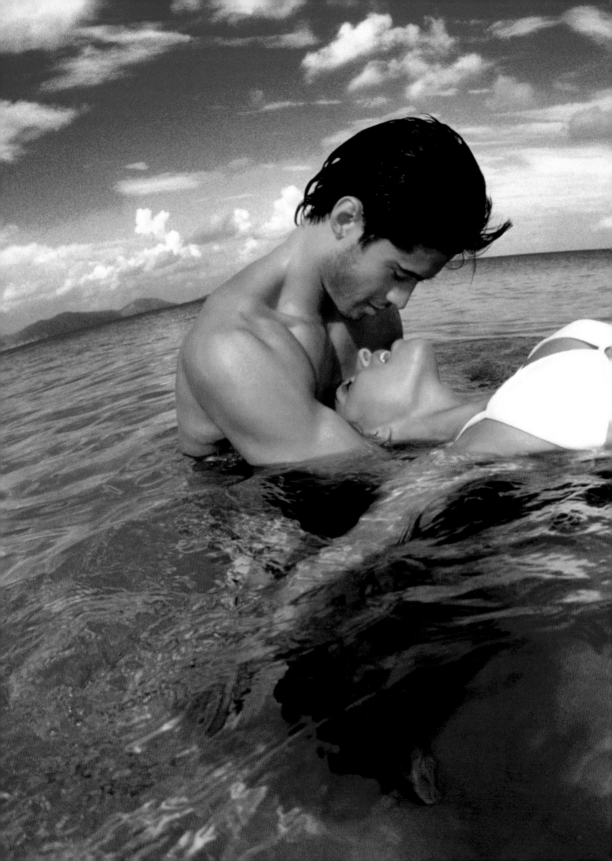

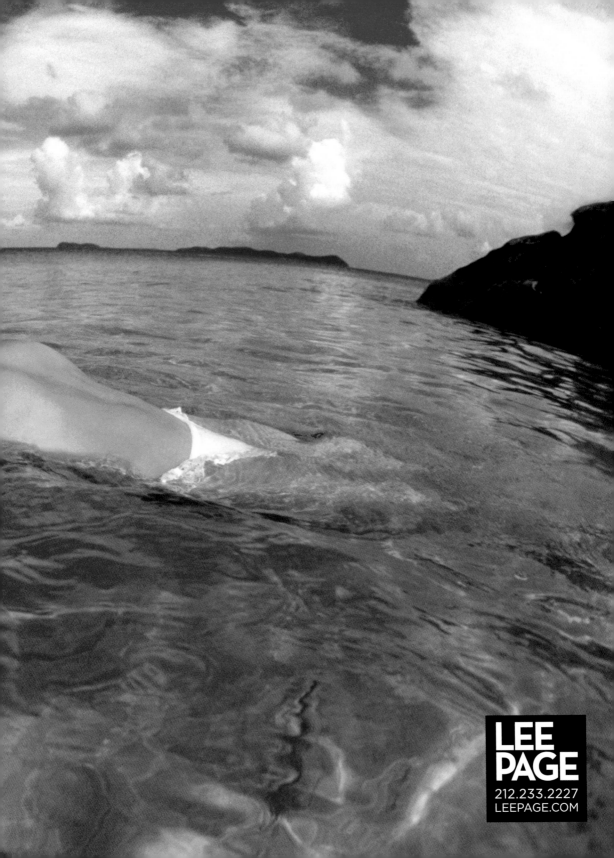

AWARDS

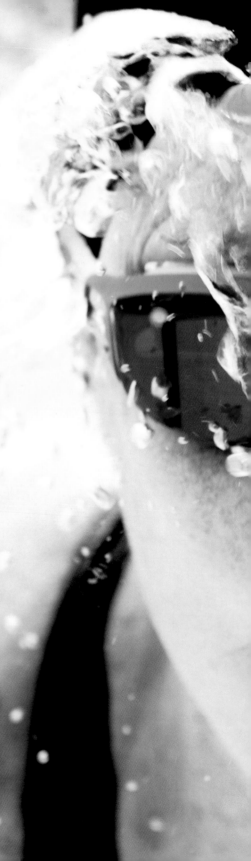

Communication Arts Photography Annual 2011
Archive's 200 Best Ad Photographers Worldwide 2010
Archive's 200 Best Ad Photographers Worldwide 2009
Graphis Photo 2009 Sports
Graphis Photo 2008 Landscape
Graphis Photo 2008 Landscape
American Photography 2008
Graphis Photo 2007 Wildlife
Graphis Photo 2007 People
Workbook inspiration page 2007
2006 Gold Addy Award
Graphis Design Annual 2006
Communication Arts Exhibit 2006 May/June
2006 Lucie Award Nature-Underwater Professional
2005 IPA Photo Award People in Professional
2005 IPA Photo Award Advertising in Professional
Workbook inspiration page 2005
Graphis Photo 2004 landscape
Graphis Photo 2004 Sports
Applied Arts Photography and Illustration Annual 2004
Applied Arts Photography and Illustration Annual 2004
Archive Magazine Vol 5 2003
2003 Altpick Award (c)
2003 Altpick Award (b)
2003 Altpick Award (a)
AdNews 2003
Communication Arts Photography Annual 2003
Communication Arts Exhibit Online 2003
Communication Arts Exhibit, March/April 2002
Graphis Photo Gallery (issue 348)
2002 Gold Addy Award
2002 Silver Addy Award (b)
2002 Silver Addy Award (a)
32nd International Underwater Photo competition,1st place
APA 2001
Graphis Photo 1996

PAOLO **MARCHESI**

Photography

MONTANA 406 _ _____ 5806040
SAN FRANCISCO 415 _ _____ 7382074

WWW.MARCHESIPHOTO.COM

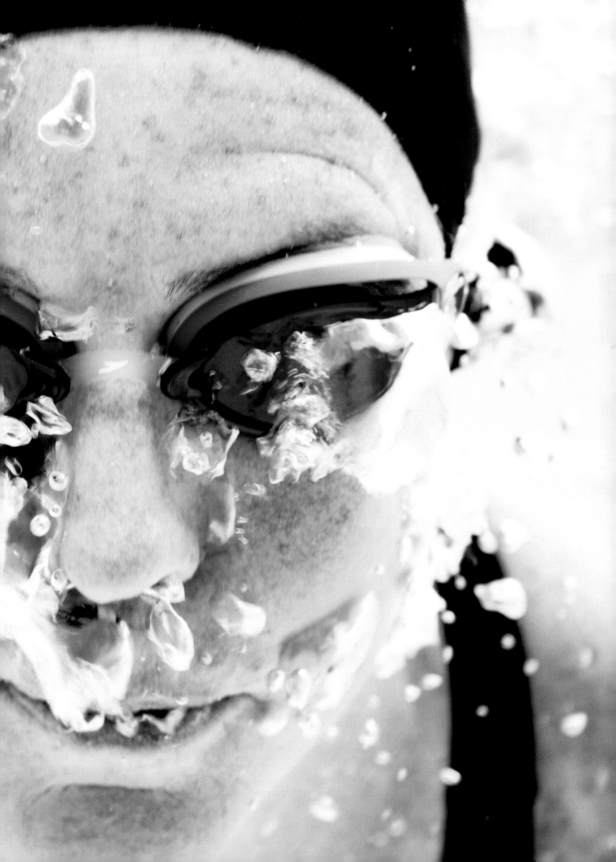

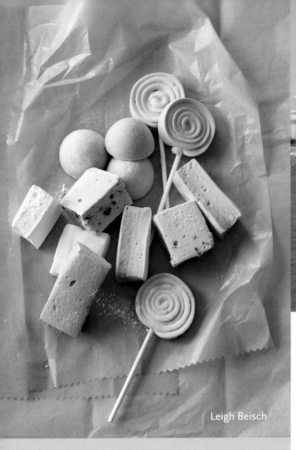

Leigh Beisch

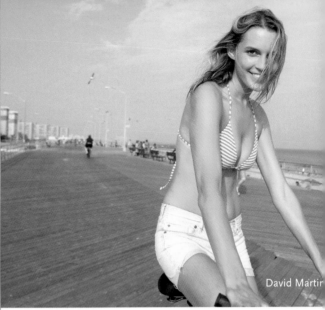

David Martin

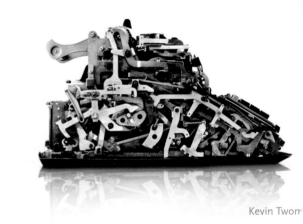

Kevin Twomey

Ann Elliott Cutting

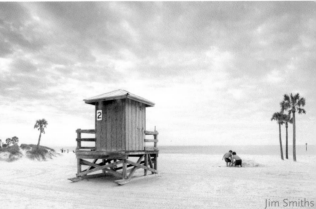

Jim Smiths

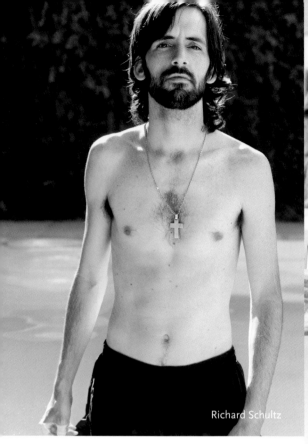

Richard Schultz

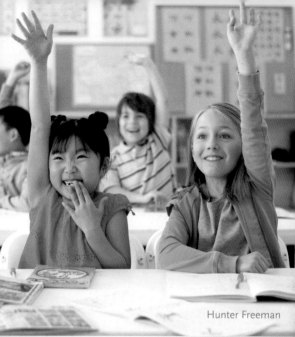

Hunter Freeman

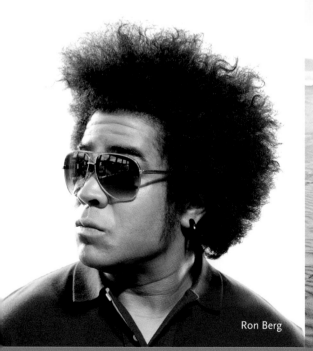

Ron Berg

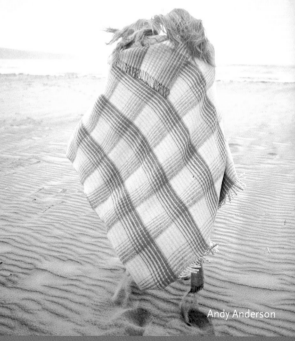

Andy Anderson

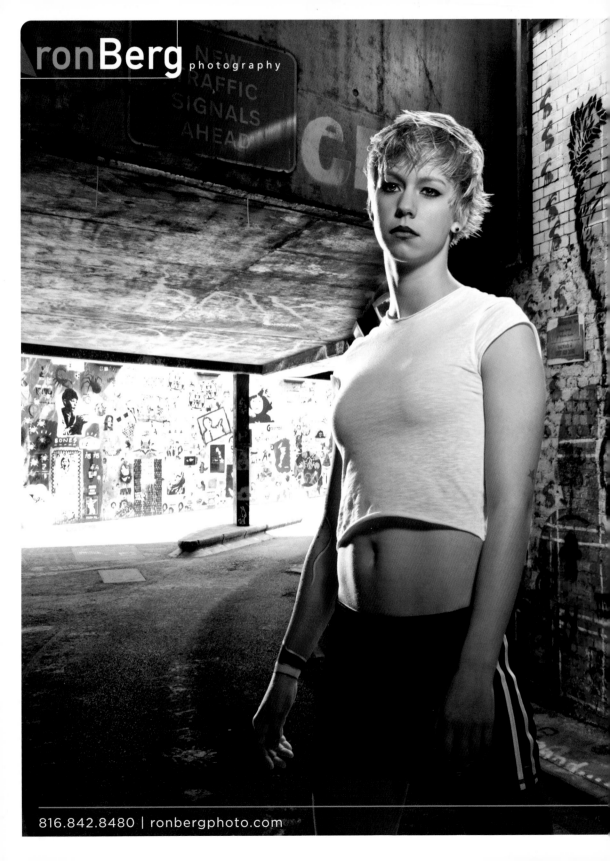

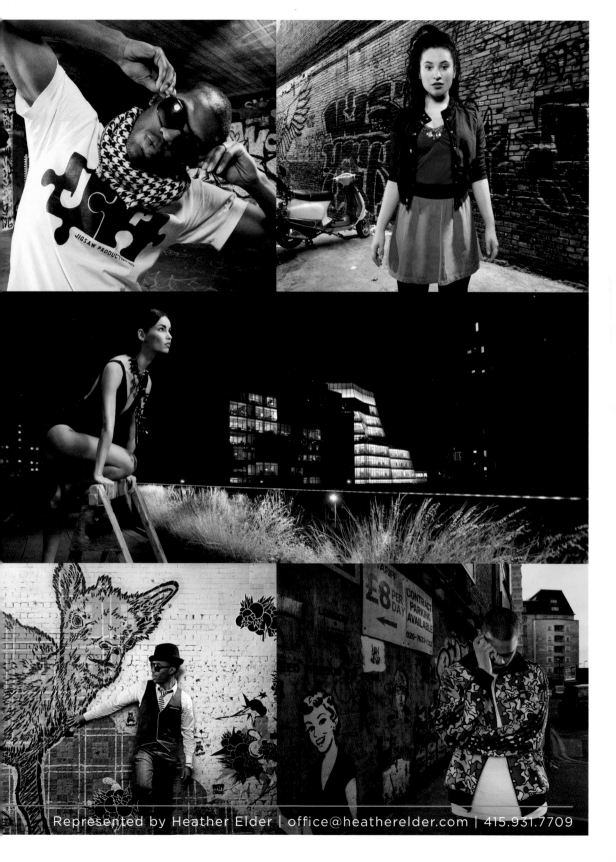

hunter@hunterfreeman.com
415 252 1910 phone
www.hunterfreeman.com
hunterfreeman.wordpress.com

Represented by
Heather Elder
415 931 7709 phone
www.heatherelder.com
elderrep.wordpress.com

Visit www.heatherelderstock.com

heather elder

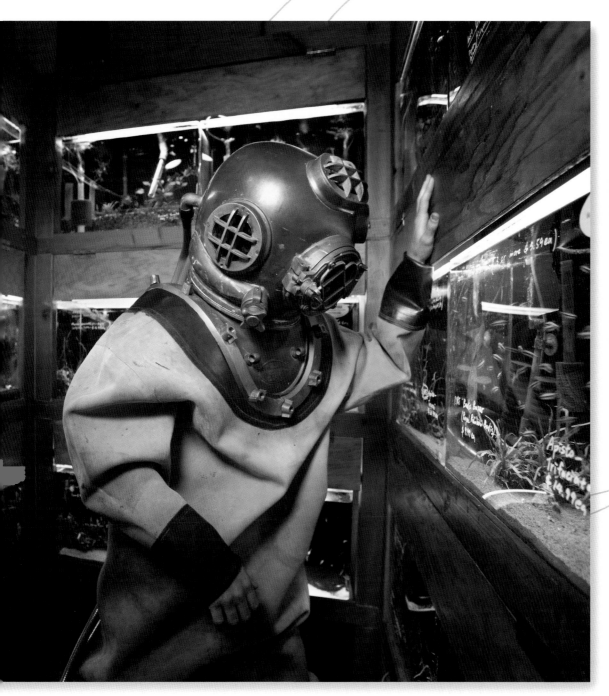

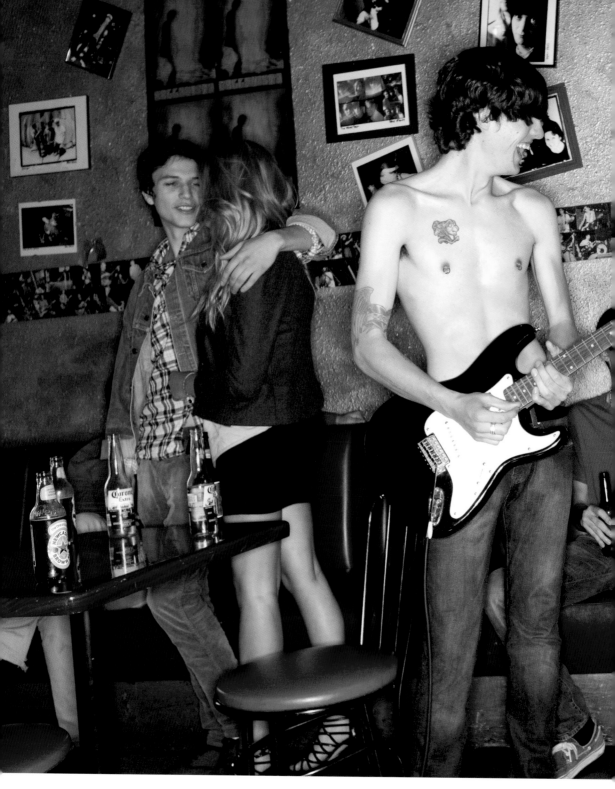

david martinez

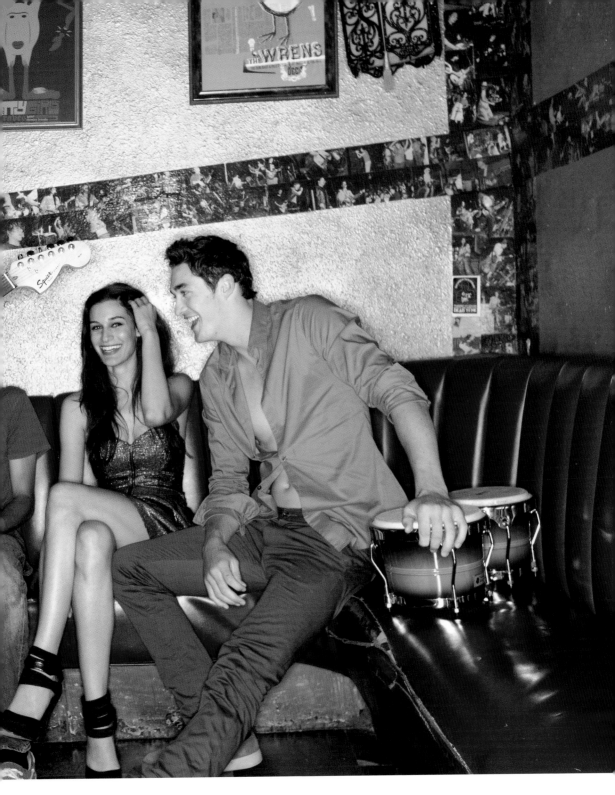

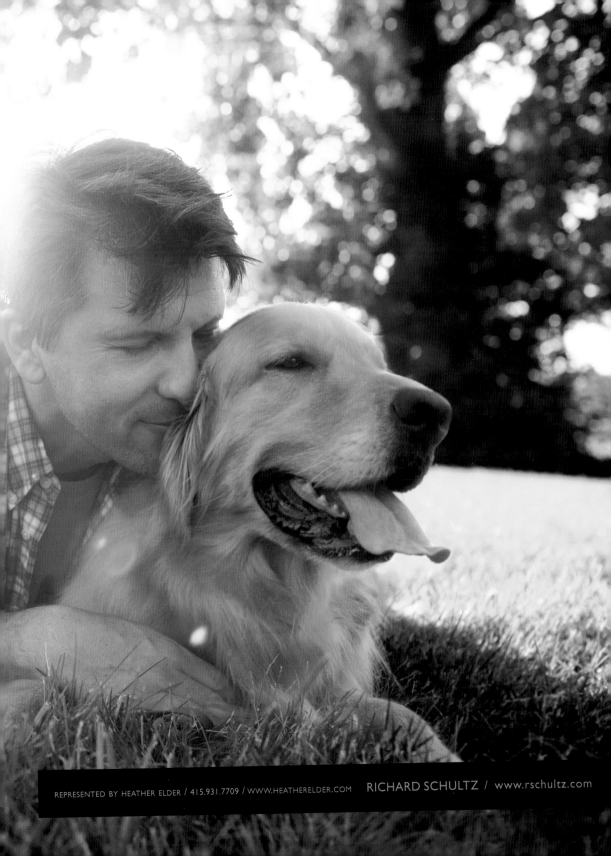

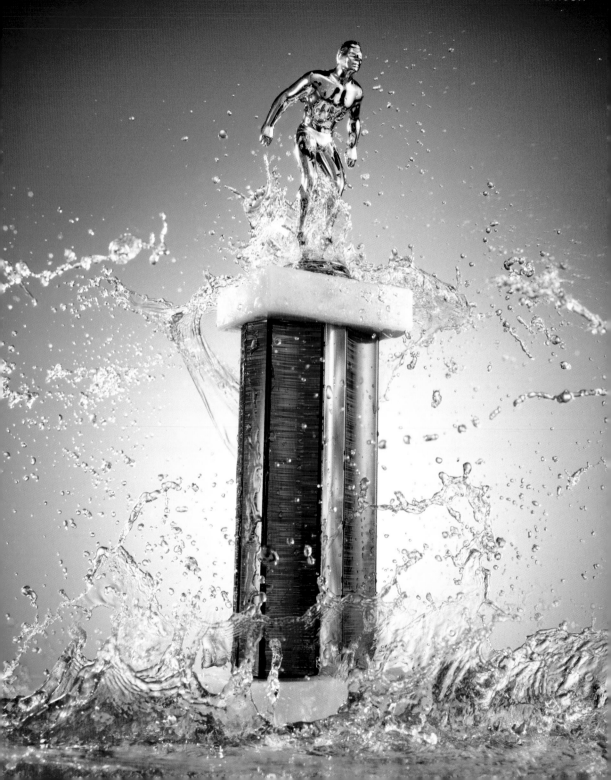

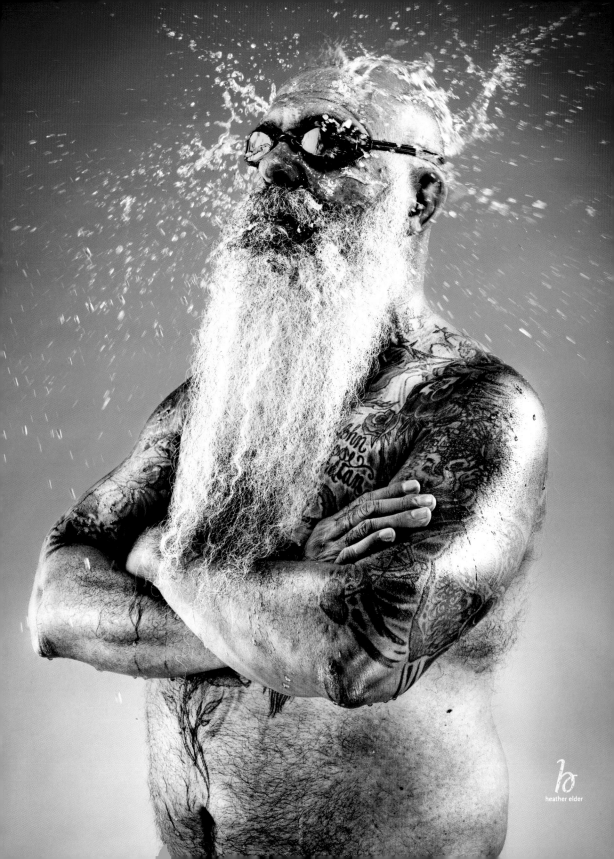

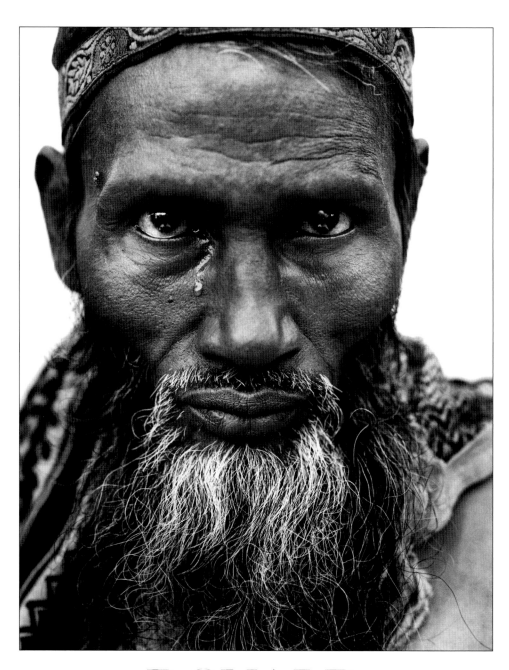

DONALD
GRAHAM

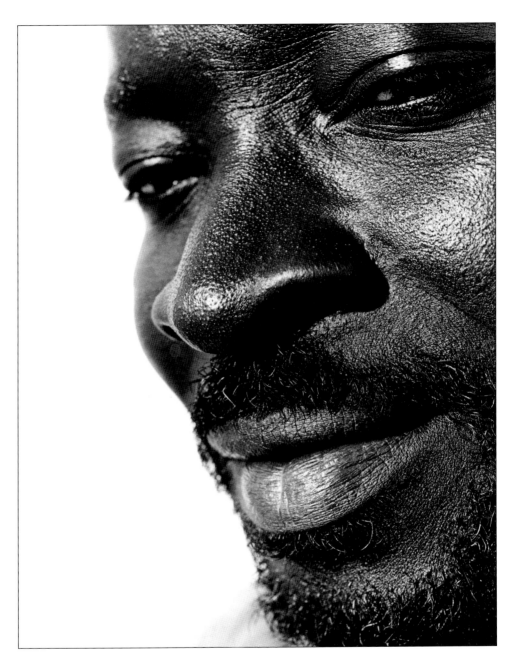

DONALD GRAHAM

www.donaldgraham.com
Represented by Daniele Forsythe Photographers
New York 212 693 7470 Los Angeles 310 450 1650

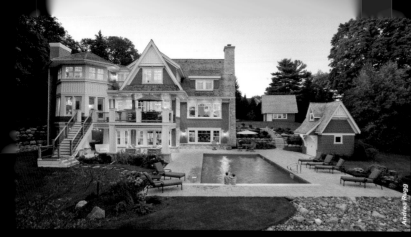
Andrea Rugg

Photography

Jeff Baker
Brian Coats
Fernando Decillis
Michael Haskins
Paolo Marchesi
Jeff Moore
Andrea Rugg

Illustration/3d

Duarte Imaging
Greg McCullough

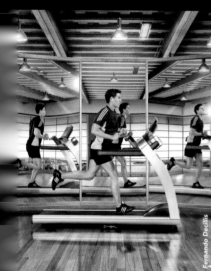
Fernando Decillis

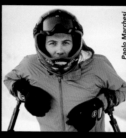
Paolo Marchesi

Michael Haskins

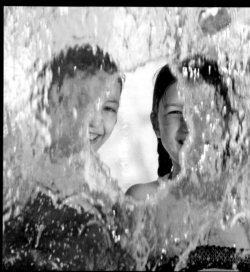

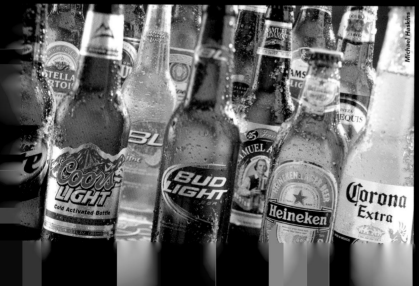
Michael Haskins

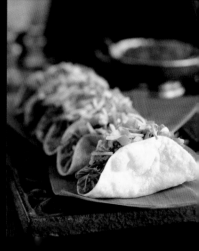

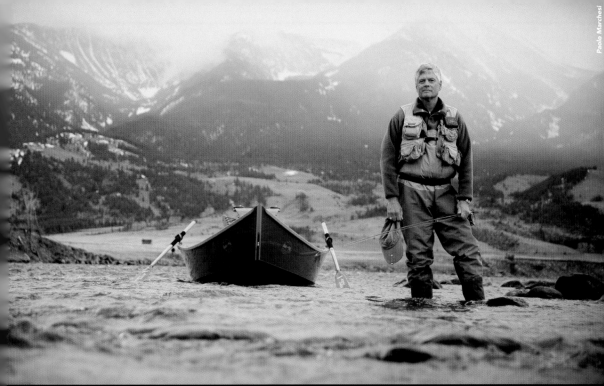

Paolo Marchesi

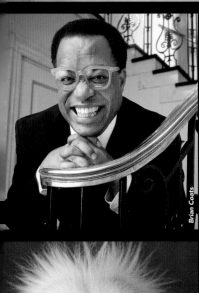

Brian Coats

Jeff Moore

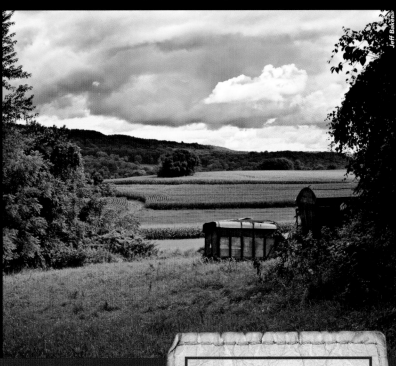

Jeff Bakken

SCOTT MONTGOMERY
smontgomery.com

Lisa Button
buttonrepresents.com

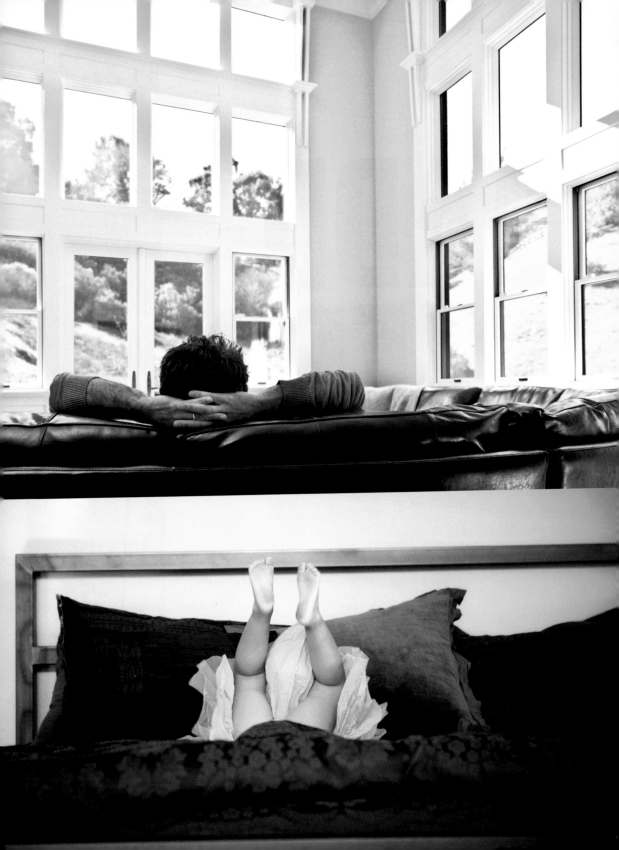

TADD MYERS

SEE MORE AT

TADDMYERS.COM

AMERICANCRAFTSMANPROJECT.COM

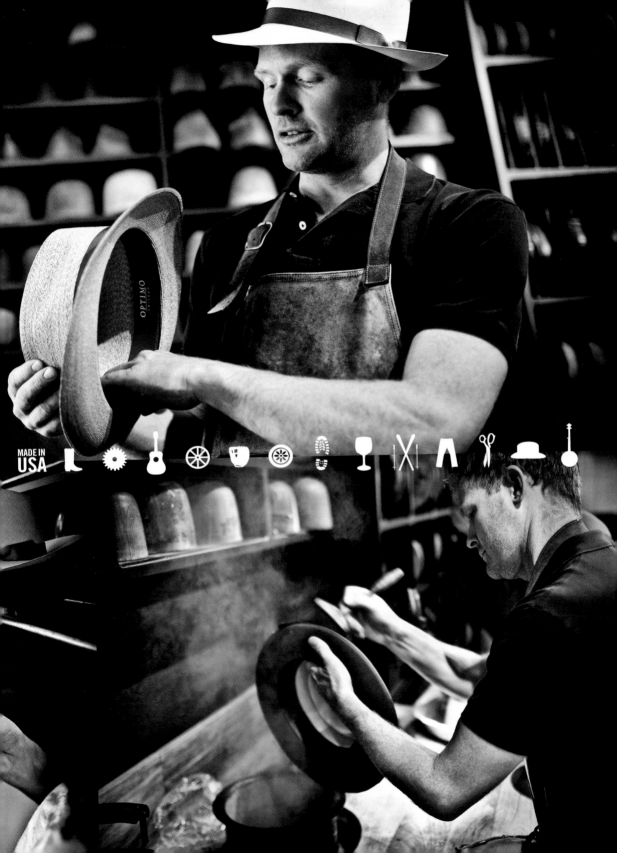

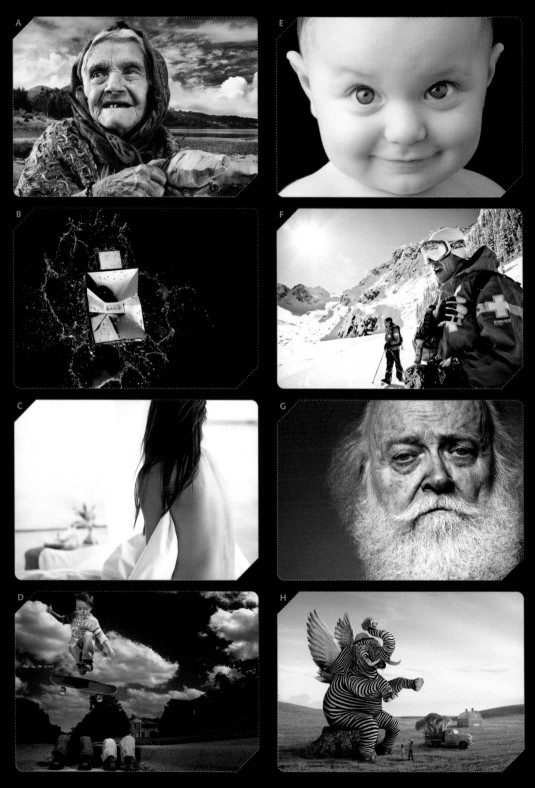

A Niels Van Iperen **B** Satoshi **C** Steve Beaudet **D** Dennis Murphy **E** Ross Whitaker **F** Kevin Arnold **G** Leland Bobbé **H** Lorenz + Avelar

RBR

ROBERT
BACALL
REPRESENTATIVES

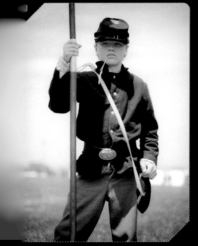
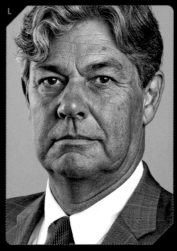

L

K

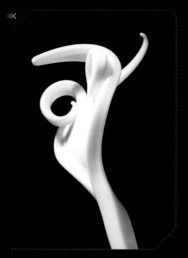
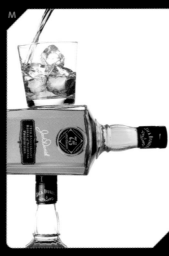

M

BACALL.COM

917.763.6554 · ROB@BACALL.COM · PHOTOGRAPHYMOTIONSGI · FINDISON in

I Sam Robles **J** Robb Scharetg **K** Andrew Hall **L** Eric Van Den Brulle **M** Terry Heffernan

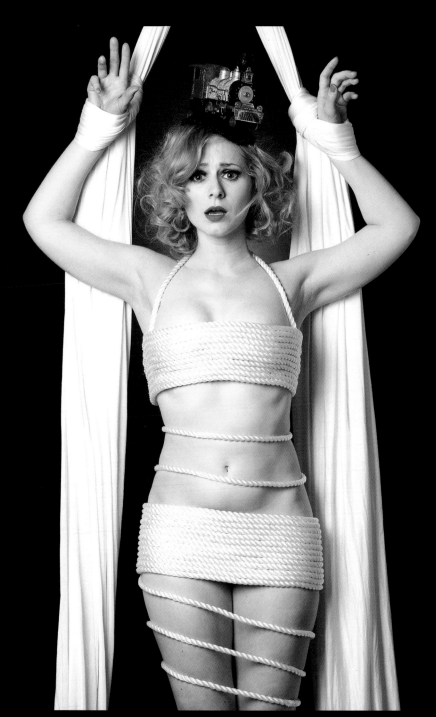

Veruca Honeyscotch

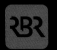

ROBERT
BACALL
REPRESENTATIVES

917.763.6554

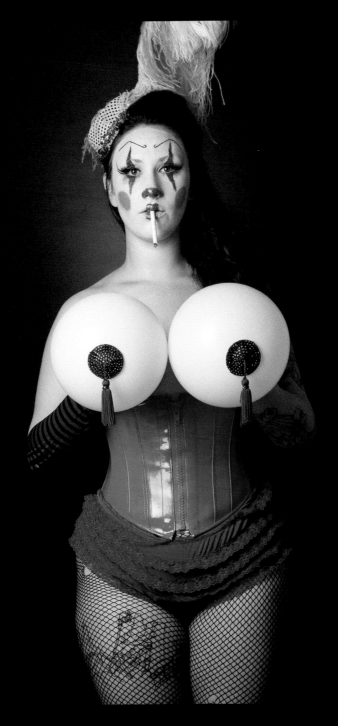

Dottie Lux

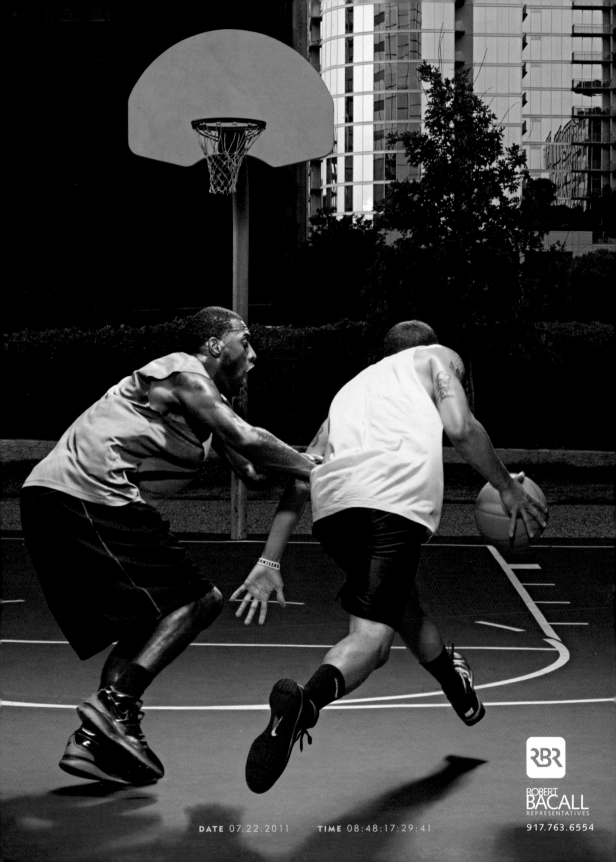

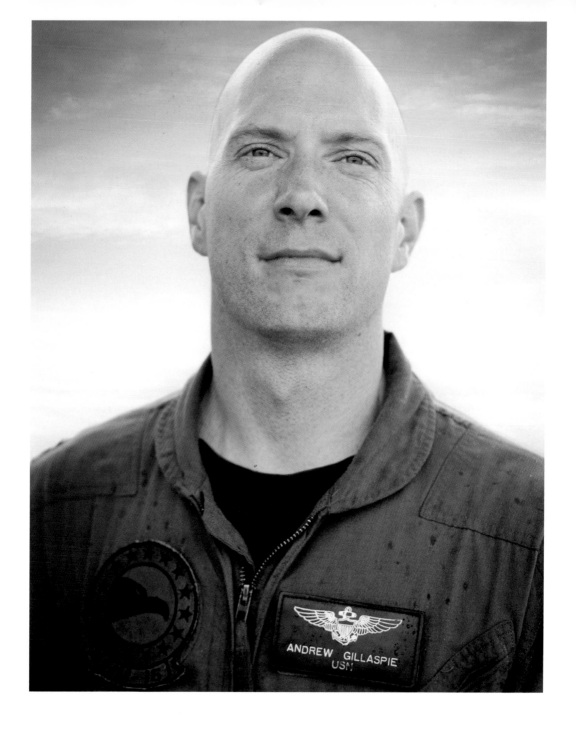

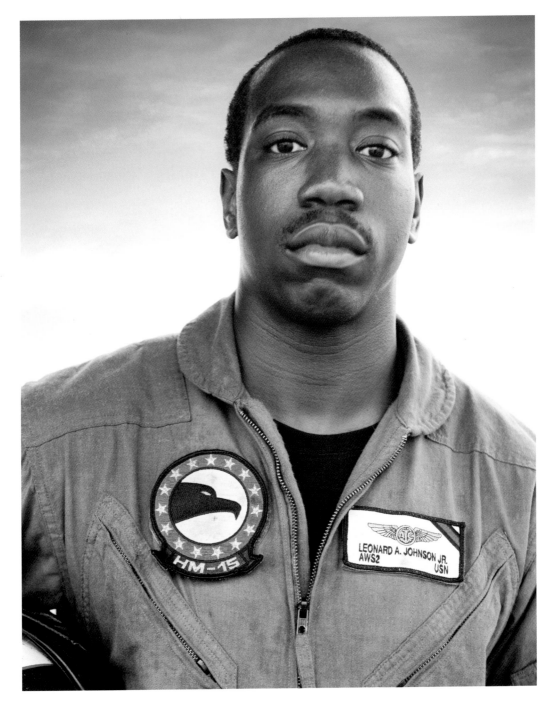

ROBB SCHARETG

[PICTURES]

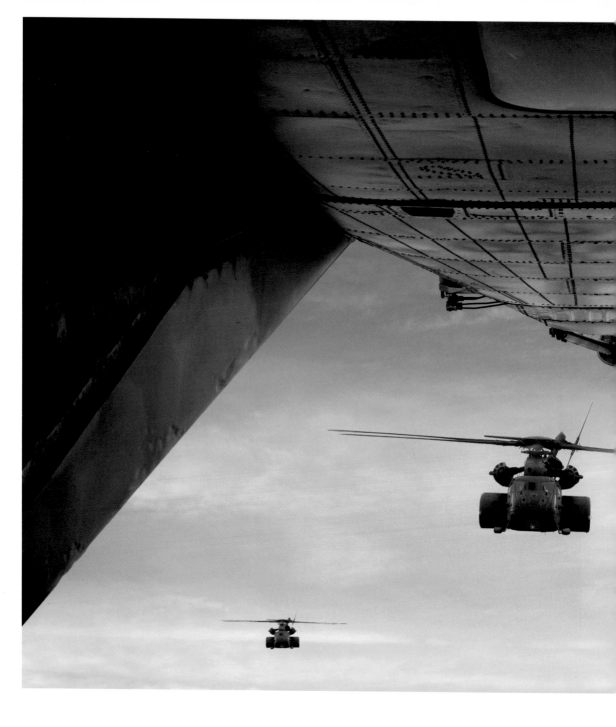

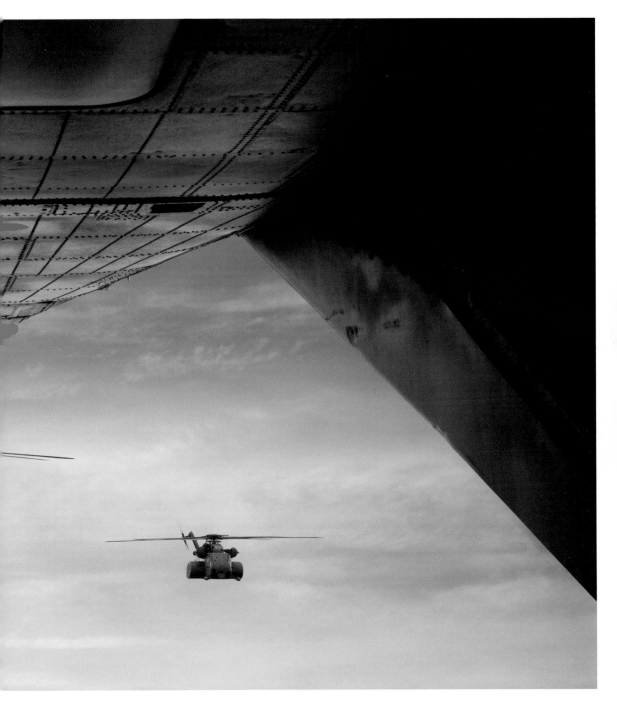

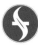

ROBB SCHARETG

[PICTURES]

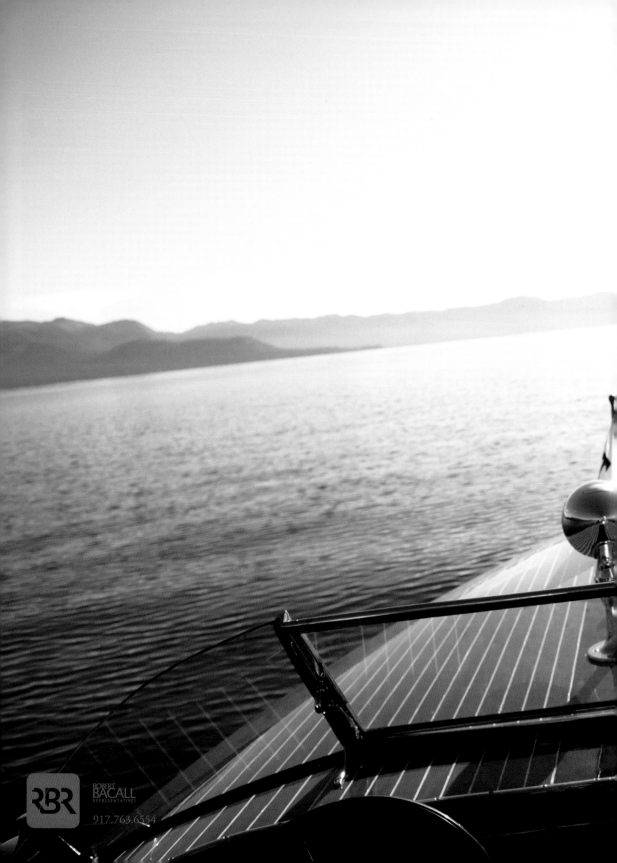

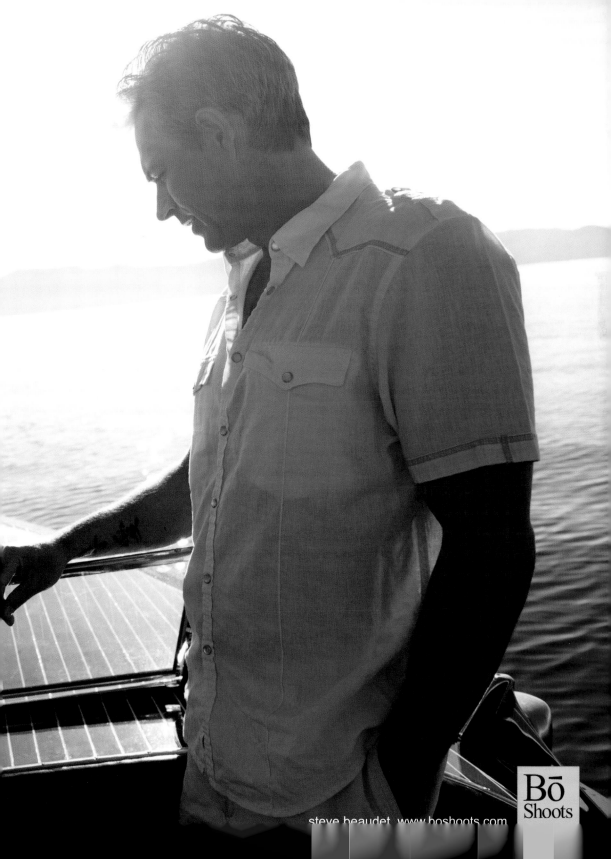

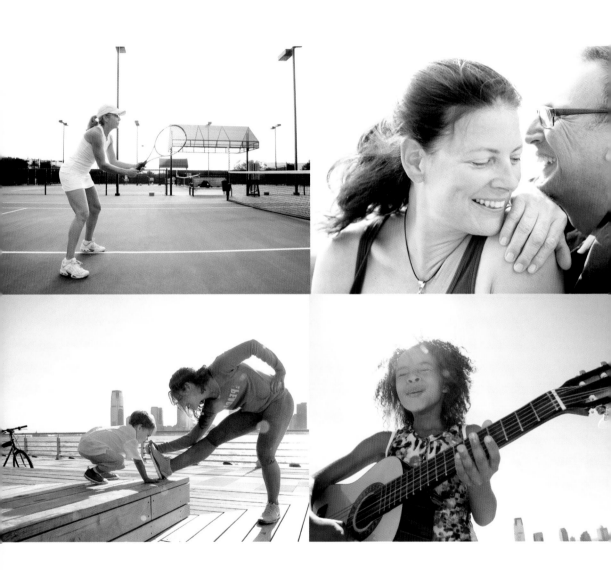

CamilleTokerudPhotography

917 821-9881 . New York, NY . ctokerud@mac.com . www.camilletokerud.com

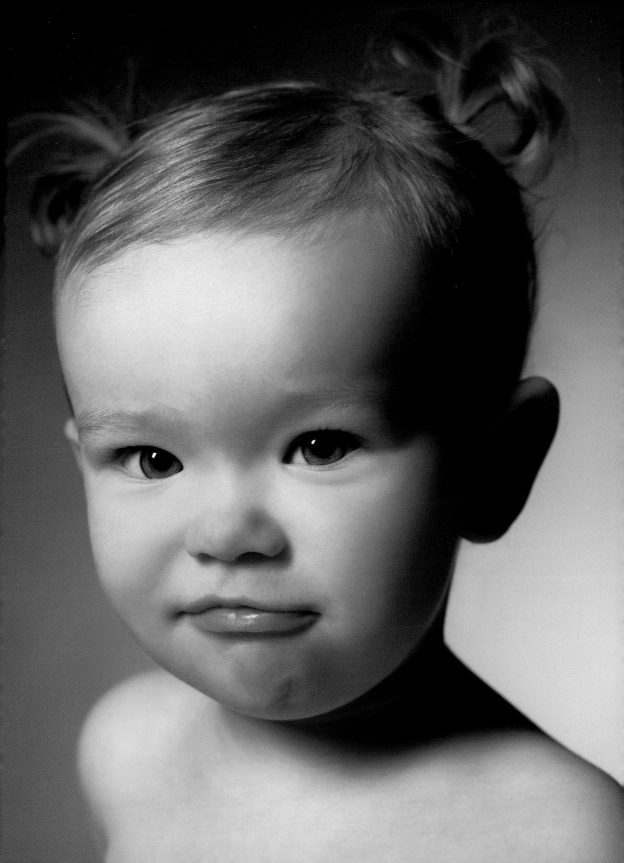

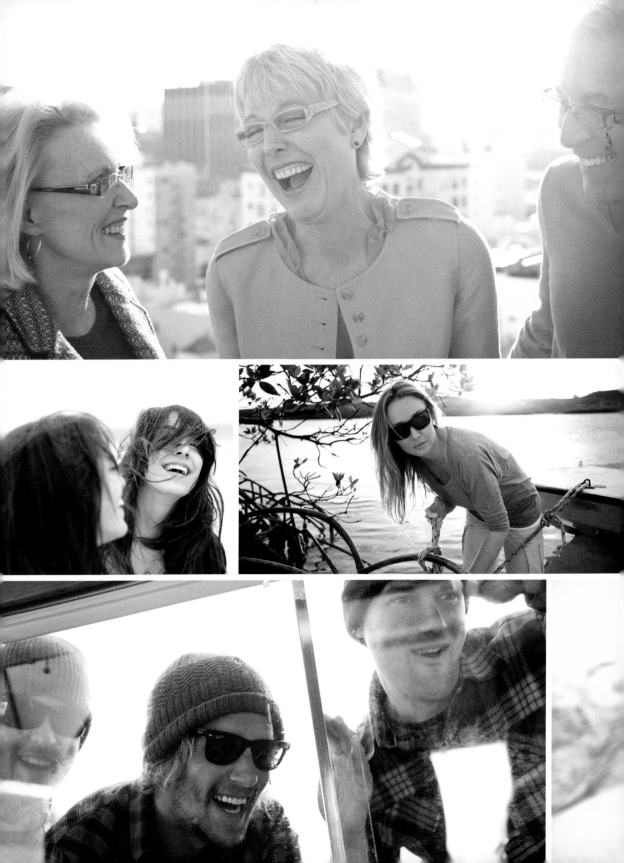

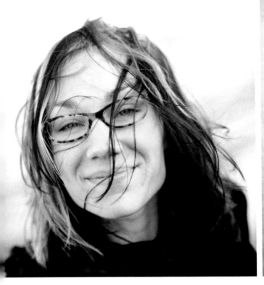
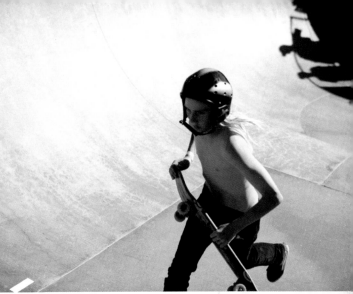
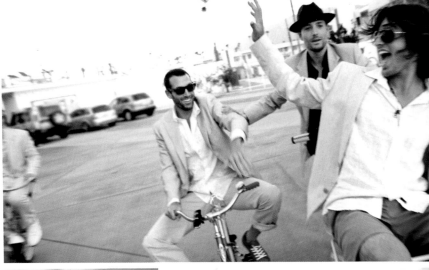

BIL
ZEL
MAN
PHOT
OGRA
PHER

zelmanstudios.com

represented by
@Radical Media

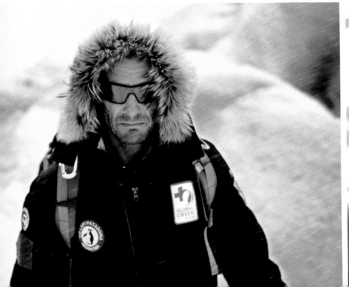

represented by
Sherry Riad 212.797.0009

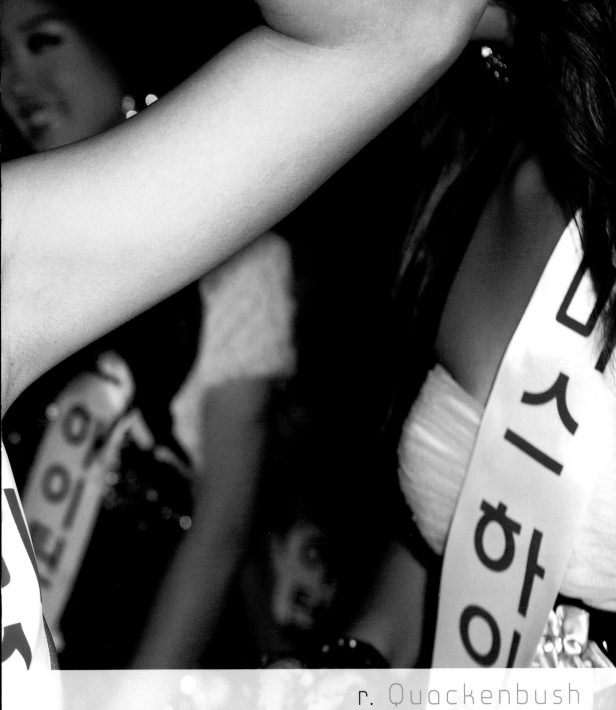

r. Quackenbush
www.russquackenbush.com

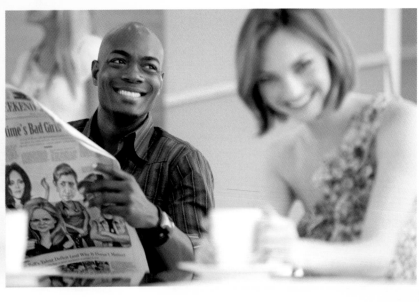

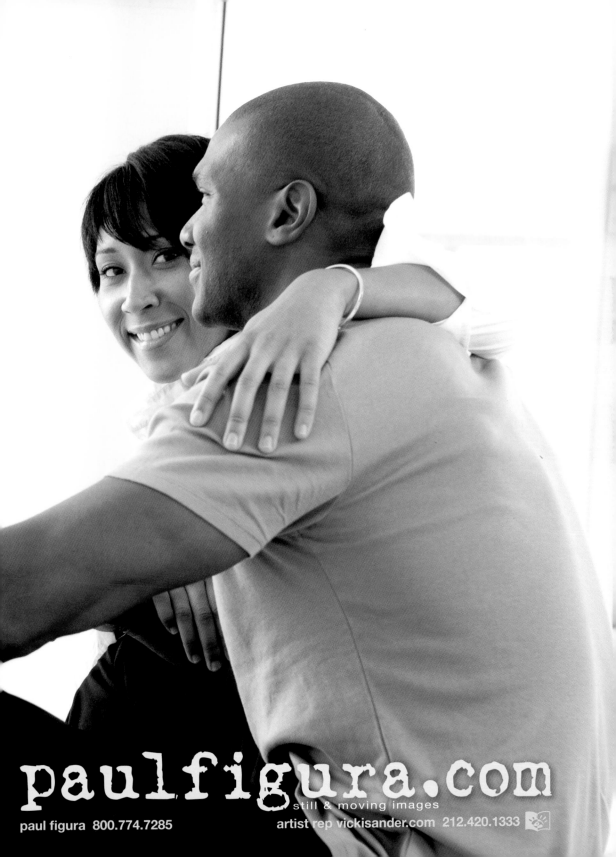

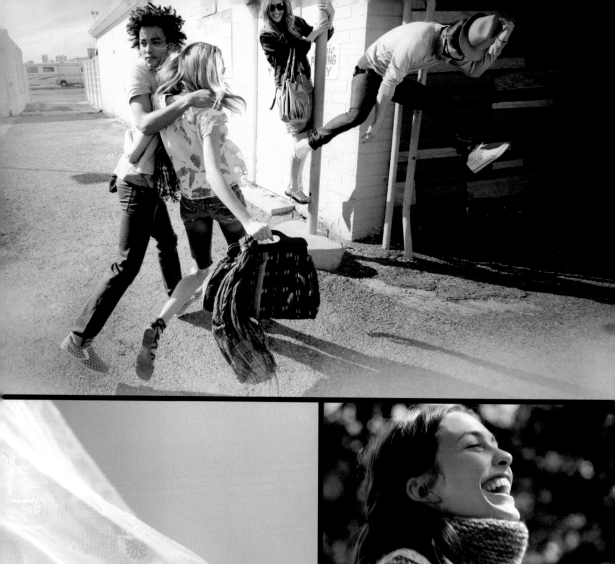
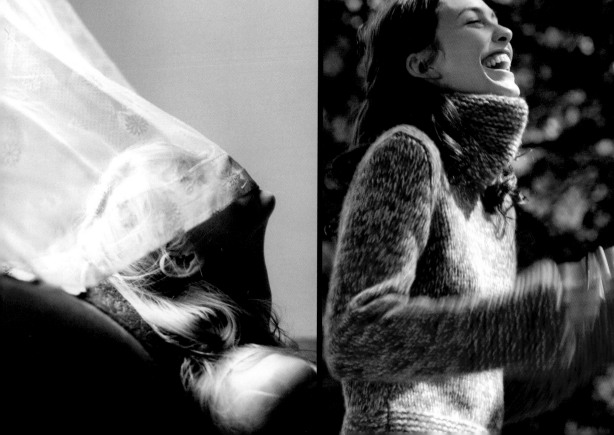

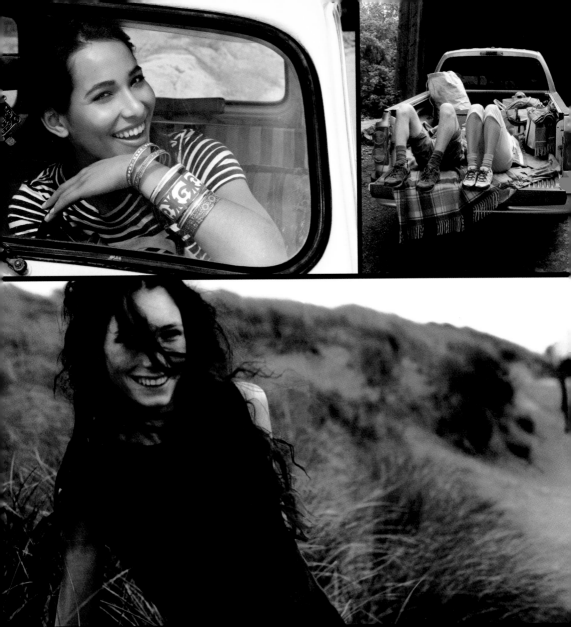

CREATIVE MANAGEMENT AT mc²

PHOTOGRAPHY | NEW YORK | MIAMI
646.638.3321 | www.creativemanagementmc2.com

REPRESENTING:

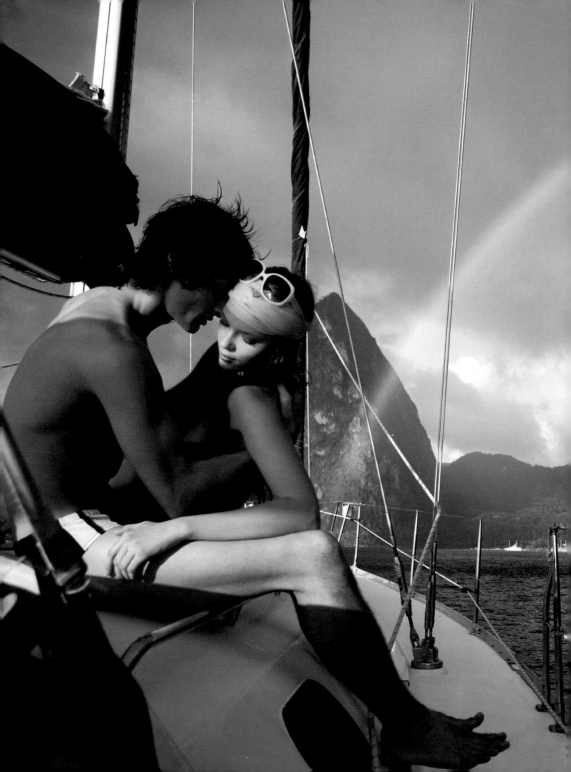

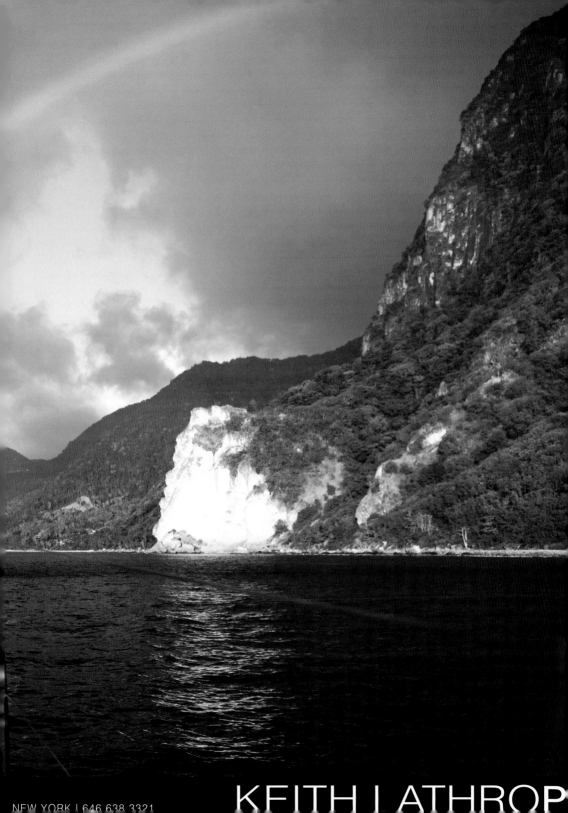

KEITH LATHROP

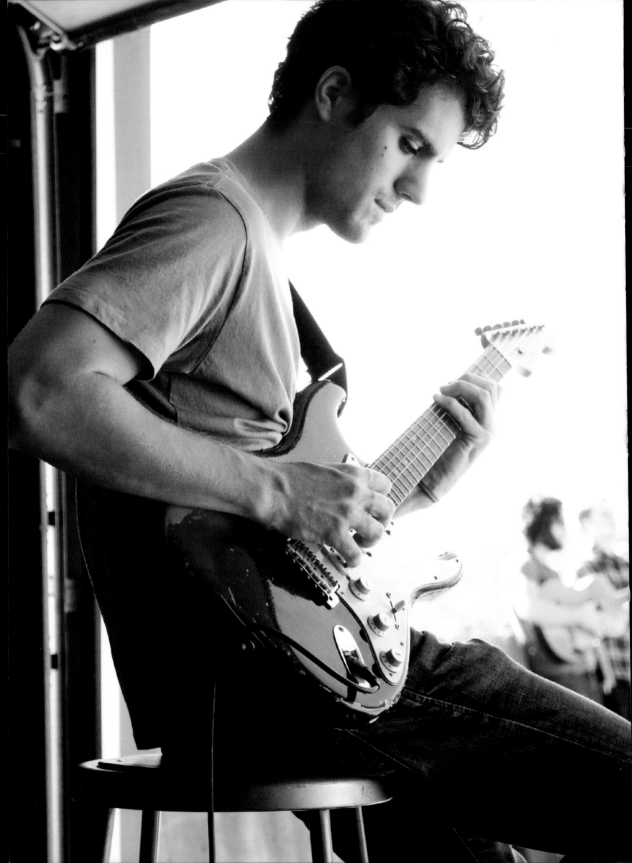

GRE**GH**INSDALE

REPRESENTED BY CREATIVE MANAGEMENT AT MC2
WWW.CREATIVEMANAGEMENTMC2.COM
NEW YORK | 646.638.3321

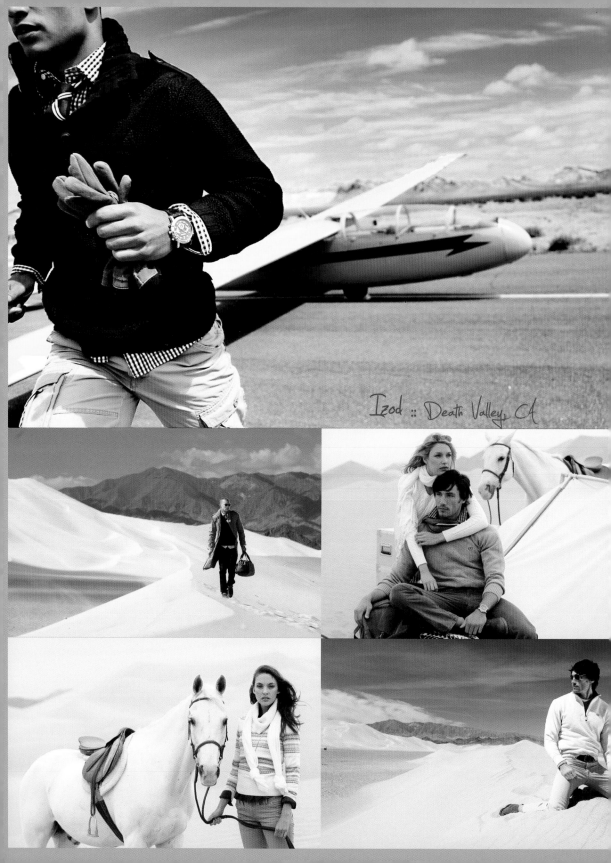

Izod :: Death Valley, CA

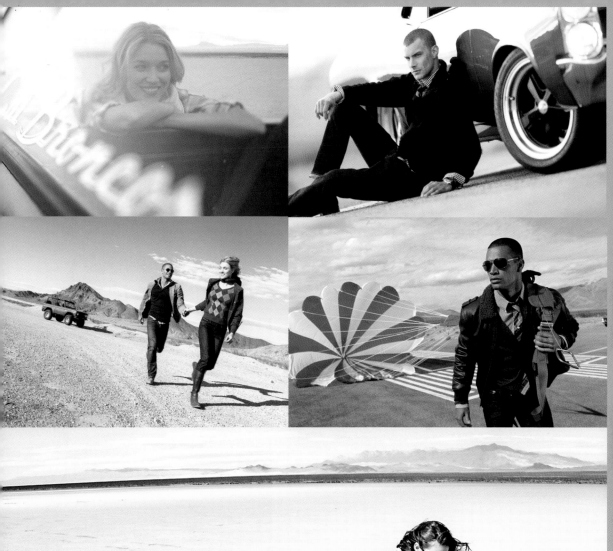
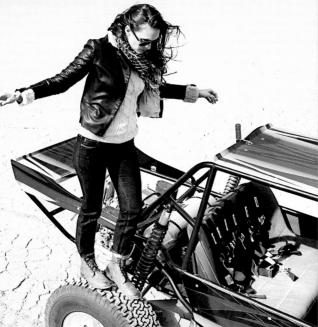

MichaelVoorhees.com
studio: 949.650.6150

CARLIDAVIDSO

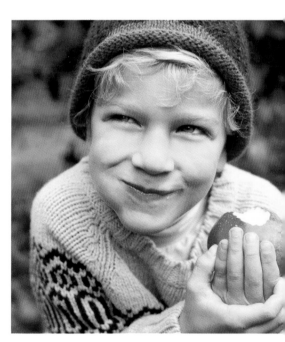

BRADGUIC

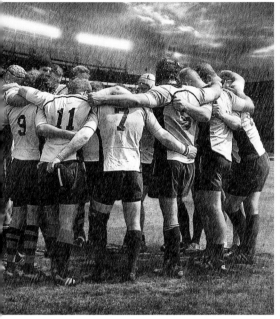

PAUL**ARESU**
PHOTO / MOTION

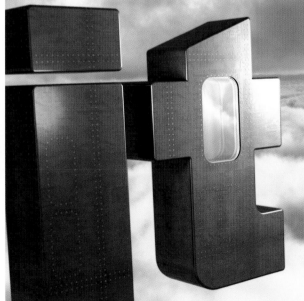

ROBERT**TARDIO**
PHOTO

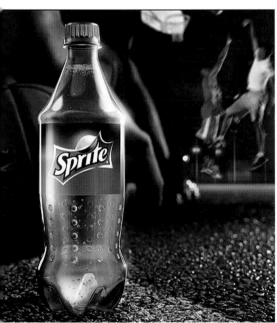

ALTER
CGI / MOTION / PHOTO

2FAKE
CGI / MOTION

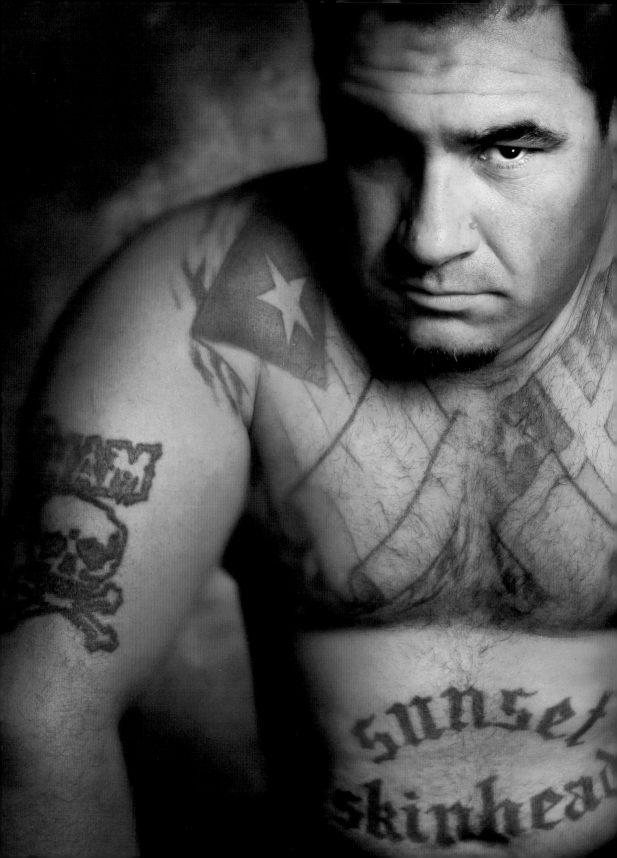

BRAD GUICE

REPRESENTED BY:
JANICE MOSES
212.898.4898
WWW.JANICEMOSES.COM

BRAD GUICE
WWW.BRADGUICE.COM

BRILLIANT

is cinema quality entertainment at the speed of 4G.

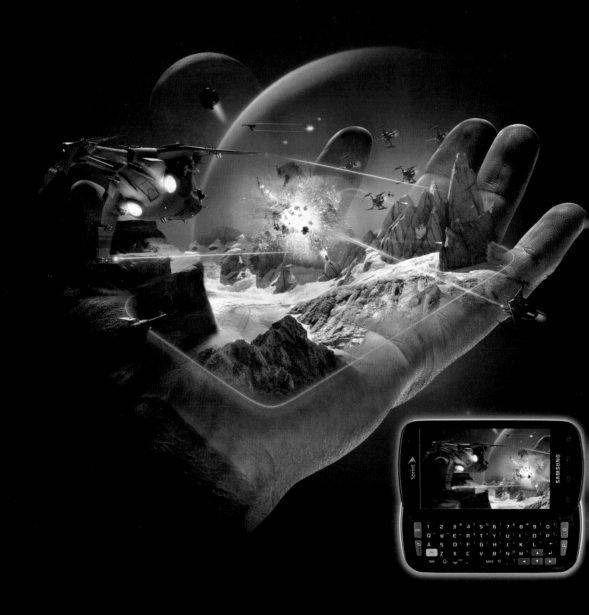

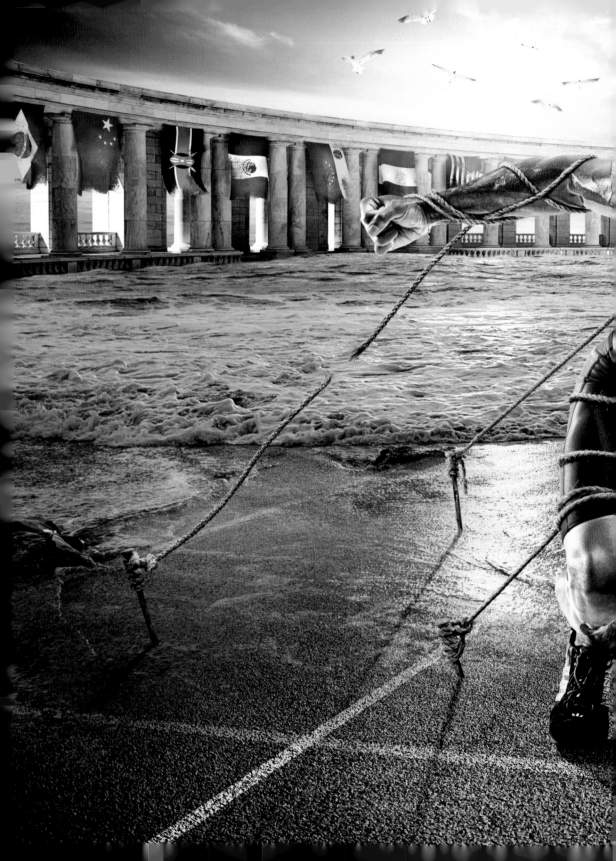

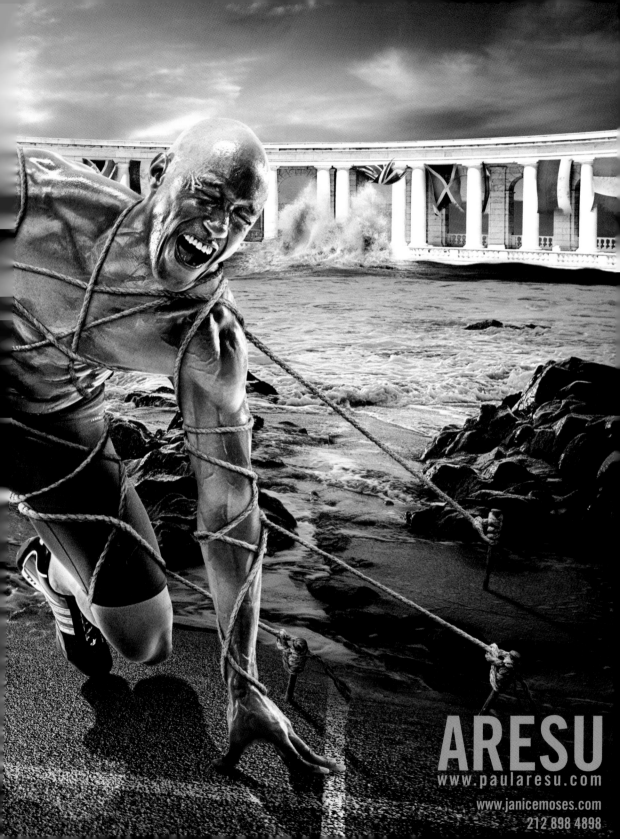

ARESU
www.paularesu.com

www.janicemoses.com
212 898 4898

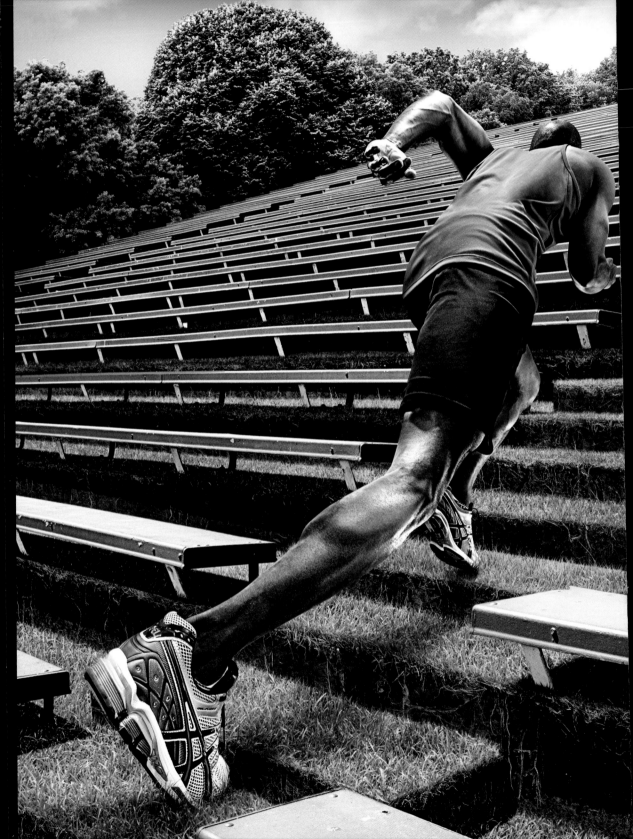

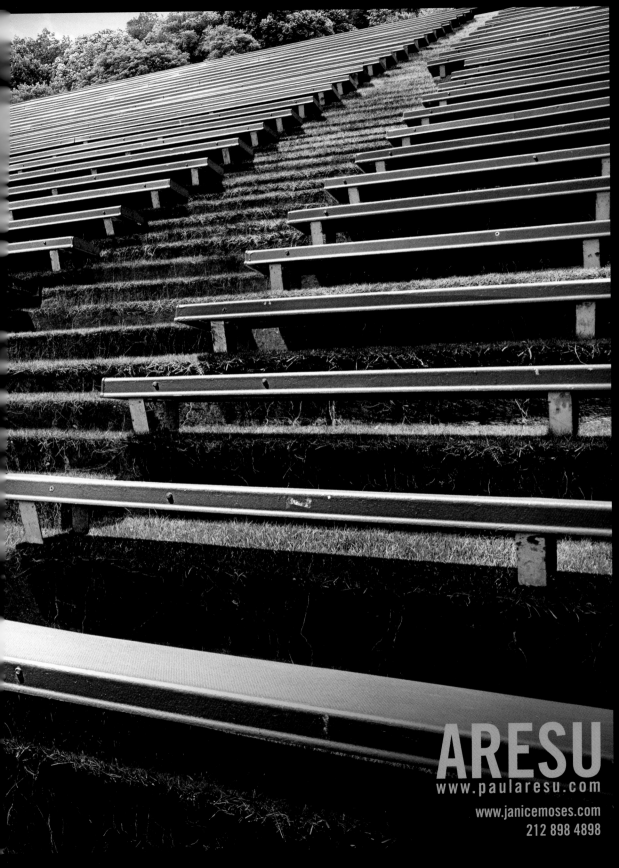

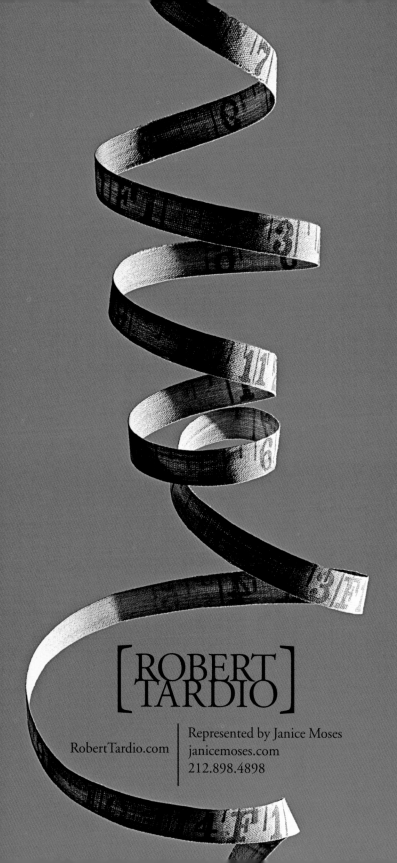

[ROBERT]
[TARDIO]

RobertTardio.com

Represented by Janice Moses
janicemoses.com
212.898.4898

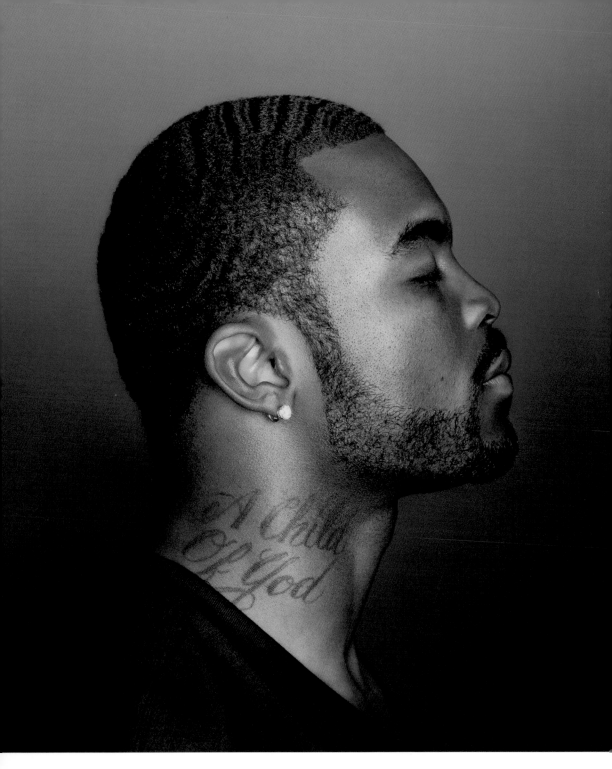

CHRIS CRISMAN

Photographer

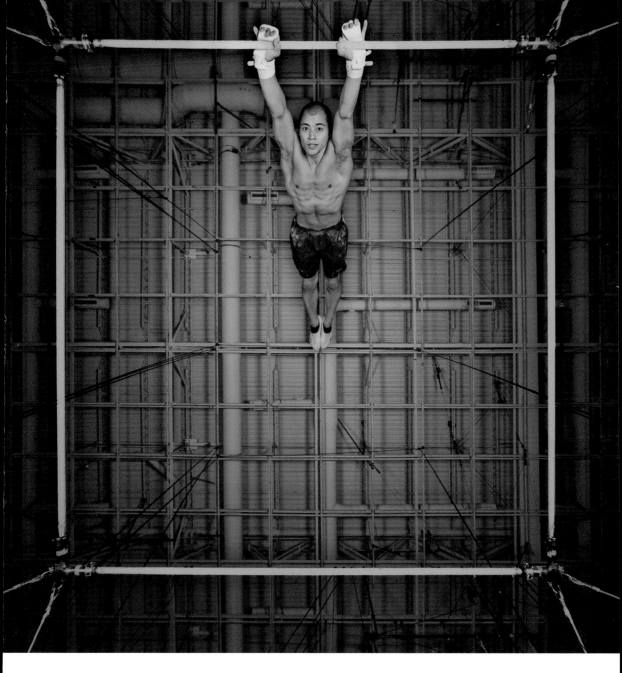

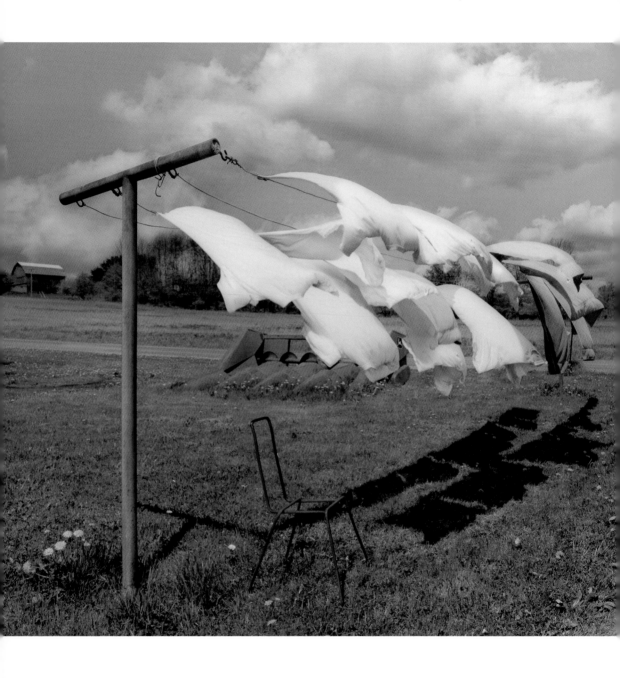

CHRIS CRISMAN

Photographer

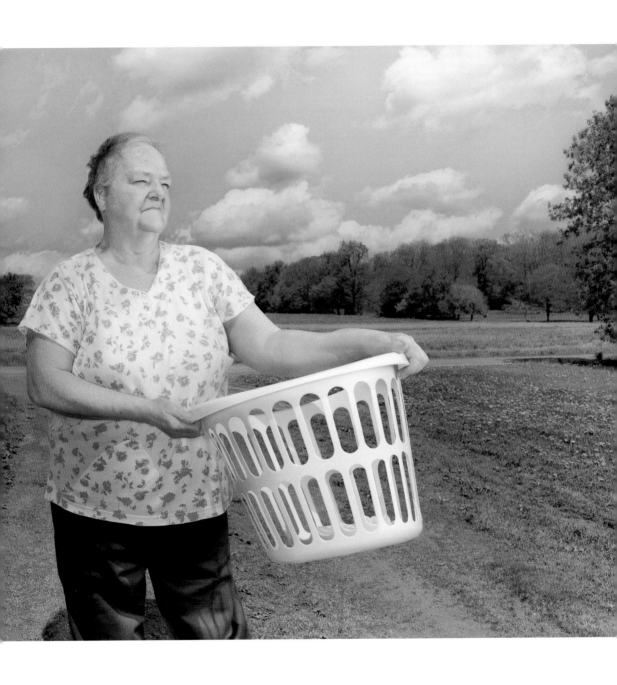

381

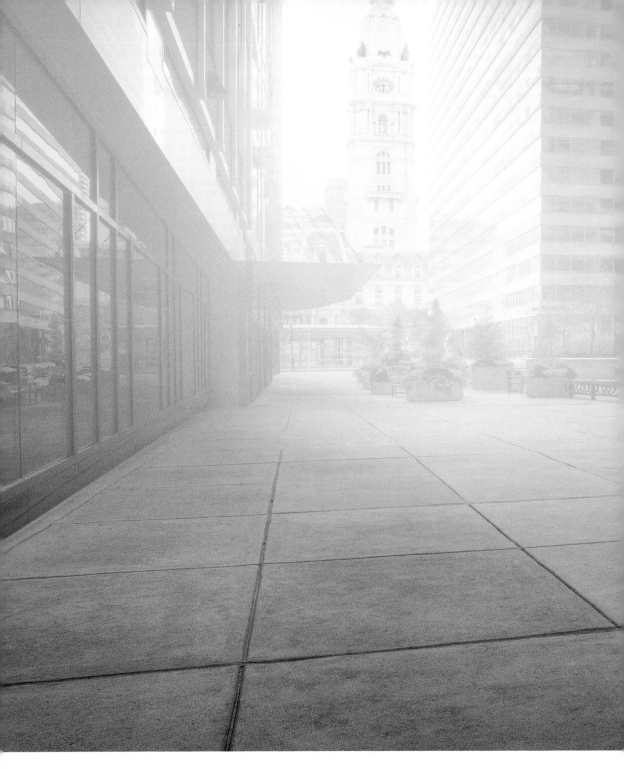

CHRIS CRISMAN
Photographer

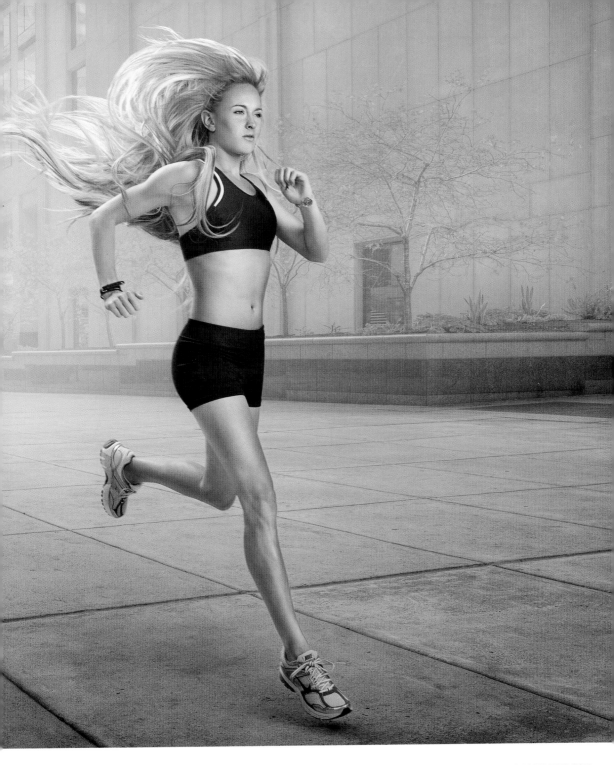

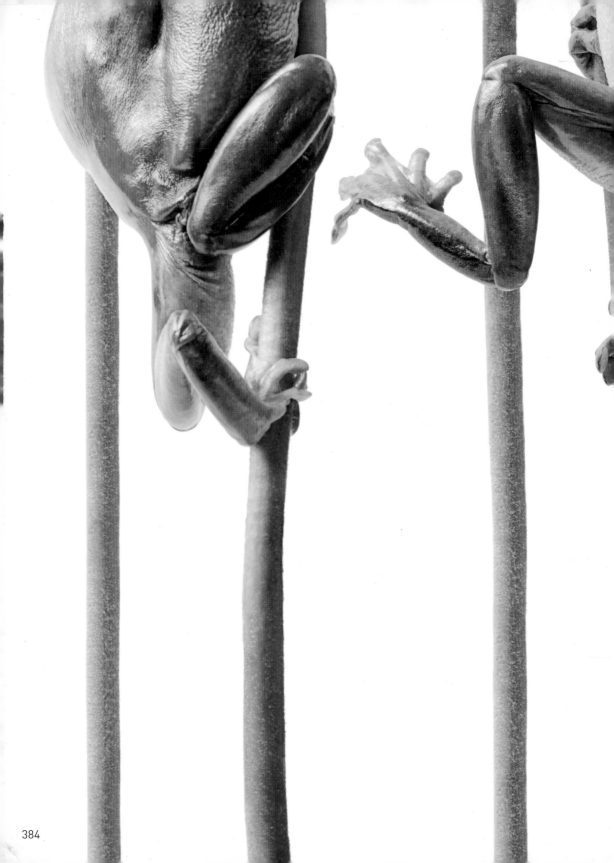